Brilliant Digital Photography for the Over 50s

John Skeoch & Antony Lees (Photographic Contributor)

PEARSON
Prentice
Hall

Harlow, England • London • New York • Boston • San Francisco • Toronto • Sydney • Singapore • Hong Kong
Tokyo • Seoul • Taipei • New Delhi • Cape Town • Madrid • Mexico City • Amsterdam • Munich • Paris • Milan

700039268261

Pearson Education Limited
Edinburgh Gate
Harlow
Essex CM20 2JE
England

and Associated Companies throughout the world

Visit us on the World Wide Web at:
www.pearsoned.co.uk

First published 2009

© Pearson Education Limited 2009

ISBN: 978-0-27-371936-6

British Library Cataloguing-in-Publication Data
A catalogue record for this book is available from the British Library

Library of Congress Cataloging-in-Publication Data
A catalog record for this book is available from The Library of Congress.

10 9 8 7 6 5 4 3 2 1
12 11 10 09 08

Prepared for Pearson Education Ltd by Syllaba Ltd (http://www.syllaba.co.uk).
Typeset in 12pt Arial Condensed by 30
Printed and bound by Rotolito Lombarda, Italy.

The publisher's policy is to use paper manufactured from sustainable forests.

Brilliant guides

What you need to know and how to do it

When you're working on your PC and come up against a problem that you're unsure how to solve, or want to accomplish something in an application that you aren't sure how to do, where do you look? Manuals and traditional training guides are usually too big and unwieldy and are intended to be used as end-to-end training resources, making it hard to get to the info you need right away without having to wade through pages of background information that you just don't need at that moment – and helplines are rarely that helpful!

Brilliant guides have been developed to allow you to find the info you need easily and without fuss and guide you through the task using a highly visual, step-by-step approach – providing exactly what you need to know when you need it!

Brilliant guides provide the quick easy-to-access information that you need, using a detailed table of contents and troubleshooting guide to help you find exactly what you need to know, and then presenting each task in a visual manner. Numbered steps guide you through each task or problem, using numerous screenshots to illustrate each step. Added features include 'See also' boxes that point you to related tasks and information in the book, while 'Did you know?' sections alert you to relevant expert tips, tricks and advice to further expand your skills and knowledge.

In addition to covering all major office PC applications, and related computing subjects, the *Brilliant* series also contains titles that will help you in every aspect of your working life, such as writing the perfect CV, answering the toughest interview questions and moving on in your career.

Brilliant guides are the light at the end of the tunnel when you are faced with any minor or major task.

Author's acknowledgements

Thanks to Sally and Anna for their enthusiasm and assistance in creating the best book Antony and I could produce. Thanks also to all our patient models, including Mum and Terry, and last but not least Canon for their loan of much of the equipment used.

Dedication

To Louise, without whose motivation and support this book might never have happened.

Publisher's acknowledgements

The author and publisher would like to thank the following for permission to reproduce the material in this book: Antony Lees who took all the photographs, ACD Systems, Adobe Systems Incorportated, Canon, Facebook, Flickr, Genes Reunited Ltd, MAGIX AG, PhotoBox SK, Media Innovations Group Ltd, Snappy Snaps and Fotolia.

Microsoft product screen shots reprinted with permission from Microsoft Corporation.

Every effort has been made to obtain necessary permission with reference to copyright material. The publishers apologise if inadvertently any sources remain unacknowledged and will be glad to make the necessary arrangements at the earliest opportunity.

About the author

John Skeoch has been making photographs for the past two decades and works on the South Coast as a professional photographer and freelance technical writer. He's written for a wide variety of magazines including *Digital Camera Shopper* offering everything from highly technical reviews to simple step-by-step guides.

About the photographic contributor

Antony Lees is a professional photographer specializing in portraiture and still life stock photography. In the past he has produced photographs for various magazines, websites, leaflets, books and bands, both in the UK and abroad.

Contents

Preface

For the uninitiated, starting digital photography can appear an insurmountable challenge, with all the acronyms and terminology associated with computers brushing shoulders with the already complex landscape of photography. It's easy to understand why the transition from film to digital made many conventional film photographers feel it was time to hang up their flashguns. But they needn't have shied away from bringing themselves into the modern age. This book breaks down the misconceptions and presents all the information you need in a simple to follow format which you can dip in and out of as the situation demands.

The involvement of computers in digital photography can also seem daunting to those of us who grew up before computers were ubiquitous. Whether you've embraced technology wholeheartedly or tried your best to avoid the subject, the tasks in this book are tailored to ease you in and expand on your existing understanding. You'll even get the chance to experiment with editing and printing your own images and you won't have to convert your en-suite into a darkroom to do it.

Aside from getting to grips with the technology behind digital photography and the digital darkroom, this book includes a series of practical tasks to improve the creation and capture of your pictures, and shows you techniques to improve your images straight from the camera. Whether you're a seasoned photographer already familiar with using film cameras or entirely new to photography this book takes you step by step through guides designed to fill in the blanks that manuals never seem to touch on.

The move from Film to Digital

For the longest time stalwart film photographers said that digital photography would never supplant their chosen medium. Their reasons ranged from early technical disadvantages, such as the lack of resolution and dynamic range, to the economic influence of chemical companies like Kodak and Fujifilm eager to protect their investments. As fervent as many people were in defending film, much of the passion in their argument was rooted in the emotional investment they had with film, and with their own early experiences of photography. Photographers who grew to understand the qualities and characteristics of different film stocks, and learnt how to get the best from each brand or product, were understandably distraught as companies consolidated poorly selling lines or just stopped producing them altogether. Film photographers often argue that there's integrity and magic to film that's missing from digital photography. For some it's the potential that unexposed

films have, and the possible images they could freeze forever. For others, the process of collecting memories is a perfect marriage with the physicality of film negatives.

It's hard to argue against an emotional attachment and with hindsight it's easy to look at these reasons as naïve but many skilled photographers and printers went out of business or retired because they were unwilling or unable to embrace the new technologies. Learning an entirely new repertoire is understandably daunting, but by no means impossible. The aim of this book is to provide an easy introduction to newcomers to photography and refresh seasoned photographers with exercises that open up the world of digital photography. You won't need to be a computer expert to start on the tasks. Indeed, many of the skills required by film photography translate directly into the digital arena. However, you'll discover there is a wealth of new options – that were previously dictated by your choice of film – that can now be changed by the press of a button or the flick of a switch. For those of us familiar with film it's important to step out of the mindset that each exposure needs to count. Now you can experiment as much as you like as memory cards offer hundreds of shots. People now think nothing of snapping anything and everything, and if you run out of space you can simply clear the card and start again.

Ultimately, the argument between film and digital is a redundant one as digital photography is rapidly becoming your only option. Film for the enthusiast is very much still alive, but it's important we cover this early: photography is photography. Just as a painter can use oils or watercolours to create his or her masterpiece, if you're able to capture an image so powerful or beautiful it moves, inspires, enlightens, angers or brings someone to tears it shouldn't be diminished by using a digital camera.

John Skeoch, 2008

Introduction

i

Welcome to *Brilliant Digital Photography for the Over 50s*, a visual quick reference book that shows you how to make the most of your digital camera and its associated software. Whether you're embracing the technology or approaching it with a degree of reluctance, you'll find tasks in this book that will build upon your existing experience and open up new opportunities for capturing memorable images. We cover every aspect of digital photography from helping you select your ideal camera and getting the best from your equipment, right through to publishing your work on the Web or getting your images onto canvas. Unlike conventional film photography you don't need to have your own dark room to edit your images and this volume will include numerous tips, from removing red eye and cropping to advanced techniques for digital retouching.

Find what you need to know – when you need it

You don't have to read this book in any particular order. We've designed the book so that you can jump in, get the information you need, and jump out. To find the information that you need, just look up the task in the table of contents or Troubleshooting guide, and turn to the page listed. Read the task introduction, follow the step-by-step instructions along with the illustration, and you're done.

How this book works

Each task is presented with step-by-step instructions and annotated illustrations on the same page. This arrangement lets you focus on a single task without having to turn the pages too often.

How you'll learn

Find what you need to know – when you need it

How this book works

Step-by-step instructions

Troubleshooting guide

Spelling

The camera

Step-by-step instructions

This book provides concise step-by-step instructions that show you how to accomplish a task. Each set of instructions includes illustrations that directly correspond to the easy-to-read steps. Eye-catching text features provide additional helpful information in bite-sized chunks to help you work more efficiently or to teach you more in-depth information. The 'For your information' feature provides tips and techniques to help you work smarter, while the 'See also' cross-references lead you to other parts of the book containing related information about the task. Essential information is highlighted in 'Important' boxes that will ensure you don't miss any vital suggestions and advice.

Troubleshooting guide

This book offers quick and easy ways to diagnose and solve common problems that you might encounter, using the Troubleshooting guide.

Spelling

We have used UK spelling conventions throughout this book. You may therefore notice some inconsistencies between the text and the software on your computer which is likely to have been developed in the USA. We have however adopted US spelling for the words 'disk' and 'program' as these are becoming commonly accepted throughout the world.

The camera

The author used a Canon IXUS 950 1S (compact digital) camera to prepare this book. However, he has aimed to make his instructions as generic as possible so that whichever camera you are using, you will find it easy to follow.

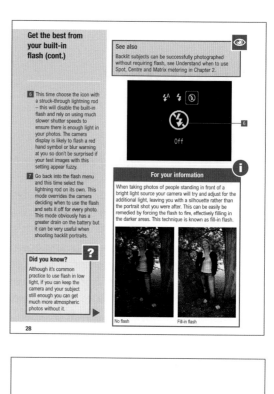

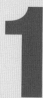

1

Getting the best from your camera

Introduction

Honestly it's a wonder anyone 'goes digital', just the process of selecting a digital camera involves wading through countless reviews, each overflowing with terminology and acronyms. Between the well-intentioned but ultimately meaningless snippets of advice from friends and family, and the pseudo sales advice typically repeated verbatim to every customer regardless of their requirements, it's all enough to make you consider picking up a paintbrush instead. When you've finally selected your new camera, thumbed fruitlessly through the manual more than once and are ready to get down to the business of taking photographs, where do you start? This book is the answer to manuals that assume you already understand the plethora of photographic phrases and magazine articles that omit vital snippets of information considering them common knowledge. To get you in the swing of things you'll start with a series of simple practical tasks that will familiarize you with your camera's layout. If you're returning to photography and feel relatively comfortable with your digital camera, it's still worth taking some time to review these tasks. The better your grasp of the basics the more likely you will successfully realize your photos in the heat of the moment.

What you'll do

Understand what a digital camera is

Keep your batteries charged

Format your memory card

Steady your hands and your shutter

Get the most from an auto-focus camera

Understand image stabilization

Experiment with image stabilization

Use a tripod

Use your zoom, optical and digital

Get the best from your built-in flash

Record short movies

Use the TV playback

Get your pictures onto your computer

Install and use a card reader

What is a digital camera?

First of all it's important not to be anxious about digital cameras, after all they're not massively different from any conventional film cameras. The principal components are much the same, there's a light-tight box with an aperture, a lens, a shutter and a light-reactive component, the new component that's been added into the mix is a tiny computer which controls the whole shooting match. While it's true the more you pay the more gadgets you get, besides the computer, the basic elements that make up any camera are identical from the most cutting edge back to Kodak's iconic Box Brownies and before. Remember the best photographers can produce exceptional images armed with nothing but a compact camera, the strength of their imagination and a solid understanding of the principles of photographic practice. Ultimately even the most automated and expensive camera can't make up for a lack of understanding.

Where a digital camera does differ is in the way that it records the light. Conventional cameras relied on various formats of light-sensitive film such as 120mm, 35mm or APS that would be sealed in a roll or canister. The chemicals that made up these films would then react to the burst of light rushing in when you take your snaps, and it wasn't until they were correctly processed in a dark room that the images could be viewed. In a digital camera the film has been replaced by a complex electronic sensor that measures and records the light in order to reproduce the original scene. When you think of the sensor imagine a series of minute wells each of which is filled up by light flowing into it. The amount of that light is then measured and the tiny computer in the camera uses these samples to reconstruct a digital representation of the complete image. At its most basic the more samples the camera can take the more detailed the image will be.

As a result of this move away from chemical reactions the digital camera enjoys one of its most fundamental advantages over film. Using the same sensor, a digital camera can take literally thousands of photos without wearing out, images which you can review immediately and decide whether or not to keep. Parallels could be drawn between the move from film to digital and the transition from vinyl records to CD. In both cases an analogue system was challenged by a digital alternative. However it's important to note that film is by no means totally superseded by digital, indeed exactly as with vinyl records there are still enthusiasts who prefer the inherent qualities it offers. In a commercial context such as news or sports photography the ease with which digital images can be transmitted or altered has meant that digital cameras have rapidly achieved almost total market dominance. As we will cover in the next chapter the move to digital has affected the way we select our images too, with memory prices in ever-decreasing circles, it's possible to take literally hundreds of images without the need to cull any from the camera.

One of the most common complaints levelled at older digital cameras was short battery life: the first generations of digital cameras would chew through AA batteries at a rate of knots. It wasn't unheard of to load a fresh set in the morning, only to be stopping at a corner shop the same evening for a refill. Thankfully the widespread adoption of digital cameras had the knock-on effect of accelerating development in rechargeable battery technology. Now you can buy very powerful batteries which allow for literally hundreds of shots, with or without a flashgun. In this task we will consider the different types of batteries available and provide some simple guidance to ensure your camera is always ready to run when the action starts.

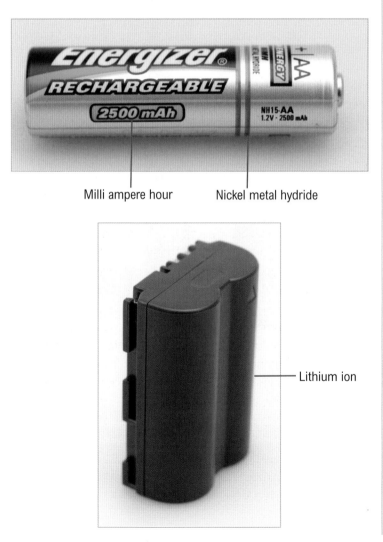

Milli ampere hour Nickel metal hydride

Lithium ion

1 Identify what type of battery you have, look for abbreviations such as NiMH, Ni-cd/Ni-cad or Li-ion. If you can't find any letters, consult the manual before attempting to charge the battery.

2 If your battery is identified as Alkaline, Lithium or non-rechargeable, do not put it in any battery charger. These batteries are not designed for more than one use and can be very volatile if recharged.

3 Once you have identified the type of battery, look for a figure followed by the letters mAh. This number indicates the battery's power rating in milliamperes per hour, the higher the number, the longer the power will last.

4 Next put your batteries in the supplied charger. Typically AA chargers will accommodate four batteries at a time, whereas Li-ion chargers will only take one.

▶

Keep your batteries charged (cont.)

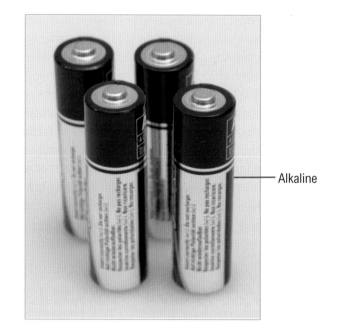

Alkaline

5 Be careful where you place your charger. Recharging batteries can generate a lot of heat and you should avoid leaving your charger on the carpet, by a radiator or in direct sunlight.

6 Leave the battery charging for the duration indicated by the charger instructions. Most modern chargers will automatically switch from full power to trickle charge when the capacity is reached, so they should be perfectly safe to leave overnight.

7 If you have more than one set of batteries it's worth using a system to indicate which have been charged most recently. After all, batteries can't be recharged indefinitely and will eventually wear out.

8 Finally, remember to put your charged batteries back in the camera. All too often people bring out their camera with these vital components languishing in the charger at home.

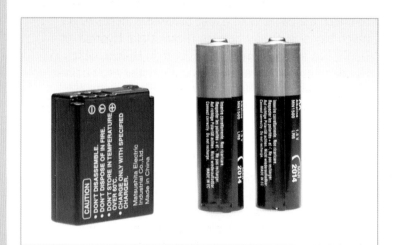

▶

For your information

Non-rechargeable batteries: Alkaline and lithium

Conventional AA batteries are normally alkaline. These work well for mp3 players but are not so good for high drain devices like digital cameras. Lithium batteries are more suited for use in a digital camera as they can deliver sufficient power to last for several hundred shots, and are worth considering if you use your camera infrequently.

Rechargeable batteries: Nickel cadmium (Ni-cad), nickel metal hydride (NiMH) and lithium ion (Li-ion)

Far and away the best solution for people who regularly use their digital camera is a rechargeable battery. There are numerous different technologies available to power your camera, we will look at the three most common. Nickel cadmium, or Ni-cad, offers a solid reliable battery that copes well with extremely cold conditions. However, to match the capacity of newer batteries it needs to be much bigger and a lot heavier. Nickel Metal Hydride, or NiMH, has a higher energy density than Ni-cad, which in simple terms means a smaller lighter battery can deliver the same amount of energy. NiMH is used in almost all rechargeable AA batteries. Finally, lithium ion, or Li-ion, power cells have several distinct advantages. They have the highest energy density of all three technologies, making them the smallest and lightest available, and they are also easy to shape and incorporate into a design. Most importantly, Li-ion has the slowest dissipation of power. In other words, if you charge all three types, leave them in a drawer for a month and then go out with your camera, the odds are only the Li-ion powered camera will be ready to go.

Important

Always follow the charging instructions for your batteries. Failure to do so could damage the batteries or charger, or even cause them to explode

Format your memory card ▶

1. Turn off the camera
2. Open the memory compartment and insert the memory card, making sure to insert it the correct way round. If you are in any doubt most cameras have a small picture of the appropriate way round beside the slot.
3. Make sure the memory compartment is closed before switching on the camera.
4. Put the camera into its Setup mode, this can be achieved by either pressing the menu button, rotating the dial to the tools symbol or navigating to the camera's Setup option via the menu.
5. Locate the Format option and select it, this is usually done by pressing an OK button or pushing the camera's four-way button to the right to access a submenu.

One of the principal benefits of the move to digital photography has been the ability to take hundreds of pictures with zero costs. As a result, people take photos of anything and everything. If you need to match your lipstick to your shoes, take a picture. If you want to describe a fixture, a quick photo will save you a thousand words. However, none of this would be possible without the massive memory cards now available. As with any of your other equipment memory cards require a certain amount of maintenance. However, as they have no moving parts and experience little exposure to the elements, you simply need to clear the card's memory by using your camera's format option. This task details the process you need to follow to wipe the card clear of any unwanted data and ready it for your next series of photos or video clips.

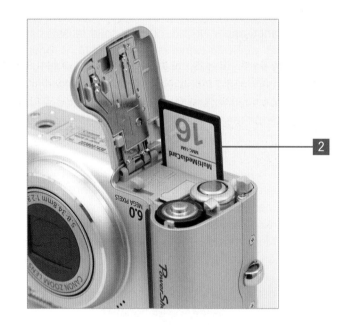

▶

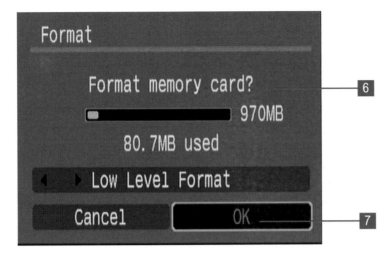

Format

Format memory card?　6

970MB

80.7MB used

◀ ▶ Low Level Format

Cancel　OK　7

6 At this stage the camera will require confirmation asking the question 'Are you sure you want to format?' or something similar. This is to prevent any existing images being accidentally wiped. All cameras default to No and you will need to select Yes to proceed.

7 Confirm that you want to format by pressing OK.

8 The camera will then ask you to wait. Depending on the size of the memory card this will take anything from a second to several minutes.

9 Exit the menu or Setup mode. You are now ready to start taking photos.

Jargon buster

Memory Card – this is the digital equivalent of film and is where your images are stored, it is not sensitive to light, however it is good practice to take care with these cards.

Format – removes all data from the storage being formatted, similar to simply deleting your images but the process is more thorough.

! Important

Never force a memory card in, if it won't fit with minimal effort it's likely the card is the wrong way round, misaligned or the wrong type for your camera.

Steady your hands and your shutter

1 Turn on the camera.

2 Grip the camera comfortably in your hands with your index finger resting over the shutter release.

3 Choose a subject and zoom in or out to achieve your desired composition. You can zoom in by pressing the T button or by pulling a dial towards T. If you want to return to the wider view, the W button or dial will zoom out. You can get closer or step back if that helps.

4 Softly press on the shutter release until you feel a small amount of resistance, when you do don't let go, instead try and keep the button held at this point – you could liken this to keeping a car's clutch on the biting point.

5 The camera will then focus and the image will snap into clarity, this all takes less than a second but surprisingly even while it is focusing the camera is also working out the available light and the best settings to use.

Modern cameras have made getting sharp photos much easier. With increasingly sensitive sensors that allow for shorter exposures, and features such as electronic and optical image stabilization, the odds are stacked in your favour. Unfortunately, even with all these advances there are still occasions where poor light or challenging conditions mean that only those with a good understanding of the best way to handle their camera will get the shot. This task will look at simple ways to adjust your posture and help avoid camera shake. We'll also take some time to familiarize you with the two-stage shutter release. Understanding how to use this feature will open up many of the more advanced techniques described later in the book. This task is worth practising regardless of your skill level, as the better you get, the sharper your exposures will be.

Jargon buster

Shutter Release – the button which releases the shutter and allows it to momentarily snap open and shut, exposing the sensor to light.

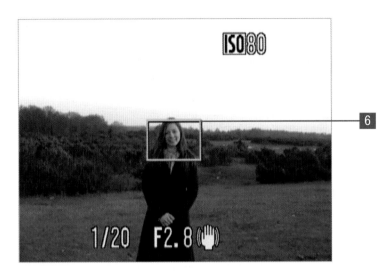

Steady your hands and your shutter (cont.)

6 Once the camera is focused there will either be an audible beep, a small green light on the camera or an indication on screen that you are now ready to take your photo. If you fail to get this confirmation you may be too close to your subject or there may be too little light.

7 Gently squeeze the shutter release a little more and the camera will take a photo. Do not pull your finger away sharply, instead wait until you are happy the photo has been taken then lift your finger.

See also

To learn more about using the zoom (and avoiding digital zoom) turn to Use your zoom, optical and digital (later in this chapter).

Steady your hands and your shutter (cont.)

For your information

When trying to take a photograph without a tripod, any hand or arm movements can soften or even blur the image. By simply changing the way you hold the camera you can increase your chances of getting a sharp shot. Avoid holding the camera one-handed or at arm's length. Always try to use both hands to grip the camera or, if your camera is too small, grip the wrist holding the camera. Ultimately, the best way to get a rock solid photo is by placing the camera on a wall or solid surface and using the camera's self timer.

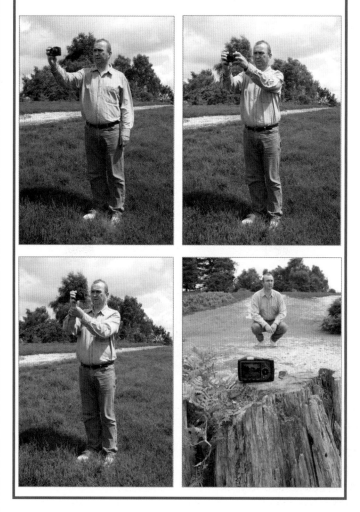

Undeniably th and reward in
manually foc not all digital
cameras offe , unless you're
very experie g fast
movement o e very difficult.
Where your icturers have
long provide on to areas of
contrast an spect of the
scene. This our digital
camera to e photographs,
using the s ake what we
learnt abou d apply it to a
technique method isn't
perfect, bu develop your
skills. Idea ed two objects, or
preferably h apart.

1. Once the camera is on, grip it comfortably in your hand with your index finger resting over the shutter release.

2. Select one of your subjects and position the target in the centre of the screen or viewfinder.

Jargon buster

Icon – graphical representation of a mode or setting. Typically used to indicate preset exposure setting such as portrait or sports mode.

▶

Get the most from an auto-focus camera (cont.)

3 Softly press on the shutter release until you feel a small amount of resistance. When you do, continue to keep holding with the same amount of pressure.

4 The camera will then focus and the chosen subject will sharpen up. Once the camera is focused there will either be an audible beep, or indicator light on the camera or screen. Keep the button held at the same point.

5 Now adjust the position of the camera to place the centre of the display between the two subjects, ensuring you do not accidentally press too hard and take a picture or let go of the shutter release. If you do make a mistake simply restart the task.

6 Now once you have both subjects in the frame, squeeze the shutter release and the camera will take a photo. As before, do not pull your finger away sharply, wait until the photo has taken before letting go.

▶

Jargon buster

Focus and recompose – auto-focus cameras often try and focus on the centre of the scene, which may not be the part you want to be sharp. By pointing at the subject first then recomposing the image you get around this.

7

7 If you simply place your focus point in the centre of the image, there is a good chance your camera will focus well behind your models.

?

Did you know?

Most digital cameras use an automatic focus system that relies on changes in the contrast of a subject to identify where to focus – this is known as Contrast Type AF. So if your camera is struggling to lock on to a subject you might have better luck by aiming at the edge of it.

!

Important

The focus and recompose technique should only be used for small adjustments, if you have to move your feet, you should refocus.

?

Did you know?

Even if you are photographing just one person you should always try and place them one third of the way from the side and the bottom of the image, this has the effect of making the photo more engaging. The name for this technique is the Rule of Thirds and has proved an excellent compositional guideline for artists throughout history.

Understanding image stabilization

There's nothing worse than patiently waiting for your holiday snaps to develop, eager to relive the magical events you captured, only to find the photos look like they were taken in a drunken stupor, all blurred and soft. While that may be the default position of most holiday photographers, there are technologies that can help you take steadier and sharper images with your camera. Image stabilization covers a wide range of technologies and some are more effective than others. In this task we will look at the tools on offer, where they can be most effective and when you'd need to employ different tactics.

Optical image stabilization

At its heart this method of image stabilization uses a mechanical system to ensure a sharp photo. The optical system has a small lens, which gently alters the path of the incoming light based on the movement of a gyroscope, correcting for the involuntary movement of the photographer's hands. Optical image stabilization produces excellent results and many manufacturers claim it can enable skilled photographers to handhold exposures for up to three stops longer. For example, an exposure that needed to be taken at 1/200 of a second could be extended to 1/25 and still achieve a sharp image. So optical image stabilization is ideal in low light or with a long zoom lens where camera shake might soften the detail on the subject. The downside, however, is the power drain created by the mechanical components, which can reduce the overall battery life by as much as half. As a result, cameras employing this method normally have a simple switch to enable and disable the feature quickly, ensuring you only activate it when you really need it. Optical image stabilization is used in some Canon and Nikon SLR lenses.

Electronic image stabilization

As a response to the power demands of optical image stabilization, and with a remit to integrate the feature into smaller and more economical compacts, electronic image stabilization forgoes a lens and gyroscope in favour of a solution developed for camcorders, where the camera uses only the centre of its sensor. For example, a 6 megapixel camera uses only the centre 5 megapixels to capture a photograph, and the surplus million pixels switch roles to act as a buffer area. Before taking a photo, the camera's processor compares the previous images for the last fraction of a second with the live picture being previewed on the display and uses a clever algorithm to instantaneously work out the direction the camera has moved. This information allows it to slightly move the active portion of the sensor used at the time of capture. Electronic image stabilization is a very elegant solution and has a low power overhead. However, the image quality is slightly reduced because of the lower number of megapixels involved in capturing the image.

Sensor shift image stabilization

This technology is one of the most recent additions to the choice of image stabilization tools and uses a combination of electronic and mechanical systems. The camera's movement is tracked by sensors and, rather than moving a lens to adjust for movement, the entire sensor is shifted on tiny actuators thereby cancelling out small amounts of camera shake. The main drawback to this solution is that, by only moving the sensor, the image being routed to the viewfinder doesn't quite match up with the sensor and the final image and can be a little different from what was intended.

Overdrive image stabilization

This is generally regarded as the least effective solution and some would even go so far as to say it shouldn't even be classed as an image stabilization technology. Overdrive image stabilization essentially boosts the light sensitivity of the camera, meaning it can use a shorter shutter speed and runs less risk of blurring during an exposure. However, by amplifying the ISO rating the image can become significantly noisier and detract from the overall image quality.

Experiment with image stabilization

1 We have covered the theory of image stabilization so have a go at capturing some images with and without stabilization to see how useful it is. First you need to capture an image without stabilization. Do this by pressing Menu to access your camera's interface and locate the option to disable whatever type of image stabilization is present in your digital compact. For digital SLR users, this feature can be toggled from a button on the camera body, or a switch on the lens, depending on the camera manufacturer.

2 Ensure that the flash is disabled, as a burst of light in an otherwise dark scene will make the final image sharp and hide any blurring.

3 Next, to ensure the effects are easily identifiable, switch the camera into shutter priority mode. Adjust the shutter speed to around 1/25. If you have very steady hands you may want to try even longer exposures.

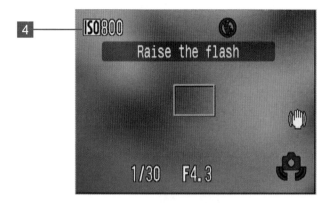

4 Once you have altered the shutter speed, be sure to check if the camera reports an over- or under-exposure using your selected settings. Depending on the results you may need to raise or lower the ISO value to compensate. Ultimately, if you still can't get a balanced exposure you may need to move to an alternative location to experiment.

5 Now you're all setup, take an image of a still life object. Anything will do, just try to ensure that if there is any movement it's only by the camera. Take a couple of shots. Remember not to stab at the shutter release, but instead gently squeeze it. When you are happy you have a still image, repeat this step with a moving subject. Passing cars make a good example.

Experiment with image stabilization (cont.)

6 Once you have taken your photos with the image stabilization disabled, access the camera menu again. This time ensure the image stabilization feature is enabled. On some SLR cameras this will mean moving a switch on the lens itself. Now repeat the same test images using identical exposure settings. By keeping the settings the same you don't introduce other variables and can directly compare photos with and without image stabilization.

7 If you look at the still objects you should notice a marked improvement in the clarity of the image.

8 The same cannot be said of the moving subjects. Image stabilization works well to eliminate your own movement but when there is limited light and your subject is moving you will need to open the aperture, raise the camera sensitivity or add light with a flash.

Once the photography bug bites you, it seems your friends and relatives get together and collectively decide to buy you anything and everything even loosely associated with the pastime. Of the myriad of gadgets and accessories out there, one of the few that's actually worth investing in is a reliable tripod. Shop around and find yourself – or convince a relative to buy you – a lightweight and sturdy tripod. With a tripod you can set up the camera to use its self-timer and finally appear in some of your own memories. Another less apparent advantage is the effect a tripod will have on your landscape photos. By anchoring your camera with a tripod the overall sharpness of your images will improve dramatically, giving your images a new found sense of depth. This task shows the best way to use your tripod and provides some simple tips to ensure other people's safety around you.

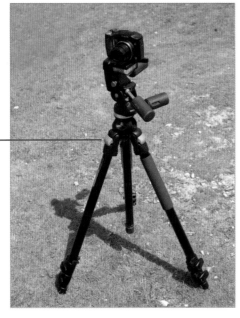

Timesaver tip

Remember, while a tripod will dampen much of the movement of pressing a shutter release, the best solution for landscapes is to activate the camera's self timer. That way your camera takes the picture without vibration from your hands.

Use a tripod

1

1 First and foremost, check your digital camera actually offers a tripod mount. Look on the base of your camera and you should find a ¼ inch diameter screw thread mount. Preferably this should be constructed from metal, however many new cameras use hardened plastics.

2 Next look at your chosen tripod. Ideally you should opt for a tripod with a quick release mount plate, so that you can quickly drop the camera in and out of the tripod and switch easily between different types of shot, for instance if you're photographing a wedding. Also ensure your tripod is rated to carry the weight of your camera, otherwise buying a budget tripod could become much more costly when your prized camera takes the express route to a concrete floor.

Use a tripod (cont.)

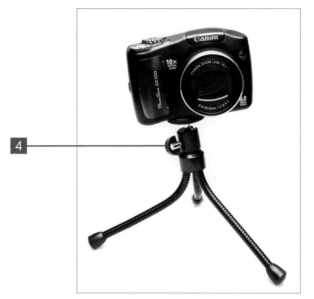

3 If you can, unclip the mounting plate and carefully marry the screw thread up to the mount on the base of the camera. Once you're happy the two parts are lined up, gently screw in the mounting plate. Many plate designs incorporate an extra wide screw head or a simple handle to make screwing in the plate easier. On smaller portable tripods, where you can't remove a mounting plate, fold in the legs and rotate either the whole tripod or camera: whichever is easier.

4 Now you should either have your miniature tripod or a mounting plate secured to the bottom of the camera. If your tripod is separate, extend each of the legs in turn until the tripod reaches the desired height. On larger tripods always work between two of the legs, this ensures the tripod presents less of a trip hazard.

▶

With tripod

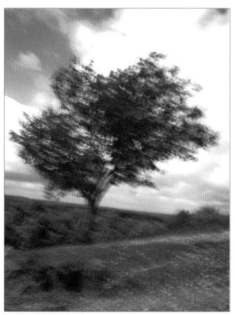

Without tripod

5 If your camera is still separate from your tripod, try locking the mounting plate into the empty head of the tripod. Practise getting your camera on and off the tripod quickly. However, never let go of your camera until you're entirely happy the mechanism is locked and your camera is secure.

6 With your camera sat securely atop the tripod, adjust the tripod's controls in order to frame your image. Most inexpensive tripods offer at least pan and tilt adjustments. Some better tripods offer more flexibility with ball and socket joints.

7 When you're satisfied you have composed your image correctly, gently press the shutter release until the camera beeps to signal the focus is locked. Once the camera locks focus successfully you're safe to fully depress the shutter and take a picture.

Use your zoom, optical and digital ▶

Thinking back to your first camera, it's unlikely it had any form of zoom. Compact cameras only started to feature zoom lenses in the mid seventies. Move forward to the modern day and every digital camera boasts a zoom of one sort or another, and many inexpensive digital cameras feature a new variation called digital zoom. This task looks at how a digital zoom differs from a more traditional optical zoom, what benefit one technology has over the other and how you can use them both to greatest effect.

1 Grip the camera comfortably with your index finger over the shutter release.

2 Find a distant subject and position the target in the centre of the screen or viewfinder.

3 Begin zooming into your subject, on most cameras this will be achieved by either pressing the T button or pulling a rocker switch toward either the letter T or an icon for a single tree.

4 While the camera is zooming in you will notice that a bar appears on the camera display showing how far through the zoom you are. In some cases the bar will have a line intersecting it, denoting where the optical zoom ends and the digital zoom begins.

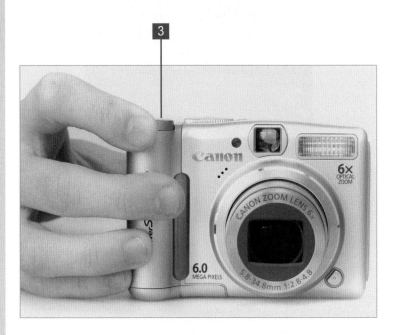

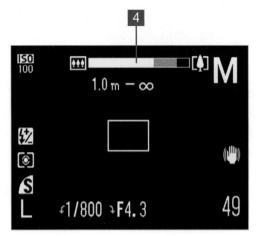

▶

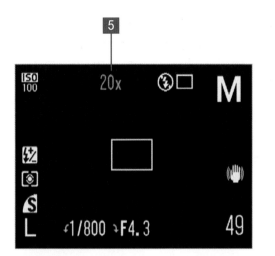

5 Experiment by continuing to zoom past the intersecting line, notice the effect on the quality of the image on screen.

6 Once you are happy with the difference between both technologies, press the W button or pull the rocker switch in the opposite direction towards the W or group of trees.

7 Try zooming in and out until your original subject is as large as possible while still only using the optical zoom.

Digital zoom

Optical zoom

Use your zoom, optical and digital (cont.)

8 Now softly press on the shutter release until you feel a small amount of resistance, when you do, continue to keep holding with the same amount of pressure.

9 Once the camera is focused, squeeze the shutter release and the camera will take a photo. Remember to wait until the photo has been taken before lifting your finger.

Jargon buster

Cropping – in an ideal world, photographers would always get the perfect photo, however the reality is that most photographers select the part of the image they want to use and block out, or 'crop', the surplus.

Did you know?

Of the digital zooms available, one of the better implementations is the cropping technique. This doesn't employ any additional image processing which can degrade the picture quality, instead it uses a smaller portion of the sensor. For example, setting your camera to 8 megapixels and zooming in 1.8x, will only record a 5 megapixel photo, zooming to 4.8x leaves you with just 1 megapixel.

AF Frame	◀ Center ▶
AF Frame Size	◀ Normal ▶
Digital Zoom	◀ 2.0x ▶
Red-Eye	On Off
Self-timer	Cċ
MF-Point Zoom	On Off

For your information

If your camera came supplied with a lens hood or lens petal you should ensure this is always attached, it's not just for sunny weather and should ideally even be used when shooting indoors. Having a lens hood attached helps prevent stray light from hitting the front part of the lens from an acute angle, the effect of which can be to reduce the overall contrast in your photos.

Regardless of how much you spend or how advanced your camera is there's one thing that every camera has in common: without enough light you won't get a good picture. That's why it's so important to make the best use of your camera's flash, ensuring you have your own portable light source to capture photos at night, indoors or even to sweep away the darkest shadows on a sunny day. Most cameras straight out of the box have their flash set to automatic mode, which fires only when it sees a dimly lit scene. This task looks at all the different settings available to you. If you can try and convince a friend or family member to pose for you as you work your way through the modes, this will give you a better understanding of the effects, and the situations when they are useful.

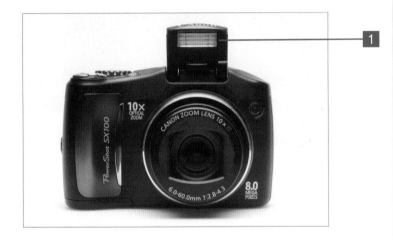

1 Turn on the camera, if you are already in a darker environment you may have to wait for the built-in flash to charge.

2 Press the directional pad or button labelled with a crooked arrow or lightning rod, this will access the flash mode selection.

3 Most cameras use icons to represent the different flash modes. For the first photo select the lightning rod with the word AUTO or the letter A, next to it. (The camera is likely to default to this setting.)

4 Now take a photo, depending on the available light, the camera will decide whether or not to fire the flash. Try this mode in a variety of conditions to get an idea of how much light is required before it stops flashing.

5 On the camera press the directional pad or button labelled with the lightning rod to access the flash mode selection again.

▶

Get the best from your built-in flash (cont.)

6 This time choose the icon with a struck-through lightning rod – this will disable the built-in flash and rely on using much slower shutter speeds to ensure there is enough light in your photos. The camera display is likely to flash a red hand symbol or blur warning at you so don't be surprised if your test images with this setting appear fuzzy.

7 Go back into the flash menu and this time select the lightning rod on its own. This mode overrides the camera deciding when to use the flash and sets it off for every photo. This mode obviously has a greater drain on the battery but it can be very useful when shooting backlit portraits.

Did you know?

Although it's common practice to use flash in low light, if you can keep the camera and your subject still enough you can get much more atmospheric photos without it.

See also

Backlit subjects can be successfully photographed without requiring flash, see Understand when to use Spot, Centre and Matrix metering in Chapter 2.

For your information

When taking photos of people standing in front of a bright light source your camera will try and adjust for the additional light, leaving you with a silhouette rather than the portrait shot you were after. This can be easily be remedied by forcing the flash to fire, effectively filling in the darker areas. This technique is known as fill-in flash.

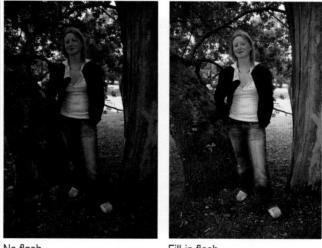

No flash Fill-in flash

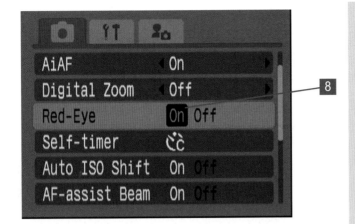

8 The last of the standard flash modes you can select is the lightning rod with a miniature eye next to it. This mode fires not one, but a series of quick flashes, the effect of which is that the eyes or rather the iris of the person you are photographing contract. By making the pupils smaller you avoid the horrible demonic looking effects of 'red eye'.

Did you know?

Red eye reduction has been around for several years, however despite the ingenious system some red eye can often still remain. Several digital camera manufacturers have developed a new high-tech answer which examines the photo after it's been taken and intelligently removes the red dots afterwards – fine unless you're photographing someone in a polka dot dress!

See also

If you find your flash doesn't provide enough light or bleaches the colour from everything you photograph, many cameras have an option to vary the output, see the Use flash compensation task in Chapter 2.

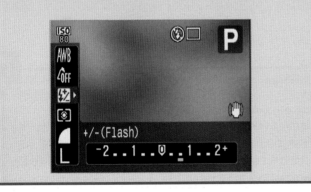

Record short movies ▶

1. Grip the camera comfortably with your index finger over the shutter release.

2. Switch the camera into movie or video mode by rotating the dial to the camcorder symbol. Alternatively choose the same icon via the camera's menu. To start recording video firmly press and release the shutter release. When capturing video, digital cameras don't use the two-stage shutter release.

Important !

Make sure you clear any unwanted photos off before you start to use the video mode, it needs a lot of space, unless your camera supports MPEG4.

Curious readers will no doubt have looked over their new cameras and found a symbol or menu option that bears a striking similarity to a video camera. Indeed, for the last five years digital cameras have offered the facility to record short clips of video with or without accompanying audio. On older digital cameras this feature was great to capture comedic moments, but the grainy image quality was no rival to results from a conventional camcorder. The situation has changed dramatically in the last year and the latest generation of digital cameras can leverage inexpensive memory cards and vastly improved video compression to remove any limitations on a video's duration and deliver image quality that compares very well with many competing camcorder models. This crossover between devices means it's finally a practical reality to avoid the frustrating choice between carrying your camera or your camcorder.

Timesaver tip

While you can normally zoom in and out when recording video quite a few cameras actually disable the optical zoom leaving just the digital zoom available, so for the best quality remember to move the optical zoom before switching to video.

▶

3 Hold the camera as steady as possible. Unlike camcorders most digital cameras don't yet offer image stabilization on the movie recording.

4 Recording any video will start a counter in the corner of the camera display, the position of which differs depending on your model. This timer can count down the storage space remaining in minutes or simply count out the duration of video.

?

Did you know?

Most digital cameras use either a movie format known as QuickTime or AVI which both provide respectable results but require approximately 128Mb of storage per minute of video meaning that even large cards fill rapidly. If your camera has MPEG4 video you are in luck as this advanced format was originally designed for compressing video on the Internet and claims to be able to squeeze around 8 minutes into the same 128Mb.

Record short movies (cont.)

5 Try experimenting with the zoom controls, often these buttons will be disabled during video recording.

6 To stop recording simply press the shutter release again. Remember that using the video takes up considerably more memory and battery power than taking still images.

7 Depending on the model of your camera you may be able to view your video immediately. (Most modern compacts also incorporate a microphone and speaker enabling you to listen to short movies.)

Important !

Be mindful of your compact's limitations, specifically the built-in microphones are normally not very good at coping with ambient noise, so try and stand close to your subjects.

Did you know? ?

Aside from different compression technologies, some digital cameras are much better equipped to handle video – amongst the better manufacturers Sony and Pentax allow for video clips to be edited while still in the camera. This kind of control is perfect for trimming the video and conserving memory for more photos. The latest generation of Casio cameras go a stage further and offer a recording mode tailored specifically for YouTube. *

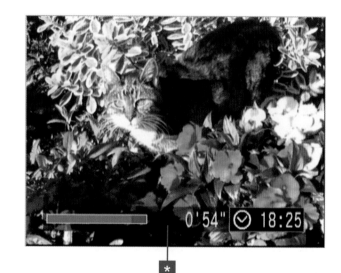

Travelling abroad or any distance from your home computer can make it difficult to quickly sort through your photos deleting blurred, underexposed or just generally unwanted photos. Whilst memory prices are tumbling, it's pointless to keep unwanted images as they take up space and, if you're not careful, get printed only to be binned. But you needn't have a laptop permanently in your holiday luggage. By bringing the audio–video cable supplied with the camera with you, it's possible to use almost any hotel room TV as a reliable way of reviewing your images. In this task we will look at how to connect your camera and the best way to use it to present an impromptu slideshow.

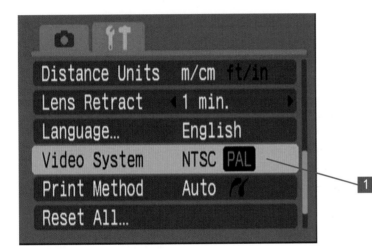

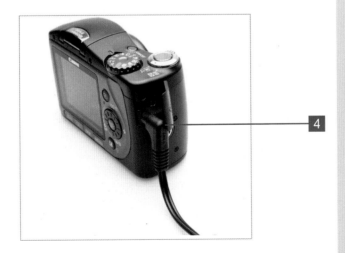

1 The first step is to check the camera's output mode to the TV. Look for this option under the camera's setup icon. If it isn't simply marked as Setup it's probably depicted as a spanner or toolkit. Most cameras switch between NTSC and PAL, you need to select PAL mode which is the UK television standard.

2 Amongst the cables that came with your camera you should have a cable with a miniature USB or jack plug on one end. On the other end you will normally find two or three connectors, these will be colour coded to identify their purpose. Yellow is for video, red and white stereo sound channels, left and right respectively. On mono systems one of these will be missing.

3 Playing back video is quite a heavy draw on the camera's power so if your camera can be powered directly it's a good idea to connect the power whilst transferring video or running a slideshow.

4 Next connect the video cable to the camera using the mini USB or jack connector. ▶

Use the TV playback (cont.)

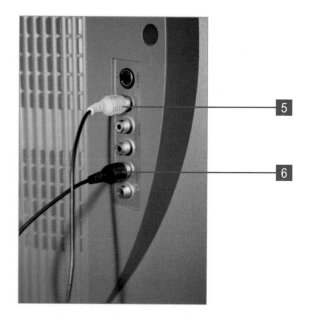

5 Take the yellow colour coded connector and plug it into one of the spare AV sockets on the television. Many modern TVs have a concealed connector on the front designed for use with a camcorder – this is perfect for this purpose. These sockets are conventionally marked as AV1, AV2 or AV3 indicating which channel must be selected to find the video.

6 Beside the video socket on the television you should also find red and white input sockets. Connect your remaining leads to these. You are now ready to watch your videos, complete with sound.

7 Select Playback on the camera by either rotating a dial to a green triangle or simply pressing a button with the same symbol.

8 Once your videos or stills are playing you need to select the correct AV channel on your TV. If you can't immediately see the output from the camera, be patient as sometimes the TV can take a second or two to display the picture.

▶

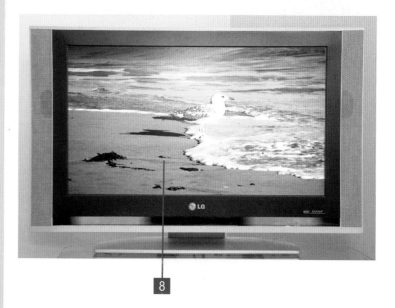

Timesaver tip

When trying to configure your TV to playback video or stills, try and take note of the image on your digital camera's screen – this will make it easier to identify the correct image on the TV.

9 Some cameras simply repeat the display on the back of the camera on the TV, which sounds okay in principle but can mean your photos are obscured by intrusive camera icons, such as the flash symbol or the number of photos remaining. If your camera has it, try pressing the DISP button or an icon with two vertical lines with a rounded square between them, this will toggle the way the display is laid out.

10 To record your videos on to DVD or VHS you need to unplug the connectors from the TV and connect them directly to your recorder.

11 Select your normal channel on the TV to watch video from your DVD/VHS recorder.

12 On the recorder press the AV button until you find your camera's images once again. Once you have successfully found the video, put a blank disk or tape in the recorder and get ready to start recording.

13 Finally, restart the video or slideshow on the digital camera and simultaneously start the recorder recording. Once the video is completed stop the recorder.

Getting the best from your camera 35

Get your pictures onto your computer ▶

1 First install the software that comes with the camera, this will provide the interface between the computer and the camera. It's well worth installing the bundled software as aside from just transferring the photos the software will typically also include editing and cataloguing packages.

2 You will need the USB cable normally supplied with your camera. This should be connected between the camera and the computer. If you are having trouble finding USB ports, they are normally located at the back of the PC on Windows-based computers and often on the side of Apple Mac machines.

3 Whilst transferring between the camera and the computer it is wise to have the camera fully charged or plugged into a power supply. This ensures the transfer completes successfully and there is no chance of data loss because the camera runs out of juice.

▶

Viewing your photos on a computer screen, television or even digital photo frame brings into focus people's changing habits about getting prints developed. With the potential to capture literally hundreds of photos on a single day, it's little wonder that many photos never actually get printed. All good things, as they say, must come to an end, and eventually, however large your memory card is, it will reach its capacity. This is when you either need to bite your lip and ruthlessly delete your precious memories or take advantage of the much larger storage of your home computer to archive your images and get straight back out there. In this task we will look at transferring your photos by connecting your camera directly to your PC or MAC, as well as installing and using a memory card reader.

Important !

When installing the software, don't connect the camera until the software prompts you to do so, getting this in the wrong order can incorrectly configure the software.

Get your pictures onto your computer (cont.)

1

CameraWindow DC

Transferring from the camera...

Cancel

5

ZoomBrowser EX - All Images

File Edit View Tools Internet Help

Tasks

Acquire & Camera Settings

View & Classify

Edit

Export

Print & Email

Last Acquired Images

Shooting Date
2008_06_07
2008_06_09
2008_06_29
2008_07_02
2008_07_06

Favorite Folders All Folders

Pictures
2008 07 10
2008 06 04

Add... Remove

View Image Properties Slide Show Search Delete Rotate

Zoom Mode Scroll Mode Preview Mode

All Filter

IMG_0173.JPG IMG_0182.JPG IMG_0183.JPG IMG_0188.JPG IMG_0190.JPG

IMG_0194.JPG IMG_0195.JPG IMG_0201.JPG IMG_0205.JPG IMG_0212.JPG

IMG_0216.JPG IMG_0220.JPG IMG_0221.JPG IMG_0223.JPG IMG_0225.JPG

IMG_0227.JPG IMG_0228.JPG MVI_0288.AVI

Selected Items: 0

ZoomBrowser EX - ... 16:09

5

4 Next, set the camera in playback mode by selecting the green triangle on the mode dial or simply pressing the Playback button.

5 If you have correctly installed the software the computer should automatically react to the camera and will either automatically retrieve the images and video or will at least prompt you on what course of action to take.

6 Once you have verified the images are safely on the computer you can delete them from the memory card.

Jargon buster

CCD – Charge-Coupled Device forms the basis of most modern digital cameras. The alternative to the technology is known as CMOS or Complementary Metal Oxide Semiconductor. Historically the CMOS technology was used for low-cost cameras as the technology was inferior to CCD but cost less to manufacture, however, now the two technologies offer identical results at similar costs.

Install and use a card reader ▶

Using the camera to transfer images is not without its disadvantages, as you can't use the camera while it's transferring, it's a drain on the batteries and it's often a lot slower than a dedicated USB card reader.

1 If the card reader comes with any software this should be installed first as it will automate much of the transfer, it may also provide a cataloguing package. If your card reader didn't come with software don't panic, the latest operating systems can incorporate card readers without additional software.

2 Simply plug the card reader into an available USB slot, preferably a USB 2.0 high speed socket. On Windows Vista-based systems this will add a series of new drive letters under the Computer icon.

3 You can now remove the memory card from your camera – this can be located in the battery compartment or it may have its own cover elsewhere. To remove Secure Digital, Memory Stick, Memory Stick Duo and xD Picture Card devices you must first press the memory in, this will cause it to spring out and it can then be removed. With Compact Flash cards you will find a button next to the slot which must be pushed to eject the card. ▶

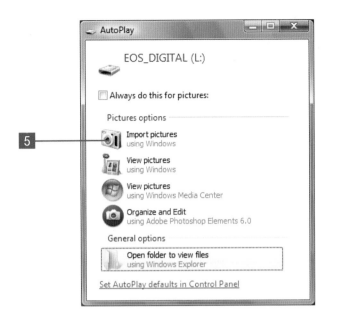

5

Finally with SmartMedia it can normally be pulled out. However if you are in any doubt consult your camera manual.

4 Next insert the memory into the corresponding slot on the card reader. Ensure you do this the correct way. Remember, there should be no need to force the memory in.

5 The installed card reader package should react and request that you start transferring the images to a directory of your choosing.

6 If it fails to react, one of the new drive letters will change its name, taking on the name of your memory card or camera. To check this in Windows Vista, double-click on Computer.

7 To transfer the images across, double-click on the new drive letter, this should open up to reveal a new directory named DCIM.

!

Important

If you have very important images try to keep a copy in several places – ideally write your images to a CD and keep them separate from the computer.

▶

Install and use a card reader (cont.)

8 Open this directory and there will be either one or several new subdirectories, these will bear your camera's name, for example, 405CANON or 100NIKON – the additional numbers give an indication as to the number of photos taken.

9 By double-clicking on each of these directories you will be able to access your images. All that remains now is to copy and paste them to your computer.

Jargon buster

USB – an abbreviation of Universal Serial Bus and by far the most common way to connect a digital camera to a home computer. You can identify the presence of a USB connector by looking for its trident icon. Unlike older methods of connecting peripheral devices, USB allows for new accessories to be connected safely while the computer is still turned on. There are two current types of USB, 1.1 and 2.0. The connectors themselves are identical however the 2.0 standard is over 40x faster than its predecessor.

2

Using the camera modes

Introduction

Every successive generation of digital camera manufacturers promises increasing intelligence from the camera's auto-focus, exposure control or white balance. However, irrespective of the computing brute force a digital camera offers, there is no way any camera can tap into your mind's eye and predict the shot before you take it. Granted, it's perfectly possible to take a back seat to the camera's technology, but if you want to create really memorable images, it requires a little additional input on your behalf. This chapter introduces the techniques professional photographers use to override the default settings and create beautiful images, which draw your attention to one razor sharp aspect of a photo, whilst gently softening the background to an abstract sea of colour. Whether you want to get to grips with every facet of your camera or simply want to understand a little more about how ISO speeds and F stops can affect your exposure, the next series of tasks will give you the chance to incorporate some new techniques into your own photography.

For your information

If you're having trouble working out what the different symbols and icons signify on your camera's mode dial and screen, take a look at the excellent Dictionary of Cryptic Symbols (!) on http://photonotes.org/. Select the 'Dictionary' tag and then click on 'Mystified by your camera's *cryptic symbols*?' link.

2

What you'll do

Use the camera's scene modes

Use aperture priority

Use shutter priority

Make the most of manual mode

Select an ISO speed

Understand when to use spot, centre and matrix metering

Use exposure compensation

Use flash compensation

Use face detection

Use the camera's scene modes ▶

Learning to configure your camera depending on the circumstances you're shooting in, or the subject you want to target, can be a little daunting at first. To make this easier, many manufacturers have included a range of preconfigured settings, known as Scene Modes. These modes instantly configure the camera with the most suitable settings for the situation. While it's not unheard of for a camera to offer more than 25 different preset exposure programs covering everything from fireworks to foliage, this task focuses on some of the most commonly used scene modes: Portrait, Landscape and Night.

As it's the most commonly used mode we will start with Portrait.

Portrait mode

1 If your camera has a dial to select modes, turn the dial to the picture of a bust or silhouette of a head. If you can't find the icon or don't have a dial you may need to select or press Scene – occasionally this is represented as SCN.

2 Once in Scene mode the camera will appear to function as normal, save for a small icon in one corner showing the current scene mode.

3 For those cameras without a dial you must now press Menu to access the available modes. Once again look for the symbol representing a head. Ensure the Portrait mode is highlighted and press OK.

▶

Jargon buster

Scene modes – achieving the best exposure settings for any given situation can be difficult. Digital cameras include numerous scene modes which take the guesswork out of configuring the camera. For example, when taking portraits a narrow depth of field is generally preferable as it draws attention to the model rather than the periphery. By selecting portrait mode the camera elects to use the largest available aperture.

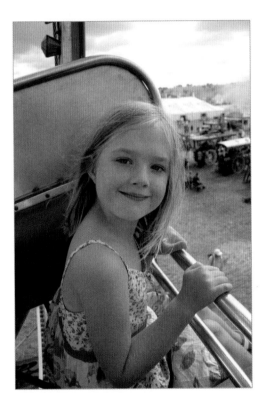

Timesaver tip

When using the red eye reduction, warn your subjects there will be multiple flashes, as people often move away after the first burst and ruin the image.

4 Using what you have learnt about flash photography select the appropriate mode. Typically auto with red eye reduction is best for indoor images.

5 Now you are ready to compose your portrait, start by moving the focus point over your subject and half pressing the shutter release. Then with the button still half depressed move the camera to get the composition you prefer.

6 Once you are satisfied with the image, and your sitter has a suitable expression then gently squeeze the shutter release to take your picture.

Use the camera's scene modes (cont.)

Another popular scene mode, especially when on holiday, is the landscape mode.

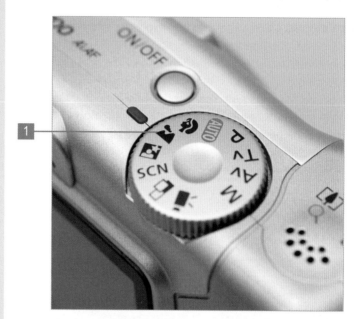

Landscape mode

1 Turn on the camera and if it has a dial, select the landscape mode this will be represented by a miniature mountain range. Not all cameras offer a mode dial and if you can't find the icon or don't have a dial, select or press Scene or SCN.

2 Once in Scene mode the camera will appear to function as normal, apart from a small icon in one corner showing the current scene mode.

3 For those cameras without a dial you must now press Menu to access the available modes. Once again look for the symbol representing a mountain range. Ensure the landscape mode is highlighted and press OK.

4 While it is possible to use a flash for landscape photography typically it is best to disable the flash before taking a daytime shot.

▶

Did you know?

On a sunny day most cameras are capable of shutter speeds in excess of one thousandth of a second. However despite these terrific speeds most professional photographers still recommend using a tripod to get the best possible image. If you don't have a tripod you can get great results using your camera's self-timer on a wall.

For your information

Auto vs Scene modes

Auto mode

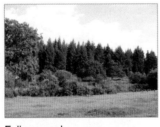

Aquarium mode

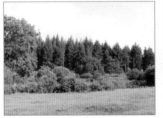

Auto mode

Foliage mode

5 With everything correctly configured you are ready to take your photo: half press the shutter release to allow the camera to focus and with the button held, make small adjustments to the camera's position until you are happy with the composition.

6 Once the camera is focused, gently squeeze the shutter release to capture your photo.

Use the camera's scene modes (cont.)

At some time we've all looked out over the ocean or cityscape at night and felt compelled to take a picture, but prints often fall very far short of the original. Your digital camera has the solution and this section will teach you how to capitalize on its night mode.

Night mode

1. Ideally when taking photos at night you should use a tripod as the longer exposure times mean there is quite likely to be camera shake, which will soften or blur the final image.

2. If you are using a tripod, locate the tripod's screw thread into the matching screw mount on the bottom of the camera. This is a standard size on digital cameras and should always fit. Screw the camera in place.

3. Turn the camera on and if it has a dial, select the night mode. This will be represented by a crescent moon or a white on black figure perhaps accompanied by a star. If you can't find the icon or don't have a dial, select or press Scene or SCN.

4. For cameras without a dial, press Menu to access the available modes. Highlight the night mode symbol and press OK.

5. Select your desired flash mode. For portraits the flash with red eye reduction is ▶

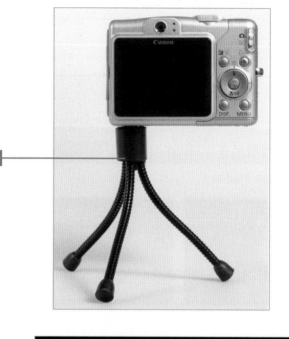

See also

For more about using tripods see the Use a tripod task earlier in this chapter..

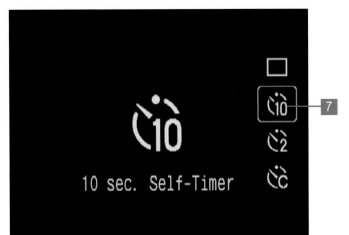

10 sec. Self-Timer

preferable and for landscape images generally the flash should be disabled. However, feel free to experiment.

6 Whether you are using a tripod or not it's worth using the self-timer as this eliminates the possibility of any camera shake introduced when you press the shutter release.

7 Push the four-way controller towards the stop watch symbol. This should bring up a menu on the camera display allowing you to toggle the timer on and off. Some cameras even have timer variables such as 2 or 10 seconds.

8 With everything correctly configured you are ready to take your photo, half-press the shutter release to allow the camera to focus and with the button held, make small adjustments to the camera's position until you are happy with the composition.

9 Once the camera is focused, gently squeeze the shutter release. This will start the timer's countdown and once completed, capture your photo.

Use aperture priority

1. Not all compact cameras provide the option to control the manual settings. If your camera has a dial to select modes, turn the dial to the letter A. If you can't find it or don't have a dial you may need to select or press M.

2. For those cameras without a dial you must now press Menu to access the available modes. Once again look for the letter A, Av or M. Once this is highlighted press OK.

3. Selecting A or M will put you into the manual shooting mode.

4. In the previous scene modes, the camera was configured to achieve the best results depending on the type of shot selected, here we have the choice to alter the camera's aperture values and rely on its built-in metering to adjust the shutter speed to our choices.

Perhaps the easiest way to think about apertures is not to dwell on the technology but consider the effects. Think of your favourite film. As the drama needs to focus on a single person or draw your attention to a particular event, the image normally sharpens on a very narrow portion of the scene, softening the foreground and background so the view is limited to only the parts the director intended you to look at. A similar effect can be achieved in photography and it can be used to add impact to beautiful portraiture or, if you're trying to present a message, it can draw the viewer's gaze to the intended elements potentially reinforcing your meaning. In this task we will investigate aperture priority, and we'll also look in more detail at F stops. Understanding aperture values can help you not just frame an image with your camera's zoom lens, but also consider which elements of the image should be focused on for the final print.

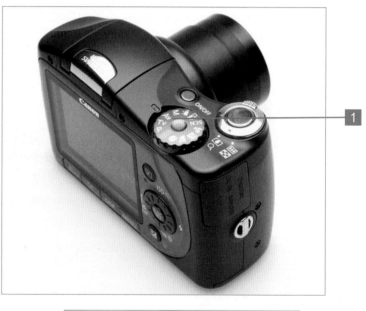

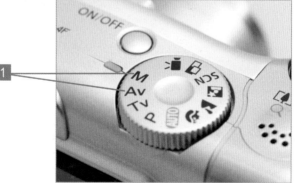

Jargon buster

TTL-metering – the term TTL stands for Through the Lens, and is usually used in the context of how cameras interact with a flash. Using TTL, the required exposure is measured from the light travelling directly down the camera's lens. When firing a flash, the sensors in the camera can then adjust the flash's output ensuring the exposure is as accurate as possible.

Jargon buster

Aperture – in simple terms the aperture is the hole through which the light travels. In photography, aperture is used to describe the diameter of the diaphragm, which controls the access of light. Using a larger opening, more light comes in, creating an image with a shallower depth of field, with a smaller opening the camera takes longer to get the same light, but the image has a larger depth of field.

5. On the LCD screen there will be an F with a series of numbers next to it. Typically by pushing up or down on the four-way control or rotating a wheel, it is possible to alter this number.

6. To produce similar effects to that of portrait mode, keep pressing the number until it is as low as it will go. For example F3.5 or F2.8.

7. If you are shooting indoors remember to turn on the auto flash with red eye reduction.

Jargon buster

LCD – an abbreviation for Liquid Crystal Display, it describes the technology used in most modern digital cameras to provide a real-time view-and-review screen. LCD is often used as a generic term and manufacturers have many new technologies such as OLED. These more advanced display technologies promise to provide better battery life whilst still being big enough and bright enough to use in direct sunlight.

ISO
AUTO

Av

F2.8 ±0 204

L

5

Use aperture priority (cont.)

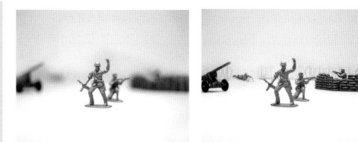

F2.8 F8.0

8 Now that you are ready to compose your portrait, move the focus point over your subject and half press the shutter release. Then with the button still half depressed move the camera to get the composition you prefer.

9 When you're ready squeeze the shutter release to take your photo.

10 Try repeating this task with different aperture values. You will notice that this has an impact on how much of the image is in focus. Using higher numbers can produce the same effect as a landscape photo, with much of the image sharp.

Timesaver tip

When taking portrait shots in strong directional light some aspects of the subject's face can be in shadow. By using a fold-out reflector you can shine light into the darker areas.

Jargon buster

Reflector – typically a fold-out disk or panel with a reflective white, silver or gold surface. Reflectors are normally used in portrait or studio work to direct light in order to lighten any darker aspects of the image.

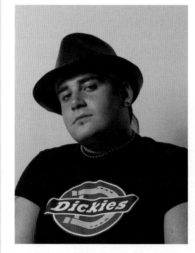

Before

After

Henri Cartier-Bresson said that photography was about capturing the decisive moment, that split second that catches the emotion of an event, frozen and held on to forever, or at least until you press delete. Switching to shutter priority mode gives you complete control over how long your shutter fires for. Sometimes, controlling the depth of field isn't the most important setting. For example, with sports it's more important to freeze the star striker's perfect touch of the ball than showing his team mates in the background willing it towards the net. To ensure you get a sharp image with fast moving subjects you need to enforce a fast shutter speed, ideally around 1/200 of a second or faster depending on the subject. One useful side effect of selecting a speedy shutter is that you can avoid the effects of camera shake, particularly useful if you're using a lengthy zoom lens. In this task we will look at adjusting the shutter speed, the effect that can have on your aperture value and the results in the final picture.

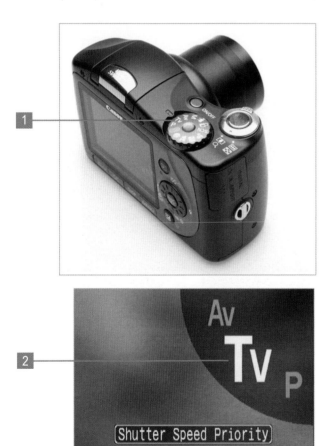

◀ Use shutter priority

1 First, we need to select shutter priority. Turn the mode dial to S for shutter priority, if you have a Canon camera this will be under Tv for time value. If you can't find S or don't have a dial you may need to select or press S.

2 For those cameras without a dial you must now press Menu to access the available modes. Once again look for the letter S, Tv or M. Once this is highlighted, press OK. Selecting S or M will put you into the manual-shooting mode.

3 In our first experiment with shutter priority we will try and freeze some movement as sharply as possible.

Use shutter priority (cont.)

4 Next to the F number from the previous task you will see another number which looks like a fraction, for example 1/25. As with the aperture value, this can be changed by pushing up or down on the four-way control, or in some cases by turning a selector wheel.

5 To freeze a moving subject you should adjust this number until it reaches 1/250, this means the shutter will be open for only a 250th of a second. If the F number next to this changes to red it is an indication that there isn't enough light for this speed.

▶

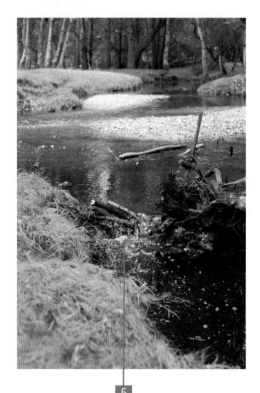

5

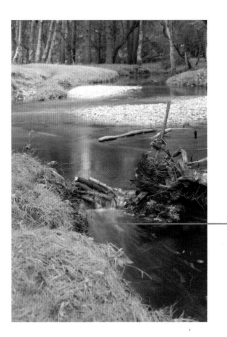

7

2

6 Now you are ready to compose your photo, quickly move the focus point over your subject and half press the shutter release. Once it confirms focus, squeeze the shutter release to take your photo.

7 Repeat this task with different shutter speeds and you'll notice the subject begins to develop a motion blur. Try using slower shutter speeds in conjunction with a flash – this can create some interesting effects.

Jargon buster

Burst mode – when photographing sport, getting the timing of your shots right can be the difference between an empty frame or a race car crossing the line, this is where burst mode or continuous shooting comes in. Burst mode takes a series of photos in rapid succession giving you more chance to get the crucial moment. Often cameras quote a FPS or frames per second.

Make the most of manual mode

Now that you've familiarized yourself with the Scene and Priority modes, you can begin to experiment with the full manual mode. By switching the camera to M you stop it trying to gauge the exposure or balance the other side of the equation. The freedom of manual mode allows you a great deal of creative control but, as it takes off the training wheels, it also makes it possible to completely foul up. This task works through the typical manual controls and familiarizes you with the way different apertures and shutter speeds work simultaneously on an image. It might seem like a lot to coordinate but, with practice, manual mode can be great fun and extremely useful for flash photography or overriding the camera's automatic exposure.

1 First turn the dial to M to select Manual. This mode combines adjustments of the shutter and aperture to give you complete control over your exposure including the ability to choose your own white balance.

2 For those cameras without a dial, you must now press Menu to access the available modes. Look for the letter M or Manual. Once this is highlighted, press OK to activate manual shooting mode.

3 Try photographing items in and around your home as this will familiarize you with the camera's metering system and just how much light is required to get a good photo.

☼

Jargon buster

White balance – digital cameras come equipped with numerous preset white balances, including tungsten, daylight, cloudy and so on. These settings are designed to compensate for the differing wavelengths of light coming from the different light sources their names represent. For example, photographing under a fluorescent strip light without selecting the correct white balance is likely to give the image a blue appearance.

For your information

To help you find the right exposure the camera displays how much over- or under-exposed the image will be by using an EV or exposure value scale. Each full EV stands for one stop too much or too little light. Most cameras display the EV as a number which can change in increments of thirds, for example -0.3 EV would mean the camera isn't getting quite enough light and perhaps a slower shutter speed would be appropriate.

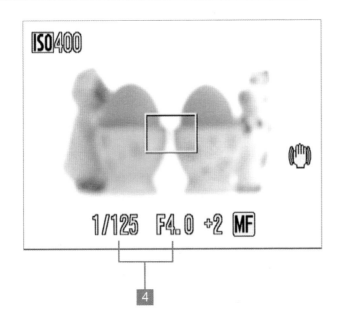

ISO 400

1/125 F4.0 +2 MF

4

Make the most of manual mode (cont.)

4 In our previous tasks we tried altering the aperture and shutter independently, in this task the same controls can be used to adjust both values together. However take note, where previously the two values automatically adjusted to compensate for your choice of shutter speed or aperture value, now it's up to you to adjust the other value and balance the equation. For example, if you change from F5.6 to F8 that will let in half as much light and so require twice the exposure time, specifically a change from 1/60 to 1/30.

5 To capture a successful photo you must set up your desired composition then tap the shutter release to take a meter reading. This will provide you with a measurement of how much light is required.

▶

Make the most of manual mode (cont.)

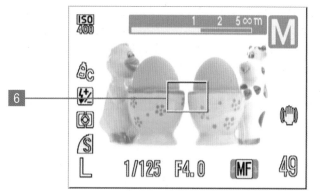

6 Next adjust both the aperture and shutter speed to the correct values to create a well exposed photo. You are now ready to capture your photo, quickly move the focus point over your subject and half press the shutter release.

7 Once it confirms focus, gently squeeze the shutter release to take your photo.

For your information

Digital cameras have an additional trick up their sleeves to check the available light, known as the histogram. Histograms provide an accurate breakdown of the light and dark pixels in your picture. Along the horizontal line the histogram represents every available tone from jet black valued at 0 to brilliant white valued at 255. The positions of the peaks indicate how light or dark the image is. Their heights show you how many pixels have this particular shade or colour. While there isn't a right or wrong way for the histogram to look, for most snap shots you should aim to have the peaks toward the centre of the image, thereby avoiding under- or over-exposure. *

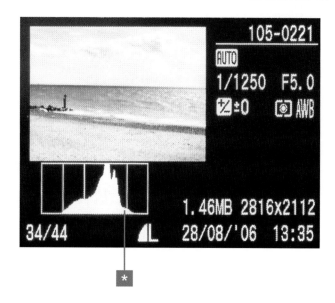

It's easy to become nostalgic about traditional film photography. Depending on the brand and speed of film you used, the prints would inherit the characteristics from the film stock you selected. For example, Kodak might give you warm slightly muted colours, where Fujifilm could give you a cooler but more vibrant photo. However, even if you weren't that informed about each film's bias, you'd still need to predict the conditions you intended to photograph in, using ISO400 for indoors or ISO100 for your summer holiday. The higher the number, the less light needed to get a good photo. Load the wrong film for the occasion or weather and you had an uphill battle to get any good photos. In contrast, digital cameras store the photos on memory cards and the brand of memory has no bearing on the final image or, for that matter, the reactivity of the sensor. As such, memory cards don't have ISO ratings. In this task we will look at a quick, easy way to adjust the camera's ISO rating to suit the situation, or even an individual shot.

Select an ISO speed

1 The first task is to find the camera's ISO control, which differs for almost every camera. However typically it is either clearly labelled as ISO on the camera's body or accessible via the Menu command. In some cases the ISO control will be labelled as Sensitivity.

2 Depending on the configuration of your camera either rotate the mode dial or press the appropriate button to open the ISO menu.

3 You will now be presented with the list of available ISO settings as well as an automatic setting. As tempting as it may be to leave the camera on the Auto setting, typically it doesn't offer the complete range of the camera's capabilities. Indeed knowing how to switch ISO modes can allow you much more creative flexibility.

Select an ISO speed (cont.)

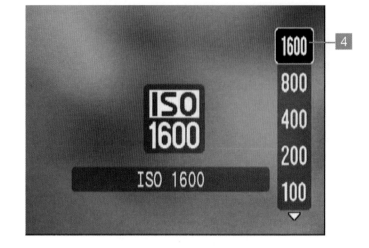

4 Now that we have found the ISO menu the first task is to select the highest value, this will normally be either, 400, 800 or 1600. While there are other values available these are amongst the most common options. After choosing the highest available value, confirm the choice by pressing OK or, in the case of Olympus cameras, pushing the navigation pad to the right.

5 The camera is now at its most sensitive, making it easier to shoot photos indoors without blurring. The downside to this mode is that the images are going to have a grainier or noisier quality to them. This will be hard to see on the small camera display, but it's there.

6 After experimenting with the higher sensitivity we will set the camera to its midway point. Open the ISO menu back up again and this time select the ISO 200 speed. While this won't necessarily be the middle speed available it should provide a reasonable average.

▶

7

7 Once set at 200, your camera will behave as normal, giving well-exposed images in typical daylight scenes and good indoor photos when assisted by the built-in flash. More important, your photos should exhibit almost no noise or grain giving them a smooth detailed quality. What we need to play with next is the camera's lowest speed – this mode can be suitable for creating longer exposures.

8 Open the ISO menu again and select the lowest value available, 50, 64 or 100 are typically the lowest speeds found on standard compact cameras. As the least-reactive speeds available they may leave you scratching your head as to their practical application. However should you want to use a long exposure or large aperture you may find the higher ISO values simply can't cope.

9 Try taking some images at night with the lower ISO setting and compare the results with higher values. The contrast in image noise should underline the value of this last group of ISO values.

Understand when to use spot, centre and matrix metering

It's a trite statement but the human eye is an amazing piece of equipment, able to resolve a staggering amount of detail, an expansive range of colours and a huge range of contrast. As an experiment, compare what you can see against what your camera captures, ideally looking from inside to the great outdoors. You'll find your eye can see a wealth of details both indoors and out. Your camera fares rather less favourably and has trouble accommodating both environments, eventually settling on one or the other. Typically, the outdoors will be metered successfully and the interior details sunk into an inky blackness. This is because cameras have a much more restrictive dynamic range. To try and help provide the best results in many situations camera manufacturers offer a range of different ways of metering. This task covers when to use each of the most common metering options and helps you visualize the effects you're likely to produce.

1 For this task put the camera into auto mode and choose a subject that is either much darker or brighter than the surrounding area – for example taking a portrait with the window behind your subject or a hallway looking out to a bright exterior.

2 This highly contrasting scene will present a challenge for the camera's average-based metering, so try taking a couple of test shots focusing on the chosen subject. The camera will concentrate on correctly exposing the vast majority of the image, which will result in massively under or over-exposing the subject itself.

3 This is where a bad workman would be blaming, if not bludgeoning, his tools! However, we know better and now we will select the centre-weighted metering mode. First, if available, rotate the mode dial to put the camera into Program AE or P mode.

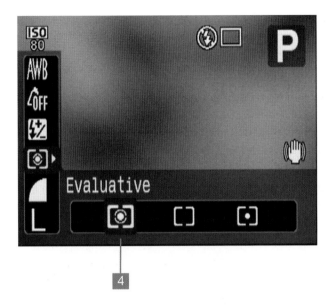

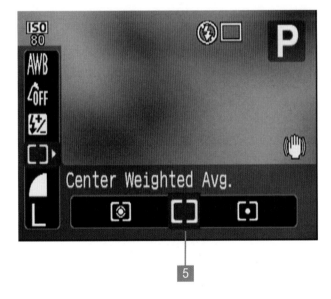

2

4 Next, press the Menu button, which should give you access to the shooting menu. Depending on the camera system you will either find the metering mode clearly labelled or you should look for a box with a dot in it enclosed by brackets above and below.

5 Press the metering icon or Menu, this will give you access to the array of metering modes. These will either be presented as a list, or you may have to press the same button repeatedly to toggle between the numerous options. For centre-weighted on a Nikon you should look for the same square box with a dot in it and brackets above and below, on a Canon the box should be empty.

Understand when to use spot, centre and matrix metering (cont.)

6 Once you have identified and selected the correct mode press OK to return to the shooting mode. Try taking some more shots of the same subject – you may be able to notice a slight shift towards correct exposure of the subject rather than the background. This is because the metering information for everything outside the centre portion is discarded, allowing you to be more selective.

7 Finally there is a spot metering mode. Not all cameras have this option but if you return to the metering mode it is represented by a square with just a dot in the centre. This mode typically only uses metering information from around 3.5% to 5% of the centre of the scene. This mode will correctly expose just the tiny bit in the centre of the image, making it ideal for shooting subjects in a shaft of light or strongly backlit without resorting to a flash.

▶

Jargon buster

Auto-bracketing – judging the correct exposure in situations with both very bright and very dark elements can be extremely challenging, and if this isn't somewhere you're likely to return to this is where auto bracketing comes in. Bracketing takes a series of shots – usually between three and five – with exposures slightly above and below the suggested metered exposure.

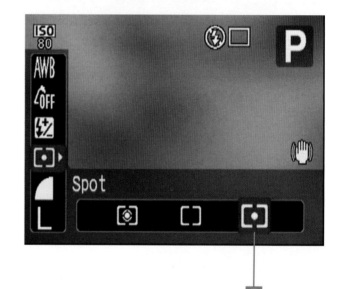

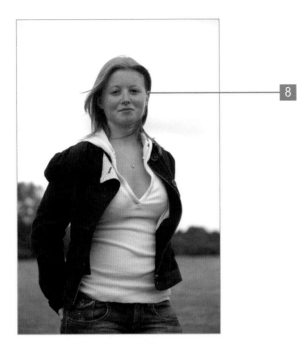

8

Understand when to use spot, centre and matrix metering (cont.)

8 Try shooting the same scene in each of these modes and experiment with the spot metering mode. It's possible to create radically different exposures with just a slight shift in the position of the camera.

2

Use exposure compensation ▶

The previous task used the correct metering mode for the subject at hand. By specifying the portion of the frame you wish the camera to use to gauge the scene you greatly increase the chances of getting a well-exposed photo. However, there are always occasions when the camera will be fooled and provide less than ideal results. One example of this is a skiing or beach holiday where the brilliant white snow or sand will always look a murky grey if you don't step in and tweak the settings. This is where exposure compensation can be very useful. Most modern digital cameras offer some provision to adjust the exposure settings, normally by a half or third of an exposure value (EV). By reducing the exposure value you can darken the results; add a third or half EV and the captured photos will come out brighter. While it is possible to adjust your photos after the fact with an image editor such as Adobe Photoshop Elements, you should always try and get the exposure right at the time of capture. Boosting the brightness of a photo too much in an editing package causes the image to look washed out and grainy. In this task we look at two of the most common situations where exposure compensation can separate a poor exposure from a great one.

Formal wear

Chances are any time you or your partner has to put on a necktie for a social occasion, it's probably worth bringing your camera along, that is unless someone's due to read a eulogy. Formal occasions all have their own protocol, but beyond the pomp and circumstance, the outfits themselves can cause the camera's metering system to under- or over-expose the scene. The most common problem faced is the traditional white wedding dress, which confuses cameras into thinking the picture is too bright and, as a result, under-exposes the photo. Be warned though, in very bright sunlight a wedding dress can be just as easily over-exposed, burning out the details. This task looks at how to check and compensate for any problems.

▶

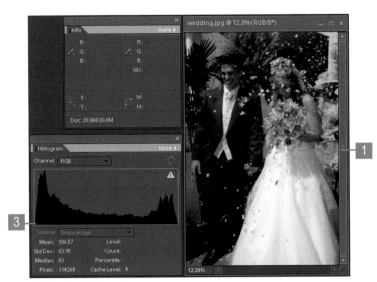

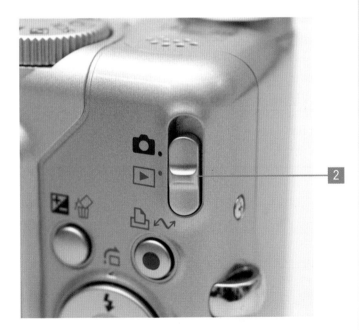

Formal wear

1 Once you have your suitably attired model, set up your ideal image and take a sample photograph. This image will briefly play back on the camera's display, however, we are going to need to see it for a little longer.

2 Switch the camera to playback by rotating the mode dial or pressing the playback button then find the sample image. The image is likely to look perfect on the camera's small display. However it's extremely deceptive and you should never trust your camera's display for anything more than checking the composition.

3 If your camera features a histogram this is where it becomes extremely useful. You can access the histogram by repeatedly pressing the display button until it toggles through the various display modes before finding the histogram reading.

Use exposure compensation (cont.)

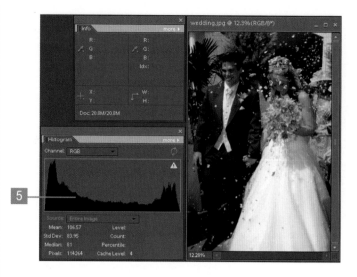

4 Typically the histogram is split into five segments representing from left to right, very dark (shadow detail), dark, mid (18% grey), light, and finally highlights. While there is no such thing as a bad histogram reading it's perfectly plausible to read the curve and re-shoot accordingly.

5 Closely examine the reading – when shooting a wedding dress there should be a peak in the fifth portion of the reading. However if the histogram shows the curve peaking in the fourth section perhaps the image could use additional exposure, whereas if it's way out to the far right it's likely to be overexposed.

6 Switch the camera back into capture mode and look for the exposure compensation symbol, this may be on the camera's exterior or within its menu. You can recognize the symbol as a diagonally crossed square with a plus and minus symbol on either side of the line.

▶

Jargon buster

Backlit – if you photograph someone with their back to a bright light source, it can fool your camera into capturing your sitter as a silhouette. This is caused by the camera trying to weigh up the darkness of your subject and the brilliance of the background. Using a fill-in flash can help to balance the image and ensure the subject is correctly captured.

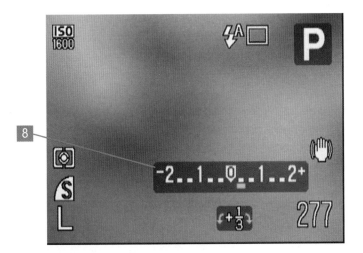

Use exposure compensation (cont.)

7 Select the exposure compensation symbol. A horizontal line will appear next to it along with a number. This number will start at 0.0 and can be adjusted by either rotating the camera's control dial or pressing up or down on the four-way navigation pad. Typically the value will go up or down in 0.5 or 0.3 jumps, negative values will darken the exposure and positive values can be used to brighten it up.

8 Depending on the results of the test shot's histogram, increase or reduce the exposure value by a third of a stop (0.3), retake the photo and check the histogram again. If you reduced the value, the peaks move slightly to the left, pulling the curve away from the extreme right and curing the over-exposure. If you increased the exposure the peak should have travelled to the right and into the fifth portion of the histogram.

9 Try experimenting with exposure compensation – it indicates how your camera is likely to perform in differing situations.

Use exposure compensation (cont.)

Beach or snow holidays

1. Step one is to take a well-deserved holiday, once abroad we can tend to the task of photographing beaches or snow. Whether you go on a winter break or worship the sun, the same thought process can be applied. Try taking some sample shots. Don't worry if they disappear before you get a chance to closely examine them.

2. Switch the camera to playback by rotating the mode dial or pressing the Playback button to find the sample image. The image is likely to look perfect on the camera's small display, but don't trust this, just check the composition.

3. As with the previous task we are going to access the camera's histogram, which you can do by repeatedly pressing the Display button until it toggles into the histogram display mode.

Even the most advanced metering systems can only guess at the landscape they find themselves in. Granted, you can help by using scene modes that match up to the situation, but sometimes you need more flexibility than your Beach or Snow mode offers. On occasions like this you'll need to compensate the exposure for these overly bright meter readings. When your camera reads the scene as being too bright, both beach and snow photographs need to be slightly boosted in order to avoid under-exposure and the brilliant white snow looking like it could do with a run through a spin cycle or two. This task shows how to ensure your winter holidays and beach breaks come out bright and bold, not grey and grimy.

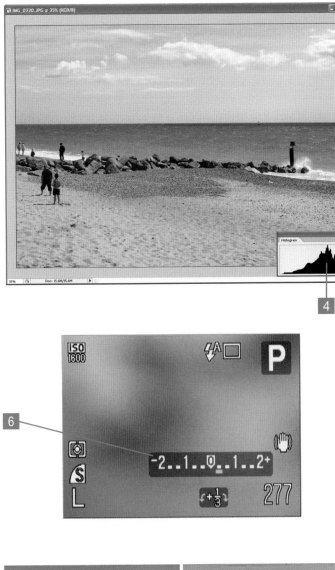

4 The test images are likely to show a series of varying sized peaks but look specifically for a tall peak rising in the fourth segment of the histogram. This represents the sand or snow. Ideally this peak should be moved into the fifth segment so that the photo looks correctly exposed.

5 Switch the camera back into capture mode and look for the exposure compensation symbol, this may be on the camera's exterior or within its menu. You can recognize the symbol as a diagonally crossed square with a plus and minus symbol on either side of the line.

6 Once you select the exposure compensation symbol a horizontal line will appear next to it along with a number. This number will start at 0.0. Try increasing the exposure value by a third of a stop (0.3), retake the photo and check the histogram reading again for this new photo. You should notice the peaks move slightly to the right – this will have the effect of brightening up the image and making the colours more pleasing.

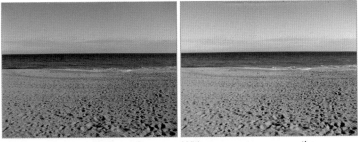

Without exposure compensation With exposure compensation

Use flash compensation

Having just covered exposure compensation the next logical feature to cover is flash compensation, especially as the two features operate in much the same way. Where exposure compensation allowed you to override the way the camera recorded the incoming light, flash compensation gives you control over the amount of light the flash bulb puts out. For example, if you are taking a photo in a long room you might need to boost the flash output just to reach your subjects. Conversely, if you are taking close up portraits in poor lighting, it's likely you'd need to dial down the flash or run the risk of blanching your sitter's face with light. In many ways this feature is more crucial than the previous task. If the flash is over powered and blasts your subject there is very little you can do to recover the image, with or without Adobe Photoshop Elements. In this task you will learn how to adjust the power of your flash, adding light when you need it or simply toning down an over enthusiastic flash.

1 You can practise either with another willing sitter or simply with a still life subject. However, it's important you get in close. For the purpose of this task try and get between 50 and 100cm away from your subject.

2 Half press the shutter release and ensure you are able to focus at this close distance. If the camera fails to focus take a step back until it locks on.

3 After confirming focus ensure the camera is set to force the flash to fire.

4 Take a shot with the camera and review this test shot by switching the camera into playback mode.

5 It's likely the image will be very obviously overexposed. However if your camera features a histogram it would be wise to access this as confirmation. You can access the histogram by repeatedly pressing the Display button until it arrives at the histogram reading.

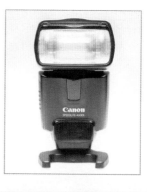

Did you know?

Chromatic aberration

This term simply means the colours on the print are out of alignment. This is due to the fact that different colours of light have different wavelengths. These wavelengths are bent by the elements of a camera lens at slightly different angles and unless the lens has additional correcting elements, the print will show slight red and blue edges on high-contrast objects.

Jargon buster

Pixel – short for picture element, it represents the smallest part of an image. Digital cameras refer to millions of pixels as Megapixels.

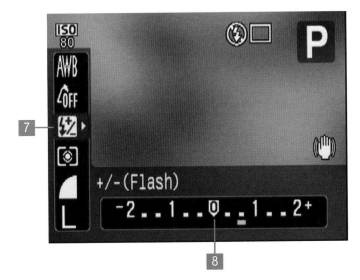

Use flash compensation (cont.)

6 Typically the histogram is split into five segments representing from left to right, very dark (shadow detail), dark, mid (18% grey), light, and finally highlights. If the histogram shows the curve peaking in the fifth segment it's likely to be over-exposed.

7 To correct over-exposure we need to access the flash compensation, the symbol has a diagonally crossed square with a plus and minus symbol on either side of the line much like the exposure compensation icon – with the addition of a lightning strike next to it.

8 Once you have selected this option from the camera menu, you can then adjust its value. This will start at 0.0 and can be adjusted by either rotating the camera's control dial or pressing up and down on the four-way navigation pad. Typically, the value will go up or down in 0.5 or 0.3 jumps – negative values will reduce the power of the flash and positive values increase it.

Use flash compensation (cont.)

9

9 If your test image was overexposed, try reducing the power of the flash value by a third of a stop (0.3). Then retake the photo and check the histogram reading again. From the camera screen you should see the subject is less harshly lit, the histogram should show the peaks moving slightly to the left, pulling the curve away from the extreme right and curing the overexposure.

10 Try experimenting with the flash compensation to learn how your camera handles both close and distant subjects.

Did you know?

Fringing

What is sometimes referred to as purple fringing has much in common with chromatic aberration. Both effects are created by the differing wavelengths of light not being sufficiently corrected for. Fringing however, occurs at the camera's microlenses. On some sensors, tiny lenses are added to help to funnel the light into the small receptors.

See also

Get the best from your built-in flash in Chapter 1.

In the Get the most from an auto-focus camera task you looked at using the focus and recompose technique as a way to ensure your camera locked the auto-focus on the subjects rather than the background. However, many modern digital cameras have an even more elegant solution which simplifies and speeds up the process of photographing people. Face detection is an innovative new form of auto-focus, previously not possible with film cameras. Cameras equipped with this feature use a miniature computer to process a constant stream of information recorded by the camera sensor. Even before you press the shutter release the camera breaks down the picture looking for human features such as the eyes, nose and mouth. When it finds what it believes to be a face, it puts a box around those details on the display. The maths at the core of this technology has been around for several years but it's only now that cameras have really had enough processing power to provide a snappy and practical alternative to more conventional auto-focus systems.

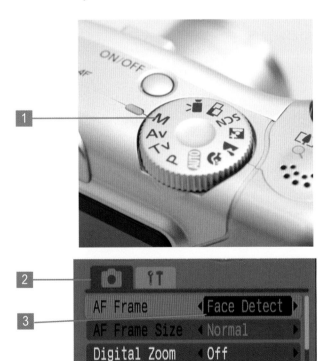

Use Face Detection

1 Once the camera is ready for use, put it into automatic or manual mode. Either mode is suitable – just avoid scene modes such as sports or landscape as these modes override many of the exposure and focal settings.

2 Next, open the camera's menu and navigate your way through the menu to find Focus method. This may also be labelled as Auto Focus. Select the Focus option from the menu, to bring up several different methods for the camera to use.

3 Scroll through the available options, find Face Detection and confirm your selection. On some cameras you won't need to confirm your choice and instead you can simply exit the menu by pressing Menu again.

Use Face Detection (cont.)

4 Once face detection has been selected as the preferred method of auto focus, the camera will begin perpetually processing the view on the display, looking for faces. As you can imagine this constant processing can have a significant impact on your camera's battery life, so make sure the camera is given a good charge if you intend using this feature for a special event.

5 Next, without touching the shutter release, point the camera at a face or a small group of people so the system can try and pick out the details. So long as people are facing you the camera should quickly identify their features and place a coloured box around each of their respective heads.

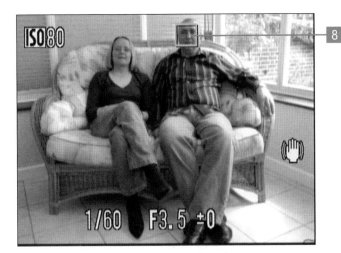

6 Ask the subjects to move around a little whilst still facing the camera, and also try slowly moving the camera itself. You should see the boxes framing the individuals' faces track their movement quite easily. As you can see, this system goes well beyond conventional focal systems that only look for simple differences in contrast.

7 When you have the individual or group posed as would like them, half press the shutter release. Depending on the camera manufacturer, this will cause the boxes surrounding each face to either change colour, or flash, to indicate focus lock.

8 Now you can fully depress the shutter and the camera will capture your composition.

9 Try experimenting with Face detection, for example, using the focal mode with different group sizes, or having your subjects closer or further from the camera. Also, it's worth understanding how much of a face must be visible before the camera can no longer indentify it correctly.

3

Advanced techniques to improve your shots

3

Introduction

By now you've got a much better idea which modes are available to help you eke out the best results from your digital camera and, just as important, how to easily alter exposure settings to suit the situation. Up until now, the tasks have focused on the operation of the camera, gently easing you into each mode and its practical application. Now you need to flip your thinking on its head and breakdown the scene so you can decide which of the available options best suits the shot or subject. In this chapter you'll go through a series of practical step-by-step guides, covering a range of advanced photographic techniques. You'll also find some sage words on how to prepare both yourself and your equipment to get the most from portraits or group shots, regardless of the event or the conditions.

What you'll do

Think in print sizes

Pose for people for flattering results

Get great portrait and group shots

Photograph children

Capture motion blur

Create a zoom blur

Shoot at parties

Use exposure bracketing

Take long exposures

Paint with light

Hit a moving target with continuous focus

Experiment with digital filters

Use macro photography

Understand white balance

Use preset white balances

Use the histogram

Shoot in RAW

Think in print sizes ▶

In the same way that a painter or sculptor looks beyond their raw materials to envision the final piece in their mind's eye, as a photographer you should visualize what you want to create before you press the shutter release. By considering the end result at the point of capture you have a far greater chance of achieving a successful print. What this means in practice is thinking about the dimensions of the prints you normally use. You don't need to memorize exact inches or centimetres, but if you become familiar with the shape or bias of a particular format – whether it's a square or a narrow rectangle – you can begin to adjust your initial composition rather than end up with a cropped image against your wishes. The most common example of this occurs with people who've used film for years and switched to digital. In the past, the 6×4 format matched your photos perfectly. However, with digital cameras, typically the closest match comes from 7×5. The prints might not fit in your old albums but at least everyone will still have their heads on.

1 First you need to arrange your scene to achieve the composition you are after – for this first section we are looking to capture a 10x8 image. With groups, don't be afraid to give people direction but remember to be friendly and clear.

2 Step back from your scene and quickly check that the light is appropriate – this is especially important for groups. Make sure everyone's face is unobstructed and isn't shadowed by any of the other group members.

Timesaver tip

A 6x4 print is narrower than 10x8, so when visualizing your composition you should ensure your sitters don't have their heads or feet too close to the top or bottom as they will be cropped off.

3 Now that you have your image, once again visualize the squarer format of a 10x8 photo. With these constraints in mind, use your camera's zoom, or alter your position or even the group to frame your subjects – but remember to leave around 10% at either side of the image unused.

4 Once you are satisfied with the composition take at least two photos from the same position. With two photos from the same position you have a better likelihood of getting everyone's eyes open, and if someone blinked you can copy their eyes from the other image.

5 Repeat this exercise but this time we will try to compose the photo to be printed at 6x4.

3

Pose people for flattering results ▶

It's said that practice makes perfect, but to really improve your photography you need to do more than jump at every opportunity to use your camera. Start to become more aware of the images around you in everyday life. Almost every advert, billboard, poster or television commercial has a photographer employed to create the effect. Try to use this wealth of ideas and techniques: if you mentally dissect how the people were posed, how the lighting was employed and how the depth of field was used, you can start to experiment with your own images. Obviously, if you intend to resell your photos you can't infringe other photographers' copyright by mimicking them exactly, but don't worry about aping other styles to practise technique. In this task we will look at some basic guidelines to improve the way you pose portraiture and groups of people for the most flattering effect.

1. Before you start taking photos, have an idea of the sort of image you want to create. Don't be afraid to experiment with the sitter and any other compositional ideas you have, but a little planning makes it easier to build a rapport.

2. Think about the constraints of your location. If space is tight, do you need a wide-angle lens? Consider the lighting: is there a large window with lots of natural light or strip lighting?

3. If you're using a studio setup you can prepare all the lighting in advance. If you're better prepared you'll appear more confident and have more time to direct the model rather than silently tweaking and fiddling, which only unsettles people.

4. Talk to your sitter. Putting someone at ease makes it easier to direct them and adjust compositions. You'll also find out more about your model, which could inform the way you shoot them. For example, why take a starched formal shot of a solicitor, if you discover they're mad about go-karting?

5. When posing people, it's very much up to the character of ▶

Eye level

5

Below eye level

8

Poorly framed

Pose people for flattering results (cont.)

the sitter. However, there are some simple guidelines worth remembering. Firstly, always try to shoot your models from slightly below eye level. Traditionally this perspective suggests the subject is a powerful or respect-worthy individual, and people are used to seeing portraits presented that way.

6 However much we look after ourselves, there are some areas where wrinkles always appear. So avoid including elbows or knees unless the legs or arms are bent enough to tighten the skin.

7 As with elbows and knees, hands seems to draw a lot of unwanted attention in photographs and many portrait poses see the sitter with their hands concealed or cropped. Only include hands in an image if you can show them in full, and try not to have them breaking the frame of the image.

8 Framing your image is entirely up to you. However it's conventional to show an extreme close-up of the face only, a head and shoulders bust, a ¾ length or a full length shot. You can always try something different but the effect might be jarring.

3

Pose people for flattering results (cont.)

Well framed

9 If you can afford one, an external flashgun with at least a hinged head is incredibly useful for portraiture. If you're shooting indoors this allows you to aim the flash towards the ceiling, which indirectly lights the room and ensures your flash doesn't cast an unsightly shadow immediately behind your subject. This technique is known as bouncing the flash.

10 Consider buying an inexpensive extension lead. This allows you to experiment with taking the flashgun off the camera body and, in combination with a tripod, makes for a basic mobile studio.

11 Avoid having your sitter's eyes look dull and lifeless by using your flash to create a sparkle or 'catchlight'. If your exposure doesn't need a flash for light, but you want to add catchlights, simply turn the flash down to its minimum power and keep it at least ten feet from the model.

12 Strong contrast can make for atmospheric character shots but for most portraits it's ▶

13

better to avoid deep shadows on your subject's face, as this has the unflattering effect of highlighting any imperfections. To soften shadows, mount your camera on a tripod and use a reflector to direct the available light on to the darker areas of your model's face.

13 Unlike the razor sharp world of landscape photography, portraits are often more striking with a narrow depth of field to soften the background and, for example, make only the model's eyes piercingly sharp. To achieve this, try using a wide aperture, such as F2.8 or even less. You'll need to pay more attention to focusing, but get it right and your sitter will love it.

14 With group photos, people need direction on how and where to stand. Take a step back and check that everyone is visible with no shadows across faces. Don't be afraid to ask your group to move in closer to each other or switch people about if it helps balance the image. For groups with rows ensure the tallest people are at the back.

3

Get great portrait and group shots ▶

When compared to painting, portrait photography has only been around for the blink of an eye. While the medium of recording peoples' images has changed over the years, the human form has remained constant, save for a few extra pounds round the midriff. This means we can draw inspiration from literally hundreds of years of work, by some of the greatest artists who ever lived. In this task you will learn some simple ideas and rules that will help you avoid any of the potential pitfalls and ensure your portraiture is eye catching for all the right reasons. You'll look at the best way to photograph individual sitters and discover techniques to improve your group shots. You'll need to enlist a willing volunteer for this task.

Individual portraits

1. Find a suitable space in your house where you have either a large window for natural light or can use an adjustable lamp.

2. Before taking any photos remember that the focus of your images should be the model's eyes. While they don't necessarily need to be looking at you, it's generally accepted that they should be the point of focus.

3. Set the camera into portrait mode or, if you prefer, try using aperture priority with a wider aperture such as F2.8 to give a shallow depth of field.

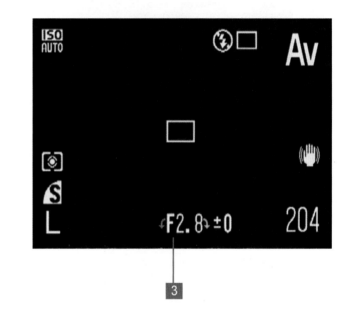

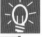

Jargon buster

Depth of field – refers to the distance between the nearest and furthest points your camera has in focus. Adjusting the camera's aperture directly controls this area. Higher F numbers such as F22 can offer almost infinite depth of field, whereas lower F numbers such as F2.8 are more suitable for portraiture as they offer a very limited focus area.

▶

4 Before adjusting the camera's zoom, turn your camera through 90 degrees so that the shutter release is above the lens. The camera is now better suited to the upright model. Make sure you are comfortable with your grip on the camera and that you can still press the shutter release.

5 For the first photo, have your model stand with their head and shoulders square to the camera – think about trying to recreate a passport-style photo.

6 Focus on the model's head and shoulders and take a photo. While your image is representative of your sitter, it's unlikely that it will be very complimentary.

7 Next have your model continue to look square at the camera but move their right foot one pace forward and lead with their right shoulder. Their shoulders should be at approximately 45 degrees to the camera. This image should be better than the first.

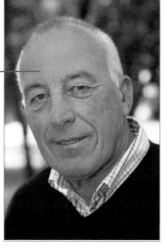

? Did you know?

When photographing men it's convention for the image to be as sharp as possible. This reveals the detail in the model's face, giving them strength and character. For portraits of women the lighting is generally much softer, employing the use of a diffuser to give the final photo a more complimentary appearance.

Get great portrait and group shots (cont.)

8 For this photo ask your model to keep their feet and shoulders the same. They should turn their head slightly away from the camera but keep their gaze on the camera. Ideally they should also tilt their head just a little so that their eyes aren't perfectly level. Now you should have a more attractive image. Next we need to address the lighting.

9 While a lamp might give you the opportunity to be more creative with your lighting, natural light typically gives an attractive, even light. In both eventualities avoid very dark shadows on your model's face. You can try moving your model but it's easier to use a reflector to direct some light into the darker areas. You needn't spend a fortune on professional equipment – a simple sheet of brilliant A3 card, paper or even tinfoil can be enough to reduce the contrast and give you a better photo.

8

9

Jargon buster

Aperture priority – cameras equipped with this mode allow you to select your desired aperture value, whilst automatically adjusting the shutter speed to ensure the exposure is still correct for the image. Aperture priority mode can be very useful for controlling depth of field.

For many people the idea of photographing a group of people, whether they're family or work colleagues sends an icy chill through their blood. This task helps you ensure the photo is the best you can make it. Remember, when photographing groups of between three and twelve people your command of a camera almost becomes secondary to your ability to direct and inform people of the best way to stand, sit or pose for the camera. So keep these rules in mind and you stand a better chance of keeping a cool head. Ultimately, the best cure for nerves is to jump in and give it a try. Whatever the result, as long as you can reflect on your experience it's invaluable.

Small Group Shots

1 Before standing in front of your group, check your equipment, ensuring you have sufficient space on your memory card, your batteries will last long enough and the camera isn't on an unwanted setting.

2 Once you have introduced yourself, consider the composition of your group and if necessary move your sitters around so that the image is balanced, with none of the group casting a shadow on the face of anyone else.

3 Don't overlook the environment around you – try using chairs or stairs to alter the composition.

4 Photos of posed groups often look very unnatural – this is because the people posing feel awkward. Try to set them at ease.

5 Once you have set up your desired image, take more than one photo of each composition – in groups it can be hard to ensure no one blinks.

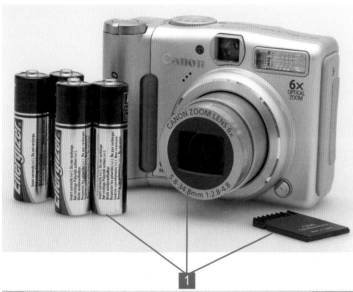

Get great portrait and group shots (cont.)

Large Group Shots

1. Before addressing your group, plan your shot. You must find a space that will accommodate everyone. Consider the lighting as well as the space, larger rooms can be very hard for a compact camera's flash to light successfully.

2. Next consider where you will be standing, you need to think about what your viewpoint will be. Ideally you should find a location that gives you a vantage point where everyone will be visible. You may have seen professional photographers carrying stepladders at events such as weddings, now you know why.

3. For a large group of this nature you have to speak up, it's no good whispering away in the back, you won't get people's attention or their faces looking at you.

▶

For groups of more than twelve people you need to consider a different set of variables. Whether you're photographing all the guests at a wedding or need a group photo to commemorate getting the extended family all under one roof, you can't hope to start posing each and every person unless you have an army of assistants or sitters with the patience of saints. One of the keys to a successful large group photo is preparation. This task will provide you with a few simple tips and guidelines to help achieve a great group photo. Most of all though, remember this golden rule: get your photos done early, before the guests have a chance to really indulge at the bar.

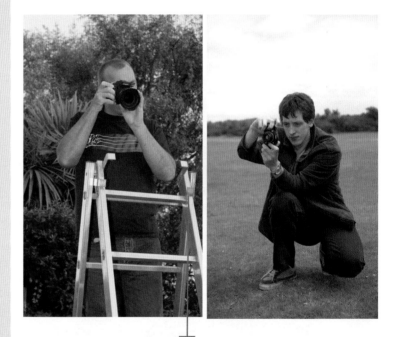

2

Important

When planning to photograph a wedding, you should always walk around the venue before the event, make a note of good areas for groups, and consider the lighting as well as the space. Plan what images will be taken where and arrange them so the people involved in each photo can be called upon only when needed and aren't left hanging around. On the day be confident, try and use your plan but be prepared to make changes without panicking.

Get great portrait and group shots (cont.)

4 Once you have everyone's attention, get your group to countdown or say 'Cheese' – while it might seem old-fashioned it still works.

5 Play it safe and take several images of each group, but remember not to take too long – the novelty of being photographed wears thin very quickly.

3

Photograph children ▶

1. Check your camera has enough battery power and storage space before setting off for the day.

2. Put your camera into automatic or Program AE mode, your attention will need to be focused elsewhere so for once let the camera make most of the decisions for you.

3. It's unlikely you will get the shots you have in mind immediately so you will have to be patient, but always keep the camera at hand for quick snaps.

4. Try and make the experience fun, engaging the children in games, as this is far more likely to pay off and get them relaxed and smiling. Most children will be at their best around mid morning.

5. As with a good portrait you need to keep the focus point on the child's eyes. To help achieve this, always try and shoot your photos at eye level. You might come away with sore knees but you're guaranteed to get better photos.

▶

When photographing children your demeanour or approach to the experience is very likely to influence how successful the resulting photos are. Ultimately, if the experience isn't fun for all parties involved that will come across in the photographs, so try to engage the children in the process. Using digital cameras makes it much easier to show children what you're up to and can get them to work with you to improve the final image. Obviously, everyone's different and sometimes parents' own issues with photography can affect their children's feelings about having their photo taken. So, if you can, bring mum and dad into the composition as well, to provide some assurance it's not going to hurt.

For more candid photos initially it's better to switch the camera to a semi-automatic mode such as Shutter Priority. Try utilizing a high shutter speed so you have a much greater chance of freezing just the right moment. That way you're free to concentrate on capturing amusing habits or a shared gaze between mother and child. In this task we will look at a couple of simple ideas to make working with children easier, along with ways to configure your equipment to avoid the need for retakes.

See also

Photographing children can be a very lucrative pastime, however understandably it's not without a good deal of red tape. Turn to the Know your rights and responsibilities section in Chapter 7 for more information.

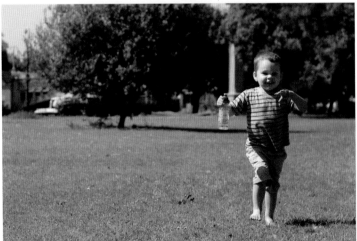

6 Don't be afraid to get in close. Once the child is comfortable you can try taking some shots of just their face – remember you don't have to have full body shots in every photo. Don't rely on your camera's digital zoom, the photos will come out grainy if you do.

7 Once you have a composition you are happy with, half press the shutter release with the child under the focus point, then with the button still depressed recompose your image with the child off centre.

8 Gently squeeze the shutter release to capture your picture, if you want to get eye contact in your photo, call your child's name just before taking the photo. By having the camera focused and ready you can capture photos with minimal lag.

9 Take lots of shots – the best poses always come when you least expect them so shoot more photos than you would normally.

10 Try taking some shots whilst your children are at play without having them pose, these candid shots can be more memorable.

Advanced techniques to improve your shots 93

Capture motion blur ▶

Much of what you've learnt so far has helped to produce sharper, better lit, more focused photos but sometimes razor sharp images can actually detract from the image you're trying to capture. A pin sharp image of a Formula 1 racing car and background creates the impression the car was parked, rather than blasting past at 150 mph. To add a sense of movement, photographers often introduce a small amount of blur. When used effectively, the majority of the image's detail is retained but the subject leaves a colourful trail in its wake. This type of motion blur can be used very effectively to show the fluidity of dance or the speed of a racer. In this task you will experiment with tracking a moving target and balancing the blur against the details.

Motion blur in natural light

1. If you're tracking something fast, take some time to find a good place around the location and remember to keep safe.

2. Check the camera's ISO speed and set this to match the lighting conditions, for a bright day, 100 or 80 should be enough but if it is overcast try using 400.

3. Put your camera into shutter priority mode, shown as Tv on Canon cameras, and set the shutter speed to 1/250. Faster shutter speeds may give you sharper subjects but can also have the effect of making them look stationary.

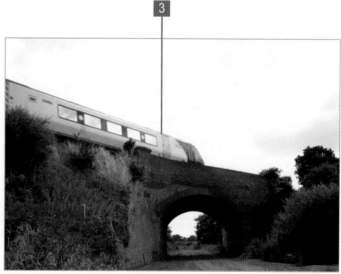

4 If your camera has an option for continuous focus then select it. In this mode, the camera will continually refocus on your moving target as long as you have the shutter release half pressed. Some cameras even focus when you're not pressing the button, but be advised that this mode quickly drains the batteries.

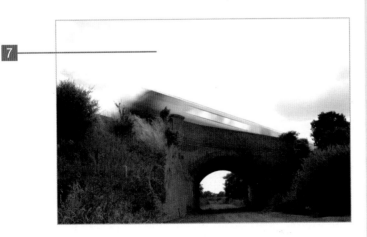

5 Practise panning the camera horizontally left to right or right to left, keeping your subject centrally in the image.

6 Track your subject while keeping the shutter release half pressed. When it is in the right position, squeeze the shutter release but keep panning the camera, stopping abruptly can ruin the effect.

7 Try repeating this task with lower shutter speeds such as 1/125, then 1/60. By using longer exposures the motion blur is magnified, however it does become more challenging to keep the moving subject sharp. See what effect a longer shutter speed without panning has.

Capture motion blur (cont.)

Motion blur with flash

1. Open the camera's flash menu, if your camera has this option you should look for second curtain flash, if this isn't available then select slow sync flash.

2. Check the camera's ISO speed and set this as low as possible – this will enable you to use longer exposures without creating too much digital noise.

3. Put your camera into shutter priority or Tv mode and set the shutter speed to 1/25. Normally a shutter speed this slow would result in a completely blurred photo but here the flash will provide the majority of the light and ensure clarity.

4. Avoid using a tripod or putting the camera down as the small movements of your hands will add to the overall effect. However don't go so far as to intentionally move the camera.

▶

In the last task you learnt how using a longer exposure with fast moving subjects could add impact and emphasise movement, but when the light is failing how do you balance blur with details? In this task you'll discover how to use your flash so it works in harmony with slower shutter speeds. On many digital compact cameras the available flash options are limited, and using your flash with an extended exposure can produce odd results that seem to show a sharp image with movement paradoxically trailing forward, almost giving the impression your subject hit reverse. To create the kind of photo you're after, your camera ideally needs to have an option called Second Curtain Flash. This mode switches the flash to the end of the exposure, capturing the final position of your subject. As a result this can be very effective for photographing musicians or dancers.

3

Jargon buster

Digital zoom – unlike an optical zoom lens, digital zoom doesn't use the lens to magnify the subject. Instead the camera discards some of the light hitting the sensor opting instead to use just the centre portion. This has the effect of making the image appear magnified. However, as less of the sensor is used it does have the drawback of reducing the picture quality.

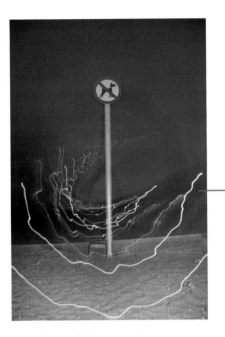

6

5 Once you've selected your subject, keep the shutter release half pressed ready to preempt any interesting movement. When your subject is in the right position for your composition, squeeze the shutter release but remember to keep the camera very steady, as any movement will be recorded in your photo.

6 Try repeating this task with lower shutter speeds such as 1/15, then 1/5. By using longer exposures the motion blur is magnified, this will also record more of the ambient light making the overall image brighter.

3

Jargon buster

Interpolated – on some digital cameras it is possible for the camera to produce images that offer a higher megapixel count than the sensor itself physically offers. This is achieved by using a complex mathematical calculation to produce a larger image than was originally recorded, this effect is known as interpolation.

Create a zoom blur ▶

Incorporating blur into your images can be a very effective way of emphasizing movement, but what if you want to add impact to an otherwise static subject? This is where zoom blur can be a useful technique. Zoom blur, occasionally referred to as zoom burst, creates a radial blur that stretches and blurs in a circle around the centre of the frame. This can take a good deal of practice to create the ideal amount and style of blur, however when you get it right it can give the image an explosive quality. This task can only be attempted if your camera has a manual zoom like that found on many Digital SLR camera lenses. Most compact cameras control the zoom with a button press or rocker switch which makes it impossible to create a zoom blur.

1 First set your camera up on a tripod, and frame the subject you want to photograph.

2 Push or pull the zoom to its widest extreme.

3 Set the ISO sensitivity to one of the lowest settings, for example ISO 80 or 100 are well suited to this task.

4 Set the camera on Shutter Priority or Tv and then configure the camera to use a shutter speed of approximately 1/5 of a second.

Jargon buster

Electronic viewfinder – if you consider purchasing a digital camera with a powerful optical zoom you will start to see the term EVF, this stands for electronic viewfinder. An EVF is used to simulate the experience of using an SLR as it can relay the live image coming in through the lens without having to incorporate another bulky lens solely for a viewfinder. Another benefit of an EVF is the inclusion of the current shot settings.

▶

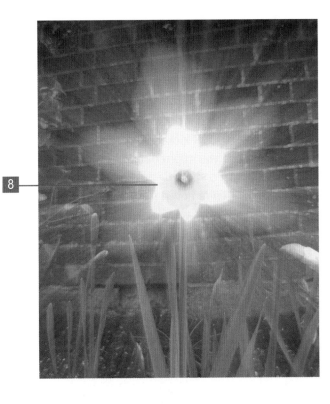

8 ─

5 Lightly depress the shutter release half way to ensure the image is focused.

6 With your hand gripping the zoom lens barrel, squeeze the shutter release so that the exposure begins and simultaneously begin to smoothly zoom in on your subject.

7 After the exposure completes, check the image to see if you have been able to capture the desired effect.

8 Try using more or less of the zoom to create different effects – longer exposures can give you more scope to experiment.

Timesaver tip

You can make the process a good deal easier by using a sturdy tripod or taking the image whilst resting the camera on a wall. This helps ensure the only blur introduced is deliberate.

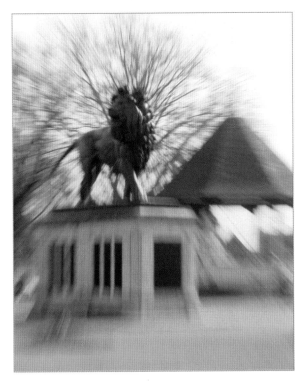

3

Shoot at parties ▶

Do you? Don't you? Unless you have the most compact of modern digital cameras, there's always some debate as to whether you should bring your camera to a party. If you leave it at home you can be assured you'll miss some once in a lifetime, never to be repeated spectacle. But bring it along and you're relegated to carrying it around all evening, potentially leaving it in a cab or getting it kicked about on a pub floor. Setting aside the chance you might damage or lose your camera many people feel constantly peering through a viewfinder puts you a step removed from the action. In this task you'll find out how to set your camera up quickly and easily for the best results, along with a couple of simple tips to make you and your subjects feel more at ease.

1. If you know the party will be indoors it's sensible to increase the ISO speed as far as you can without sacrificing the overall image quality. On a modern digital SLR, ISO800 is normally perfectly acceptable, with some cameras capable of a very good ISO1600 setting. Experiment with these settings for yourself and you may find even higher speeds provide acceptable results.

2. A zoom lens can provide a flexible solution when walking around a party. However, if you're using an SLR why not try using a fixed focus lens, ideally a 24mm or 35mm which give a wider perspective and make it possible to shoot from the hip. Another advantage of fixed lenses over zooms are their larger apertures, such as F1.4 or F2, which can make using a flash unnecessary.

▶

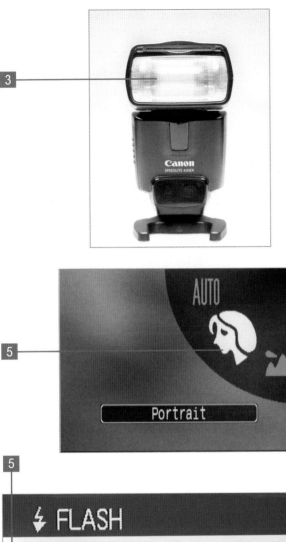

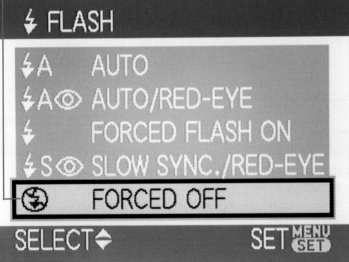

3 If your camera supports one, an external flash is ideal for parties, as you can bounce the flash burst on to the ceiling to diffuse the light and produce much more attractive results.

4 A compact digital camera is less likely to offer you the option to shoot manually, or to attach an external flash. However, you can still capture great candid shots. Switch your camera to either Night Portrait or Night mode, and you can concentrate on getting funny moments as they happen, without worrying about tweaking exposures.

5 If you're prohibited from using a flash don't let this put you off. It's still possible to get some good images. Set your ISO as high as possible and select the standard Portrait mode. Access the flash menu and disable it. Remember, if you switch scene modes the flash will come back on.

Shoot at parties (cont.)

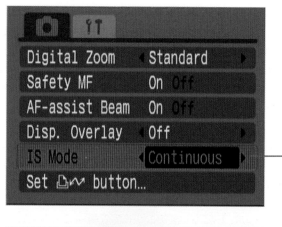

6 In order to get a sharp image you need to eliminate any camera shake and ideally any movement from your subject. The first step towards reducing camera shake is to enable your camera's Image Stabilization function.

7 If you can, find a safe place to rest your camera during the shot, otherwise enable the camera's built-in self-timer and brace yourself the best you can. Try using this technique for candid shots that don't necessarily need your subject's attention, that way you can keep shooting without annoying anyone.

8 If you have to photograph any formal shots, keep a list of the groups you need to capture to hand. Chat with ushers in advance so they can help gather groups together. Make sure you stress the need for flash lighting.

9 Don't overlook the details, the little touches such as cake decorations, presents, name cards or flower arrangements can help tell the story of the event. They can also be a good opportunity to gauge the lighting without repeatedly photographing one guest as you refine your settings.

Timesaver tip

When shooting indoors many venues use tungsten or incandescent lighting, this will produce a strong orange cast on the image. Remember to adjust your white balance before taking the shot, as correcting for it later can be very time consuming.

See also

If you're happy to adjust to the conditions you can set the exposure manually. This might seem potentially disastrous, however if you balance your available light with the flash you can produce some striking images. For more on this see the Take long exposures task later in this chapter.

When your film camera offered you 24, 36 or 40 exposures, each photograph tended to be unique. Now memory cards can offer enough storage for video and more still photos than the display can count up to, so you can afford to be a little more snap happy. In this task you'll learn about exposure bracketing, a feature which automatically fires three or five exposures in rapid succession. However, unlike a standard burst mode, this isn't aimed at capturing a fleeting action moment. Instead, each photo is taken with slightly different exposure settings. Typically, the first is metered for a marginally darker exposure, the second uses the default settings and the third opts for a brighter result. This type of sequence makes it possible to hedge your bets with subjects over a very wide exposure range, for example shooting a street scene with long shadows and a bright sky. Exposure bracketing can be used to great effect when creating high dynamic range photographs.

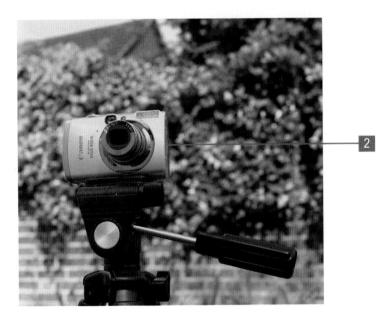

Use exposure bracketing

1 Find a location or scene that offers a wide range of light and dark areas. Good examples of this are indoor spaces with an open window or alternatively a corridor or walkway with daylight at the end.

2 Whilst exposure bracketing can be used to great effect with the camera handheld, if you have one, try setting your camera up on a tripod. This ensures the camera remains fixed on the same scene when it captures the three exposures.

3 Begin by using either the command dial, if available, or system menu to switch the camera into Program AE or P mode.

Use exposure bracketing (cont.)

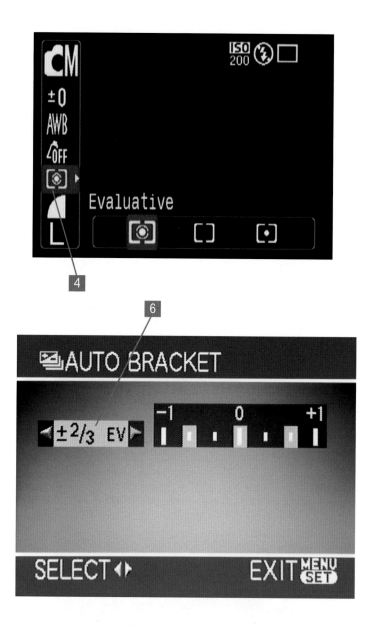

4 Next press the Menu button, which should give you access to the shooting menu. Depending on the camera system, you will either find the metering mode clearly labelled or you should look for a box with a dot in it, enclosed by brackets above and below.

5 Press the Metering icon or Menu to gain access to the array of metering modes. Switch the camera to Evaluative or Matrix metering. This setting will look at the scene in its entirety to decide on the correct exposure.

6 Close the metering menu and scroll through the available options until you find Exposure bracketing or Auto bracketing. Depending on the complexity of your camera you may simply be presented with the option to toggle the bracketing on or off, or you may be able to specify the number and variance of the exposures. Some cameras even offer the ability to bracket white balance settings.

▶

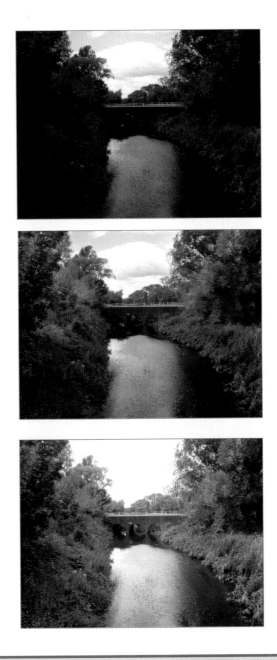

7 Activate the exposure bracketing and, if available, set the camera to capture three exposures. Then close the camera menu and half press the shutter release to lock the focus.

8 Gently squeeze the shutter release and keep the button depressed as the camera takes three images in quick succession. If you're not careful, the images are likely to show signs of blurring.

9 When the third and final exposure finishes you can press Play on the camera to review your photos. You should see three images that get successively brighter or darker. Look closely at each image – it's likely that the darker and lighter photos have both retained elements of information lost in the standard image.

3

See also

This task illustrates the compromise your camera has to make every time you take a picture. Keep hold of these three photos – in our later Create high dynamic range images task in Chapter 4 you can combine all three photos to great effect.

Take long exposures ▶

Night Landscapes

1. Key to getting a good landscape photo, never mind a night landscape, is having your camera absolutely still. As a result, for this task a tripod is essential. If your camera supports the use of a cable release or infrared remote, bring it along. This great accessory eliminates any camera shake created by pressing the shutter release.

2. Outside of camera equipment if you're going off the beaten path remember to bring a flashlight. While a path may be familiar and easy to navigate during the day, lugging your gear in poor lighting could have you breaking equipment or worse.

3. It doesn't hurt to check the weather forecast before venturing out. Obviously this will let you know if it's going to rain, but you'll also have a better idea of potential cloud cover and how much light to expect from the moon, if any.

Flash photography enables you to freeze an instant or capture images in the inky black that would have otherwise been missed. However, it doesn't have to be used in isolation, and in this task you'll learn some techniques to help you combine flash photography with longer exposures. Long before digital, and even before film became a mass-produced commodity, posing for a photograph was an arduous experience. The Victorians had to stand stock still for between 15 to 30 minutes to ensure their likeness didn't blur and ruin the portrait. Technology may have changed, and light sensitive material improved, but the rules of physics remain the same, so when you're taking a long exposure it's vital both the camera and your subject keep as still as possible. This task describes some simple ways to avoid blur and provides some creative suggestions to show you what's possible with shutter speeds measured in whole seconds rather than hundredths of one.

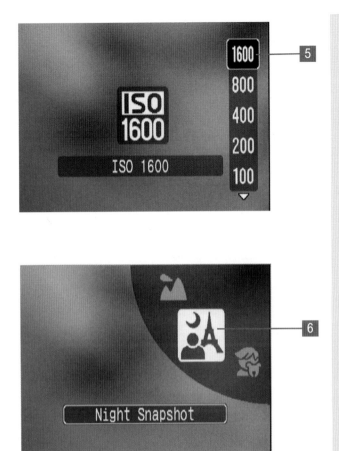

4 Try to setup as much of the camera for your desired exposure before you leave the comfort of your home. It's always easier to configure your camera in the light of your living room, instead of trying to lock a torch under your chin to free up your hands.

5 One setting that's worth adjusting is the ISO speed: for low light subjects switch to higher sensitivities. For darker conditions, ISO400 or above is better.

6 Next select the Night mode or Night Landscape from the camera's scene modes. By switching to a specific night mode the camera will use a much longer exposure and ensure enough light is collected.

7 Don't be surprised if focusing takes significantly longer in very low light, with little contrast to lock on to your camera will have to work much harder.

3

Jargon buster

Pincushion distortion – manufacturers try and squeeze the most flexible zoom they can into a camera design but this can mean the image quality offered throughout its working range can suffer. One characteristic problem of bad lens design is known as pincushion distortion. This effect can be seen when looking at the lines of a window – often the straight frame will curve gently inwards.

Take long exposures (cont.)

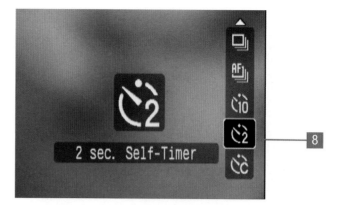

8 Once your camera locks focus, fire the shutter using either your remote release or, if you don't have one, press the Timer symbol to enable the self-timer mode. This typically fires the shutter after either 2 or 10 seconds.

9 Don't rush back to your camera straight away. You may hear the familiar sound of your shutter opening but wait for the second sound, of the shutter closing again. When you hear it, it's safe to handle the camera without risking a blurred final image.

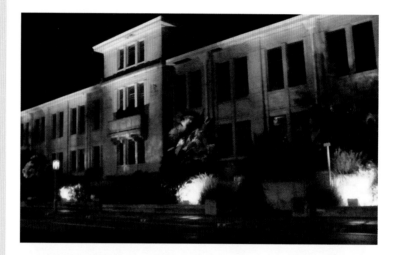

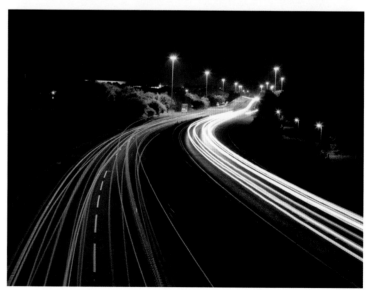

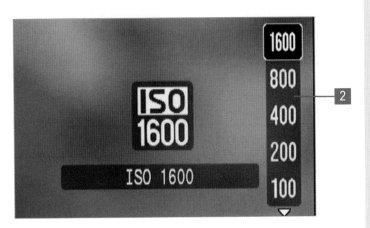

Balancing Flash light with available light

1 In larger rooms the lighting is often better suited to socializing than photography, and even the most powerful flash can struggle to brighten up the darkest corners. The trick is to embrace these situations to create a more atmospheric shot. You can use a tripod for this task if you like.

2 The aim of this task is to balance the available light with the flash, without destroying the ambience of the room. Firstly, to record as much of the ambient light as possible the ISO speed should be increased. Most cameras offer between ISO100 and 1600, however you should never use the highest speed offered by your camera. Aim for around ISO400 to 800 depending on how dark the room is.

3 Next, override the camera's automatic settings to ensure the camera gets long enough to record the available light. Switch the camera into M mode and set your aperture value to around F5.6.

4 With the aperture set, adjust the shutter speed to around 1 to 2 stops under-exposed. You can confirm how much the image is under-exposed by keeping an

Advanced techniques to improve your shots 109

Take long exposures (cont.)

eye on the flashing exposure scale. Don't worry, the flash will compensate for the extra light needed.

5 Next, enable your camera's flash and access the flash settings. If available, set the flash to Second curtain flash, otherwise select Slow sync flash. This ensures the flash doesn't override the exposure settings and preferably fires at the end of the exposure.

6 Compose your shot, but try and focus on a subject towards the front of the room. If you're photographing people, try and get them to remain relatively stationary, small movements shouldn't be problematic but someone crossing through the frame could ruin the effect.

7 When you're ready gently squeeze the shutter release, trying to avoid any camera shake. The distant objects will most likely blur, but your closer subject should be lit primarily from the flash and therefore retain much of its sharpness.

8 This technique can yield some excellent results but it needs steady hands and a willingness to experiment with the length of exposure. If you don't get the results you want first time, keep trying. ▶

Flash alone

Flash balanced

Take long exposures (cont.)

Portraits in poor light

1 Careful lighting of a subject's face can dramatically affect the mood and tone of a portrait. Opt for harsh highly contrasting light and your sitter will appear hard and powerful. Switch to a more diffuse or soft light and the result can be more appealing, eliminating deep lines and smoothing a wrinkled complexion.

2 To create a highly contrasting appearance your subject should be lit from a single directional light source, for example, a bright window in a dark room, a spot lamp or a camera flash used on an extension. Try to avoid photographing your sitter looking square at the camera, especially with the light source fixed next to the camera, as this has the effect of flattening the sitter's features. Experiment with this configuration of lighting. The effects can be quite moody and well suited to character portraits.

▶

3

Take long exposures (cont.)

3 If you're looking to create a more flattering portrait, ensure your light source doesn't come from one direction. If you are using an external flashgun, pivot the head to point towards the ceiling rather than at your sitter. Provided your ceiling is plain white or cream, the light bounces off it and creates a much softer glow to your portrait. If you have a brightly coloured or decorated ceiling, avoid this technique as your photos run the risk of becoming tinted by the light reflected. With a conventional pop up flash you can create your own diffuser from greaseproof paper attached to the flash in a simple upward v shape.

4 If you find the light from a flash too harsh, but the available light doesn't reveal enough detail, look out for a simple 5 in 1 reflector dish. This clever accessory works like a cross between a compact mirror and a pop up tent, offering a spring-loaded fold-out fabric dish with a choice of highly reflective sides. It's inexpensive, compact and ideal for removing darker shadows from your subject's face.

When recreating any photo from your mind's eye, you'd be forgiven for concentrating on the most obvious elements first, for example your position or point of view, how much of the scene you choose to frame and where you place the focus. However it's equally important you consider the way the scene is lit, for example landscape photographers often revisit the same location at dawn, midday and dusk to capture the transition in palettes. Different lighting can have a profound effect on the appearance of a location, object or person, and can change the mood or ambience completely. For this task you'll shift your attention to lighting, using a simple torch to effectively paint the light on to your subject. Try to imagine playing with firework sparklers, drawing shapes or writing your name with their brilliant light. Don't worry if your first couple of attempts fall short. Just try and enjoy the experience.

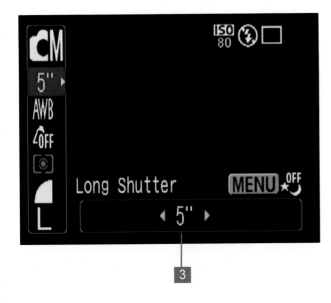

◀ **Paint with light**

1 For this task, a tripod is essential, as the camera will need to be absolutely still. Aim for something light but obviously strong enough to support your camera.

2 Predictably, in order to paint with light we are going to need a torch, if you have different colour filters you can experiment with these too.

3 Access the camera's Scene mode menu and select Night mode. Alternatively set the camera to shutter priority or Tv and use an exposure longer than one second. If it's available, select approximately five seconds.

4 Typically you should use a lower ISO speed – try setting the camera to 80 or 100.

5 Point and hold your torch on the area you wish the camera to focus on. This small pool of light won't be included in the photograph but without it the autofocus won't be able to lock on.

3

Paint with light (cont.)

6. Half press the shutter release and allow the camera to lock onto the light from the torch. If your camera still refuses to focus try switching it to manual focus and doing it yourself.

7. Once the focus is locked, press the timer symbol to activate the self-timer mode. Now when you press the shutter release the camera will countdown for 2 or 10 seconds before taking a photo. This gives you an opportunity to get your torch ready.

8. When the exposure begins, move the torch around the area you wish to reveal, holding the torch in any area for longer will make that area brighter in the final photo.

9. Repeat this task at least a couple of times using longer or shorter exposure times – see what you can create.

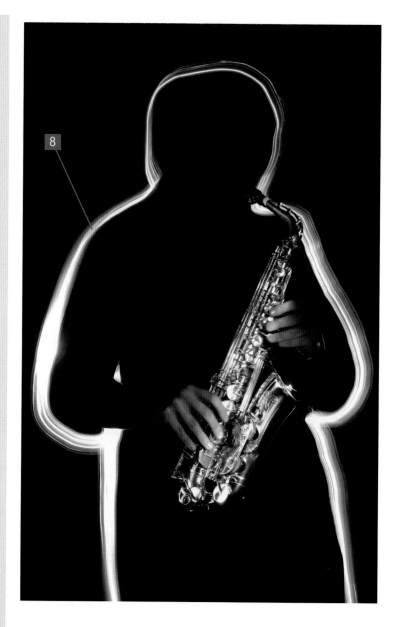

There are many stalwart film enthusiasts that argue against the automation found in digital cameras. If you have the time and skill to manually adjust your exposure settings, focus the lens by hand and develop your own prints, the process by which you create your photos is no doubt as enjoyable as the images themselves. But not every situation lends itself to such a considered and deliberate way of capturing photos. Indeed, you won't find a sports photographer alive who doesn't view auto-focus as a godsend. In this task we will look at using continuous focus to help you keep the action in focus. You'll also discover how you can use it to practise panning your shots.

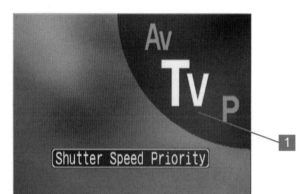

Hit a moving target with continuous focus

1 In order for this task to work you must set the camera into a different mode from auto as not all cameras will allow you to alter the camera's focus method while in automatic. If your subject is fast moving you may want to switch the camera into sport mode. Alternatively you can use shutter priority, as this will allow you greater control over the shutter speed.

3

Hit a moving target with continuous focus (cont.)

Auto ISO Shift	◄ Off ►
MF-Point Zoom	On Off
Safety MF	On Off
AF Mode	◄ Continuous ►
AF-assist Beam	On Off
Review	2 sec. ►

2

2 Once you have switched shooting mode, you must press the menu button and find the auto-focusing options. You are likely to see several options, covering aspects such as the available focus points, but you are looking specifically for the setting for focusing method. This should allow you to switch between S or Single and C or Continuous – for this task select Continuous.

3 After you exit the menu, you should be aware that the camera is now continually refocusing – this happens even if you aren't pressing the shutter release. By continuously adjusting the focus the camera is always ready to take an instant snap and capture the action, but it does mean a heavy drain on the power so remember to switch back to Single after this task.

Jargon buster

AF servo – refers to a camera's ability to continually focus on a moving subject – this feature is sometimes called AI Servo or Continuous. This focus mode is ideally suited to use with sports events or motor sports. To start the process of focusing, the shutter release typically needs to be half pressed – on higher-end cameras the camera will even continue to adjust its focus as the image is recorded.

Without continuous focus

With continuous focus

4 On the display of the camera you should have a focus area typically dead centre of the screen. This is where the camera is trying to lock on to, move the camera so that this small square moves over distant and near objects, you should see the image quickly snap into focus between the two distances as you do so.

5 Select a practice subject and try and keep the square over this element, by doing this the camera tracks their movement and adjusts as the subject moves closer or further, ensuring you get a sharp photo. Try this again but hold your finger over the shutter release and try taking a couple of photographs this time.

3

For your information

Learning how to follow a moving subject is a vital skill and perfecting this will dramatically improve the quality of your images. However, learning more about your chosen subject can also pay dividends and can be a shortcut to getting better images. For example, taking photos at a dance competition is a great deal of fun but understanding how the dancers move and where the best place to stand is, will always beat even a quick focus.

Jargon buster

35mm equivalence – as digital cameras all have differing sizes of sensors, manufacturers have adopted the standard 35mm measurements to give you an idea of the focal range of the camera lens, for example a typical 3x optical zoom would be an equivalent of 35-105mm.

Experiment with digital filters

Much of modern digital photography takes its cues from what went before and this is very evident with filters. The latest generation of digital cameras offers a wide range of filters with effects such as sepia or cyanotype. However, these effects aren't achieved with gel packs or glass filters, they are digitally reproduced by the camera and can be applied or removed by the press of a button without having to haul around a heavyweight bag of glass slides for every occasion. While digital photography owes a lot to its past, the processing power in digital cameras offers a new bag of tricks which can go so much further. There are effects that alter the colour and contrast of the entire image, such as black and white, vivid and neutral filters. Or you can use selective filters to explore more creative angles, such as the popular colour accent. In this task you will look at how to access and apply a range of different digital filters and the way they affect images.

1 First we need to switch the camera into P or Program AE as this allows us to make changes that might be unavailable in the camera's fully automatic mode. Rotate the mode dial to P or select the P option from its menu.

2 Next we need to find the camera's colour mode options. The problem is that every camera manufacturer adopts a different way of categorizing this feature. Some place it under scene modes, while others may give these options their own submenu. Canon, for example, have a new section named My Colors.

3 Once you have found the appropriate menu, look through the options available to you. Most cameras offer at least black and white, sepia, vivid and neutral, but some extend these features with digital versions of traditional filters such as red, yellow and blue, or even stylish new features such as colour accent.

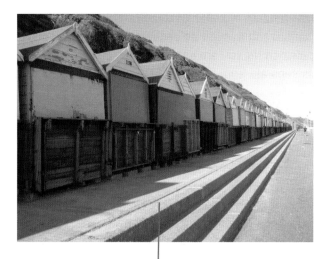

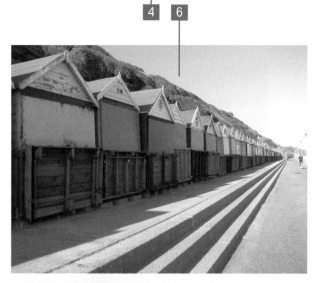

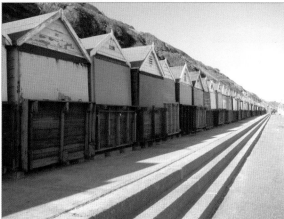

4 For this task we will select Sepia – this should immediately change the display colour to give us an idea of what to expect. The display icons surrounding the live image shouldn't change colour but the image itself will have a light brownish appearance.

5 Now that the camera is configured to use Sepia tinting, try taking a couple of shots. Once you have captured some test photos, switch the camera into Playback mode and check out your handiwork.

6 The next effect we'll look at is the black and white mode. Once again open the camera menu and toggle the current selected effect to black and white. Please note on some cameras this is likely to be under BW or even Mono.

7 As with the sepia option try taking some sample shots and checking them out in Playback mode.

3

Experiment with digital filters (cont.)

The final effect we will look at is the Colour Accent mode. On some cameras this might be under a different name such as colour element. If you are using a Canon camera, note that this effect is separate from the My Colors under the scene modes.

8 Once you have selected the Colour Accent mode, try slowly pointing the camera at different subjects as this should give you a good idea how it will typically react to different compositions. Once you are satisfied that you understand which elements the camera is most likely to automatically select to retain in colour, try taking a couple of test shots.

9 To get a better idea how each of the effects we have looked at will appear, transfer the sample image over to your computer. Which of the effects works best?

Jargon buster

Colour accent – as computer processors have continued to get smaller and increasingly more powerful, some digital cameras have been able to leverage this additional processing power to add popular effects directly into the camera. Colour Accent converts a colour photo into black and white leaving only one colour element such as a bridal bouquet, which provides a bold contrasting detail.

Colour accent

At its heart photography has a very voyeuristic quality to it. Photos let us look at details, objects or people with the kind of scrutiny that would normally be returned with annoyed glares. It also allows us to look into new worlds that would otherwise have been obscured or were simply too small for us to resolve any real details. Your eyes might have problems focusing on the minute details, but a camera's mode can easily be switched to focus as close as 1cm away. This kind of close-up photography is known as macro photography and is represented by a simple tulip icon. In this task we will concentrate on using the macro setting of your camera, with some simple advice for achieving a sharp focus and compensating for your camera's built-in light metering. It's worth practising these techniques on a colourful flower.

◀ Use macro photography

1 First we need to select the Macro mode – this is represented by a simple flower icon. If your camera uses a mode dial select the macro by rotating the dial to the flower. Alternatively you may have to push the four-way navigation pad towards the flower symbol.

2 On most digital cameras this will have the effect of adding the flower symbol to the camera's display to confirm your choice. Some cameras such as Olympus models have two macro modes, standard and super macro. This second mode further reduces the focusing distance making it possible to get right on top of your subject.

3

▶

Use macro photography (cont.)

3. Using the macro option to take photos can be successful with or without a tripod, however it's good practice to use one. By fixing the camera it allows you to concentrate more on the focus without worrying about your own movement.

4. Select your subject and set up as close as possible. Decide on the element of the flower you wish to capture – with macro photography the depth of field is extremely shallow. Normally the stamens or the pistil are a good choice.

5. Once you have selected the area you wish to highlight, look beyond the subject and check the background is sufficiently blurred so as not to create distraction. It's all too easy to get wrapped up in the subject and overlook things which will later ruin the image.

6. Aside from the clarity of the background consider the colours, if they aren't going to complement the composition you should consider moving to a better vantage point.

▶

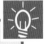

Jargon buster

Macro – the macro setting on your camera allows you to focus the lens very closely. By focusing only a short distance from the lens, cameras can capture very fine detail on smaller subjects. Typically macro photography is used for insects and plants, and indeed, the icon for macro is a simplistic flower.

3

Jargon buster

Focal length – the distance in mm from the centre of the lens to the focal point when the subject is at infinity and in sharp focus. In a digital camera the focus point is the sensor. Focal length is normally represented as mm on the front of the lens. However for these figures to be useful you need to know the 35mm equivalent. Everything lower than 35mm is considered wide angle, over 80mm is normally referred to as telephoto.

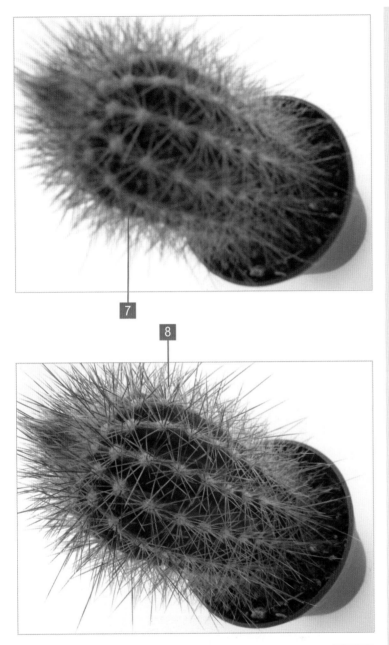

7 If you can, disable the camera's auto-focus. Auto-focusing cameras will work happily with macro photography, however manually changing the focus gives you much more direct control to select exactly what you want.

8 Adjust the focus until you are happy with the composition and then gently squeeze the shutter release. You can choose to use a remote release as this may help to keep the camera steady.

9 Once the camera has recorded the image, use the playback function to check the photo's histogram. When photographing the brilliant colours of flowers the metering system may try and compensate by darkening the exposure.

10 If the histogram is shifted to the left, repeat the process but select the exposure compensation and try adding 0.3 to the exposure.

3

Timesaver tip

For the best results, photograph your flowers first thing in the morning when they're covered in dew, however for late risers a spray bottle of water or glycerine can create the same effect.

Use macro photography (cont.)

Jargon buster

Focal length multiplier – the advent of digital SLR cameras has meant that many photographers have been able to reuse their old lens systems on their new camera. Unfortunately, many digital SLRs use a smaller sensor size than conventional 35mm film meaning that the focal length offered by the lens produces a different field of view, with a narrower perspective. This effect is known as a Focal Length Multiplier. Typically, most entry-level digital SLRs have a 1.5x or 1.6x multiplier – this means that the bundled lenses which offer such alien focal lengths as 18-55mm actually produce similar results to a more conventional 29-88mm.

Focal length multiplier

Did you know?

Exposure compensation

Digital cameras do much of the work of determining the correct exposure for you, allowing you to concentrate on taking your photos rather than configuring the camera. However, on occasions, your camera will struggle to produce the desired results and exposure compensation allows you to override the camera's choice and force it to lighten or darken the exposure.

⊠EXPOSURE

−2 −1 0 +1 +2

◄ +1/3 EV ▶

SELECT ◄▶ ⊠▲ EXIT MENU SET

One of the most common complaints about photos printed from digital cameras is that indoor shots tend to look a little too orange. This tint isn't a side effect of digital processing, or too much time on a sun bed. In fact, it's something far more fundamental, white balance. Without getting too technical, different light sources, for example bulbs, strip lights or the sun, all give off different types of light, each with their own bias towards one colour or the next. Your eyes automatically detect these differences, and the human brain very quickly adjusts to the variation, making you think a white piece of paper is still white, even under a household bulb. Your digital camera isn't as clever. It just records what it sees without making any adjustments. Even with an automatic white balance setting, it often gets it wrong, leaving you with a slightly orange photo. This is where preset white balances come in. If you specify the type of light you're under, the camera can capture the photo perfectly. This task will familiarize you with the typical white balance presets and how they're used.

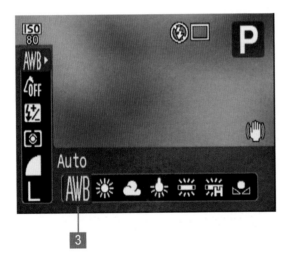

Understand white balance

1 In order to access the white balance option we first need to switch the camera out of automatic. For the purpose of this task, we should select Program AE which appears on the camera as P.

2 Next we need to examine the available white balances – on most compact cameras this means we need to press the Menu button and select white balance. On some higher end cameras the white balance option maybe directly accessible by simply pressing a button marked WB.

3 Once you have the white balance menu open you will be presented with a variety of preset values, typically represented by simple icons. The camera should currently have auto selected.

Understand white balance (cont.)

4 Select the symbol of a small light bulb – notice how the display immediately changes to a slightly bluer tint. This mode is called Tungsten or in some cases Incandescent – it is well suited for most household lighting.

5 Next move the selection to the icon that looks a bit like a glowing magic wand. As you switch to this mode you should notice the display turn slightly orange. This selection is called Fluorescent and is designed for photos taken under strip lighting. Some digital cameras have more than one variant of Fluorescent, catering for differing tubes. You just have to experiment to determine the best results.

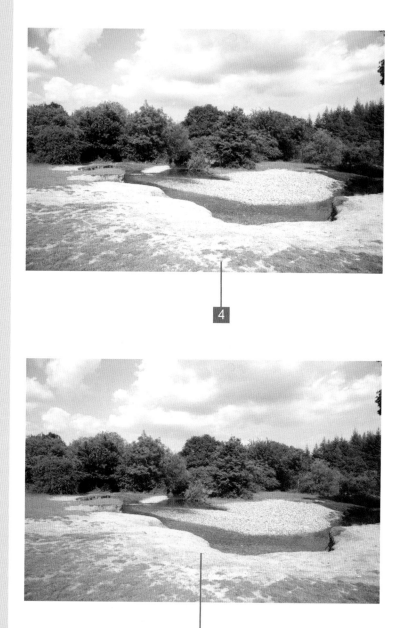

4

5

6

6 Our next stop is the symbol of the Sun. Rather predictably this mode is configured for, and known as, Daylight. You will also notice an image of a cloud. If you change to this white balance you may not see much immediate difference from the Sun option. However on a cloudy day, less light comes directly from the Sun which gives the photo a slightly blue tint – by using the cloudy option, the camera counteracts this.

3

7 Another standard option on most digital cameras is the flash white balance. The burst of light from a flash usually has more blue in it than standard daylight. By using the flash white balance the camera can correct the colours, making the final image more natural.

8 Depending on the complexity of your camera you may have additional options such as Shade, which works in a similar way to Cloudy only with a stronger correction. You may also have Custom white balance. This option allows the photographer to sample the available light and create his or her own white balance.

For your information

RGB stands for red, green and blue, the three primary colours that make up all light. The retina in the human eye is made up of cells, which are sensitive to the wavelengths of these colours. RGB is often referred to as an additive model which means by combining all three lights in these colours you would end up with a white light, however as we all know if you add all three paints together you would get a dark mess, which is why RGB is used to describe light, for example from a computer display. To describe printing or any paint based process we would refer to CMYK. On a computer red, green and blue are represented as three values with each number typically ranging from 0 to 255. By using this system the computer is able to reproduce up to some 16.7 million colours, and, as the human eye can only discern around 10 million, it looks pretty good.

Use preset white balances

In the last task you were introduced to the idea behind different white balances. Now you have a chance to really get hands on and put what you've learnt into practice, to better appreciate the effect of selecting your white balance. For this task you will switch the white balance between the correct mode for the lighting and an obviously mismatched mode. Before you begin, be aware each camera has a different range of white balance presets and, predictably, often a radically different way to access and change them. Thankfully, between manufacturers the standard presets normally use the same names, with the only notable exception being incandescent which is often known as tungsten. For this task, try to recruit a model to help illustrate the effect on skin tones.

1 For this task we need to take a couple of photos indoors and then a couple outdoors – first we will head outside. If you can bring along someone to photograph this will be really useful to illustrate the changing effect on skin tones.

2 As with the previous task we will set the camera into Program mode P so that we can manually select the white balance.

3 Now that we are in P mode, depending on the layout of your camera either press the WB button or open the camera's menu and locate the white balance options.

4 We will try taking our first sample photo with the wrong settings to illustrate the advantages of selecting the white balance manually, so select the small light bulb symbol to indicate Tungsten or Incandescent.

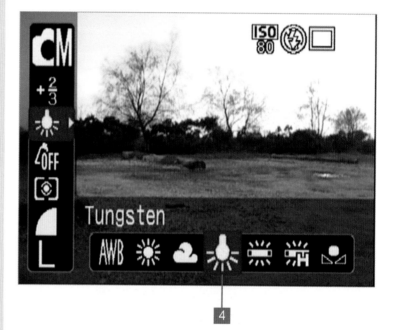

5

Use preset white balances (cont.)

5 Your surroundings as viewed through the camera display should appear cold and bluish, and your model is likely to appear hypothermic. Take a test photo anyway as this will be useful as reference against the next sample photograph.

6 We need to change the camera's white balance to the correct preset for outdoors, so open the camera menu again and select either the Sun or Cloud symbol depending on the weather conditions.

7

7 Immediately you should see the camera's display revert to a much more natural representation of the environment around you. By correctly specifying the lighting conditions your images record the right colours and skin tones appear more accurate.

3

▶

Use preset white balances (cont.)

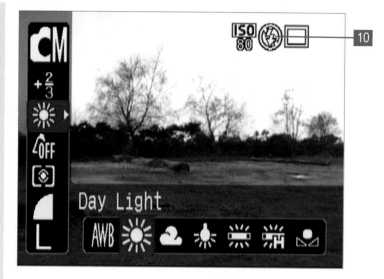

8 Take a quick test image and switch the camera into Playback, then use the four-way navigation pad to compare this photo with the previous one. Despite the exposure settings remaining identical, by just using the correct white balance the images should be worlds apart.

9 Now we are going to reverse this experiment and move indoors – again if there is someone around to be photographed that will be very useful.

10 We left the camera set for either Sun or Cloudy so we will try taking the incorrectly set white balance shot first. These images need to be lit by your household lighting and not your camera's flash, so we must disable the built-in flash.

11 Press the lightning rod symbol and select the option to disable the flash.

Timesaver tip

Your camera's auto white balance can get you through most situations but if you manually select Tungsten when shooting under a bulb you will see the biggest improvement.

130

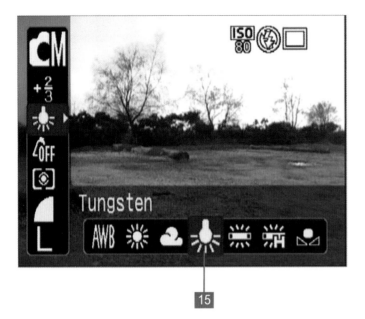

Use preset white balances (cont.)

12 One of the first things you will notice is the addition to the camera's display, of a shaking hand symbol. Your camera isn't sensing movement, it is just warning you that there is very little available light and as a result your photos may come out blurred.

13 To lower the likelihood of blurred photos, try increasing the camera's ISO to 400 or higher to speed up the shutter. Remember also, to squeeze the shutter release gently.

14 Next take a test shot. This photo should have a strong orange tint to it and your model is likely to look like an oversized tangerine.

15 Obviously we need to correct this, so dip back into the white balance presets and once again select the light bulb symbol, as a result of this change the display will revert to much more natural colours. Now when you take your photo the room and your model will look as they should.

Use the histogram ▶

Live Histogram

1 We will first look at live histograms. Assuming it has one, activate your camera's live histogram by repeatedly pressing the display button until the moving mountain range pops onto the screen. On the current crop of digital compacts, the histogram will typically be a combined RGB one. This means all the colour information is shown in one wave. Some high-end cameras however, go a stage further and show each colour separately.

2 You will notice as you move the camera, the mountain range undulates, swaying from left to right as the view gets darker and lighter respectively.

3 Typically the histogram is split into five segments representing from left to right, very dark (shadow detail), dark, mid (18% grey), light, and finally highlights.

Of all the new technologies and advances digital photography offers over conventional film photography, the most daunting for newcomers must be the histogram. Even on playback, the static hills and troughs of a full RGB reading can seem as incomprehensible as a logarithm workbook. Add to that the live histograms available on many modern digital compacts and the cluttered display is more likely to resemble the backdrop to a budget Sci-Fi movie, than a point and shoot camera. While histograms might appear inaccessible they're perhaps the most powerful part of your photographic arsenal. This is because your camera, or more specifically the camera's display, has a nasty habit of lying to you. It's nothing personal, but big bright displays sell cameras, and accuracy isn't much of a selling point, yet. Results from a histogram are more cut and dried. In this task you will learn how to interpret a histogram and understand how reading the peaks can help you get the best exposures.

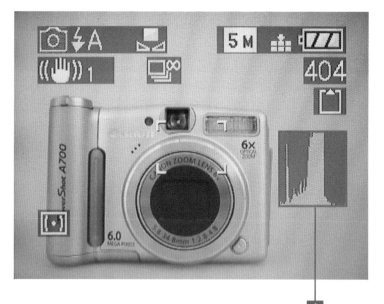

▶

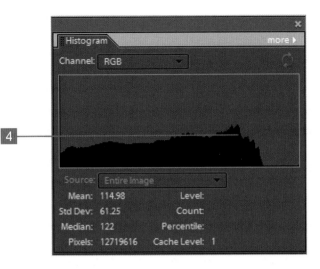

Channel: RGB

Source: Entire Image
Mean: 114.98 Level:
Std Dev: 61.25 Count:
Median: 122 Percentile:
Pixels: 12719616 Cache Level: 1

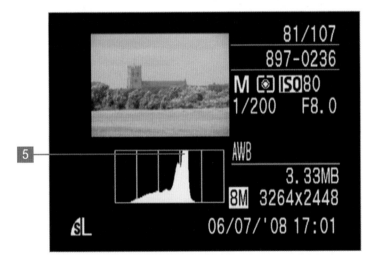

4 Before taking your photo check the peaks. If the histogram shows the curve peaking in the segment to the far left it's likely to be underexposed, conversely if there's a peak in the far right it's probably rather overexposed. To be fair, with these extremes the image would probably have tipped you off to this already.

5 Try framing up a couple of standard shots, perhaps a portrait or landscape, and keep your eye on the histogram – the top of the main peak will settle between the third and fourth segment. Take a few test shots and play them back on the camera's display, again they will appear well exposed.

6 Transfer these photos to your computer and ask yourself, are you still happy with the results or could they do with being just a little brighter? It's a fair guess you would be happier with them a bit brighter.

3

Use the histogram (cont.)

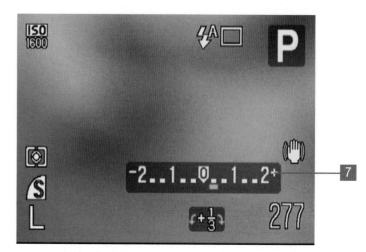

7 Repeat the same shots, but this time as well as using the live histogram use the camera's exposure compensation feature. Keeping your eye on the histogram's movement adjust the amount of additional exposure until the main peak of the histogram hovers somewhere between the fourth and fifth segment. Remember that the slope shouldn't bunch up at the right edge as this means you are losing the highlights.

8 These images may initially appear over-exposed on the camera's built-in display. Nevertheless, persevere and compare them to the previous batch on your computer – which do you prefer? In most instances, digital cameras intentionally underexpose their photo by around -0.3 EV. This reduces the chance of over-exposure but by tweaking this value your colours can become punchier.

Playback histogram

1. Without a live histogram you can still make good use of the information provided. However, you will find the process requires a little more patience and experimentation.

2. Compose some typical shots to familiarize yourself with the camera's metering, for example, a group, portrait or landscape and then take a couple of shots.

3. Once you have your test images, switch the camera into Playback mode and press the display button until the histogram information is revealed. If the histogram shows the curve peaking in the segment to the far left it's likely to be under-exposed, conversely if there's a peak in the far right it's probably rather over-exposed.

3

Use the
histogram (cont.)

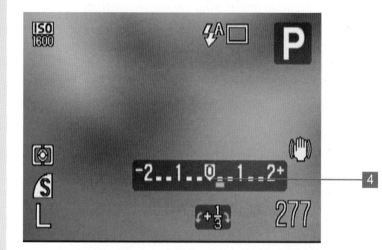

4 Depending on the location of the main peak, try altering the exposure compensation one step at a time to move the peak into the fourth segment. There is no such thing as a perfect histogram so this obviously won't work for every shot but getting used to the way your camera reacts will stand you in good stead when it comes to tweaking it for the best results.

All digital cameras allow you the flexibility to choose the quality level your photos are captured at. Whether this is presented simply as low, medium and high, or shown in actual megapixels, you can control the trade off between quality and memory space, choosing lower quality options for everyday snaps and higher settings for more important events in your life. If, however, the image needs to be the best your camera can record, check to see if your camera is equipped with RAW mode. In RAW mode, the image is recorded without being processed at all. No processing means no compression and as a result no loss in image quality, but it also means the image takes up a lot of space on your memory card. For example, an eight megapixel camera might offer approximately 400 photos on its top JPEG setting and only 100 on RAW. That said, memory cards are much cheaper now, so it raises the question, why doesn't everyone use RAW all the time instead of JPEG? As RAW image files are completely unprocessed, you can quickly correct the white balance of an image or tweak a photo's sharpening. However, this is all quite time consuming and means additional steps are required for perfectly exposed images: not a problem when you're shooting a handful but it could be arduous if you have to slog through hundreds. In this task you'll learn how to shoot in RAW and consider which situations might merit the additional quality and flexibility.

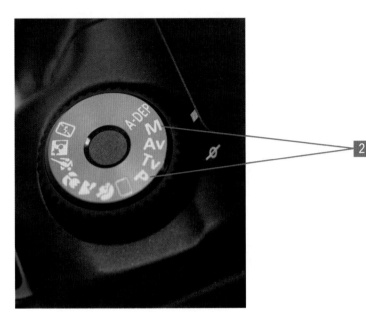

Shoot in RAW

1 To decide if your image would benefit from using RAW, look at your subject and if it has very dark elements alongside very bright ones then switching the camera into RAW is well advised. You can select RAW for any photos, however, remember the trade-off between space and quality.

2 To put the camera into RAW mode, first switch it to P, S or M depending on your preference. The reason for this is that normally the ability to use RAW is disabled in full automatic.

3 Next access the camera's settings by pressing the Menu button.

Shoot in RAW (cont.)

4 Look through the camera's menu until you find the image quality setting, on some cameras this will have a stepped or smooth curve next to it, or the words Norm or Fine to indicate the current quality of the compression.

5 Select the image quality setting and move through the available options until you find the setting for RAW. Press OK to confirm your selection.

6 The camera is now ready to take your photo. Once you have captured your images you can still review the image on the camera's built-in display. However, you currently won't be able to print it out or view it on other people's computers. To make this possible, you first need to process your RAW files into a more universal format such as JPEG or TIFF.

Quality	Large
Red-eye on/off	Large
AEB	Medium
WB-BKT	Medium
Beep	Small
Custom WB	Small
Color temp.	▶RAW

Jargon buster

Megapixel – digital cameras record the light coming into the lens on a sensor, or CCD (charge-coupled device), made up of thousands of individual receptors known as photosites or pixels. A megapixel is one million pixels – modern cameras are typically measured in six to eight megapixels. While it is true that the more megapixels the bigger the image is, it doesn't directly relate to quality.

Type: cr2_auto_file
Size: 10.1 MB
Date modified: 13/06/2008 13:22

7 Next use your flash card reader or USB cable to connect up your camera as you would normally do and open the RAW converter package. At this stage the files will have unfamiliar file extensions, where a JPEG would end '.jpg' or a TIFF '.tif', the RAW files are different depending on the manufacturer of the camera, for example Canon use 'CR2' and Nikon 'NEF'.

8 Every package is different, however, you simply need to select your RAW images and use the available tools to adjust the image settings until you are happy with the results. Most RAW converters allow you to make alterations to the photo's brightness and contrast, as well as the white balance. By being able to adjust the white balance in the RAW converter after the image has been taken, it becomes much easier to correct for any unusual colour casts brought about by lighting.

3

▶

Advanced techniques to improve your shots 139

Shoot in RAW
(cont.)

9 Once you have the desired appearance, you then need to choose the option for outputting the files. This is normally to JPEG but if you intend to submit the images to a publication or image library you may choose to select TIFF.

10 These outputted files can then be treated in the same way as your standard photos and be printed or edited. The RAW files, however, will remain untouched and can be used repeatedly to produce more copies with no loss in quality.

Selecting the best RAW Converter

If your camera offers a RAW mode, you'll find software supplied to allow you to manipulate it. By rights you would imagine this represents the best program to use but this isn't always the case. The range of RAW converters out there is very diverse and each package claims to give better results than the others, using better, more advanced, systems to handle your raw files' unprocessed original data. Using different packages does indeed produce a variety of results and some packages seem to have the edge, retaining more of the detail in very bright and very dark areas. With the latest RAW converters, apart from just simply processing the raw data, the more advanced packages also take account of the lens being used and automatically correct for any inherent issues such as the edges of the image being barrelled. Ultimately, don't stick with just the original software, try experimenting with some other packages – after all, they all provide trial versions.

RAW converter

4

Touching up images

Introduction

Trick photography was once the realm of only the most skilled photographers or talented developers. With the advent of digital photography, however, the necessary skills to tinker with every aspect of an image are now easily within your reach. In this chapter you'll take on tasks that range from simple everyday adjustments, such as correcting an image's exposure, removing unwanted colour tints and removing red eye, right through to more adventurous exercises that have you reproducing your own trick photography by adding or removing elements of a digital image. If you haven't yet purchased a photo editing package, don't worry. We even cover suggestions on suitable software, catering for a range of budgets.

4

What you'll do

Pick the right tool for the job

Learn about layers

Remove red eye

Adjust exposure

Convert colour photos to black and white

Create colour accents

Correct colour cast

Sharpen your shots

Control digital noise

Level uneven horizons

Add soft focus

Create a perfect panorama

Create high dynamic range images

Selectively dodge and burn an image

Add and remove elements (even people)

Restore damaged prints

Perfect your group photos

Crop your photos ready for print

Experiment with vignettes

Add frames to images

Pick the right tool for the job

Realizing a good print from a film camera could be as simple or complex as you wanted it to be. If you wanted a faithful reproduction of your holiday snaps, a visit to any 1 hour photo booth would soon have the prints in your hands. If you had your own home studio you could even be hands on, dodging, burning and cropping your images to get the print exactly how you wanted it. The same is true of digital photography. If you just want the photos from your last vacation, you can eject the memory card and head straight for your nearest photo developer. However, in this chapter you'll learn some easy techniques that could have you doing everything from pre-cropping your photos to creating panoramas, and even restoring your old prints. Before you can delve into digitally reinventing your images you need to find the right tool for the job.

Depending on your budget there is something for everyone. If you spent every last penny on your camera then rest easy, our first suggestion is the curiously named free application, 'Gimp' (Graphic and Image Manipulation Program). Gimp offers a wealth of photo editing features and is trumpeted by many as a rival to the industry standard, Adobe Photoshop. Be warned, it might take a little getting used to as its multiple windows don't make it the most intuitive package ever designed. But, as the saying goes, you get what you pay for. Besides, if you don't like it, what have you lost? Just the time it took to download the program.

For many, Photoshop is a verb rather than a product. However, Adobe's Photoshop CS3 is squarely aimed at a professional market and costs in excess of £500. Thankfully, Adobe recognizes this is well outside the price range of many enthusiasts, and has tailored a variation of the package for those with a more modest budget. Adobe Photoshop Elements 6 leverages the power of the professional tool in a way that beginners and more experienced users can pick up quickly, without being so trimmed down it limits functionality. In this book we will concentrate many of our tasks on Photoshop Elements 6, as it will teach you skills that can be translated to the full-blown Creative Suite.

Pick the right tool for the job (cont.)

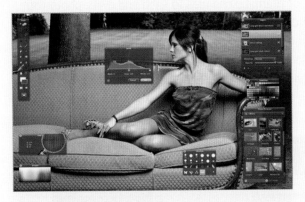

As with any other business there are always new upstarts that challenge the market leaders, forcing everyone to improve and innovate. Apple Mac owners have recently enjoyed several new applications, the most promising of which is Pixelmator. Already on version 1.2.1 at the time of writing, this package boasts exceptional results at blistering speed. The stripped down menu lets you use the entire display for editing, with tool windows only popping into view when you need them. Whether Pixelmator will steal much, if any, of Photoshop's market share remains to be seen, but more choice is always a good thing.

Finally, there's a new category of applications designed to manage your photo workflow. Although aimed more at the professional photographer they could be equally appealing to enthusiasts. The two market leaders are Adobe's Lightroom and Apple's Aperture. These packages combine the management of your photo library with a powerful set of photo editing tools, making it possible to automate many of the typical image editing tasks, such as altering exposures or removing red eye.

4

Learn about layers

When you hear the term layers being used to describe editing photographs, try to imagine building a photomontage with cuttings from a magazine. Each piece is separate and can be moved, rotated, resized or removed completely independently. In the context of your own photos this means you can choose to make subtle or dramatic changes to each and every photo you capture, without ever running the risk of making destructive changes to the original image. Even the order in which you choose to stack the layers can allow you creative control. This task will familiarize you with the concept of layers and ensure you learn the safest way to manipulate your own photos.

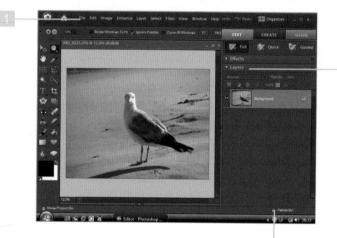

1 To start, open the photo by selecting the File menu and clicking on the Open option. From here, navigate to the folder where your photograph is stored; you should see all of the photos as small thumbnail images making it easier to find the image you're after. Select the file and press the Open button. Photoshop Elements will now open your file, fitting the window to your screen.

2 Next we need to ensure the Palette Bin is open. If it isn't already open you should see a tab in the bottom right corner which allows the bin to be toggled open and closed.

3 When the Palette Bin is open it should appear as a bar on the right side of the display, split into four sections: Effects, Layers, Content and finally Favourites. Each of these sections can be expanded or hidden by clicking on the arrow to the left of the section title.

4 Open Layers by clicking on the arrow. You should see a grey bar entitled Background – this is the image you have opened to work on. On the left of the background layer is an eye; on the right is a padlock. The eye normally acts as a way of switching the visibility of a layer on and off. However, when combined with the lock this feature isn't available

5 Right click on the background layer and from the submenu select Duplicate Layer. This will open a new window allowing you to name the new copy; by default it is named Background copy. For more complex projects it can be useful to give additional layers names that specify their function or identify the area being altered but, for this example, we'll use the default.

Learn about layers (cont.)

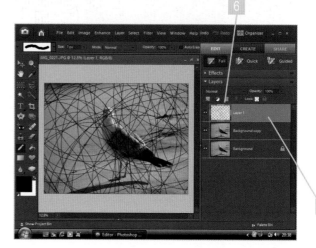

6 This creates a duplicate layer over the background. Now, still in the Layers section of the Palette Bin, you should see six icons just above the new background copy: a curled page, a half-moon, a rubbish bin, a chain, a chequered board and a second lock. These icons represent the actions of creating a new layer, creating an adjustment layer, deleting a layer, linking layers, locking the transparent pixel and locking everything. For this task, click on the curled page to create a new layer, which will automatically be named Layer 1.

7 Now there are three layers, try left clicking on each layer to switch the focus back and forth. At any time the layer that is being worked on will be highlighted in grey. Click on Layer 1 and, with the pencil symbol selected from the toolbar, scribble on the image. Don't worry, your photo is safe!

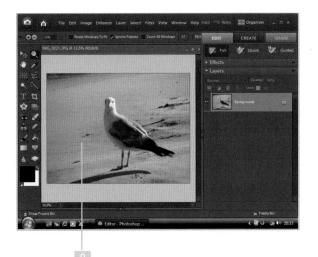

8 Next try reordering the layers by clicking and holding the left mouse button whilst you drag Layer 1 between the Background copy and the original Background. The scribble will appear to have been removed, but it's simply hidden under the top layer.

9 Try clicking the eye to the left of the Background copy to turn the layer off and on. Each of the layers shows an eye next to it, however only the original background retains the padlock icon. If you try and reorder the background, you'll notice that it's locked and cannot be moved.

10 By learning to use layers when making changes or edits, the original image can remain safe as the background and any alterations can be turned off and on as easily as clicking the eye symbol. When you're happy with your improvements, save the Photoshop Elements file first, as your archive. Then save a copy as a JPEG, to get any prints done. JPEG files are easy for developers to print from, but discard any layer information. So, just like your negatives, it is vital not to lose your original Photoshop Elements file.

Remove red eye

It's a fact of flash photography that when you photograph people at night you run the risk of getting photos back with some of your subjects looking like extras from the cast of *The Omen*. Manufacturers have tried clever techniques that strobe the flash before actually taking the photo but this only works if your subject's eyes react as predicted and contract, which tends not to happen when the people you're photographing are either excited children or ever-so-slightly tipsy adults. More recently, digital cameras have tried a different way of eliminating red eye, by using clever software that looks for human features then when it recognizes the characteristic colours of the eye's retina effectively airbrushes out the offending element. However, even this doesn't catch everything. In this task we will look at the tools provided by Adobe Photoshop Elements to ensure our images only capture the red eyes of sleepless nights and not flashes.

1 Start by opening the photo by selecting the File menu and clicking on the Open option. From here, navigate to the folder where your photograph is stored and finally select the file and press the Open button. Photoshop Elements will now open your file, fitting the window to your screen.

2 Choose the Zoom tool, which can be identified by its icon, which resembles a magnifying glass.

3 Move the mouse cursor to the region of the photograph that requires correction and use the left mouse button to zoom in and enlarge the subject area. Repeat the left-click action until the subject's eyes are clearly visible.

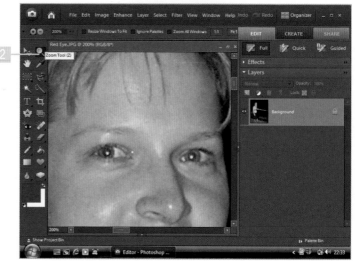

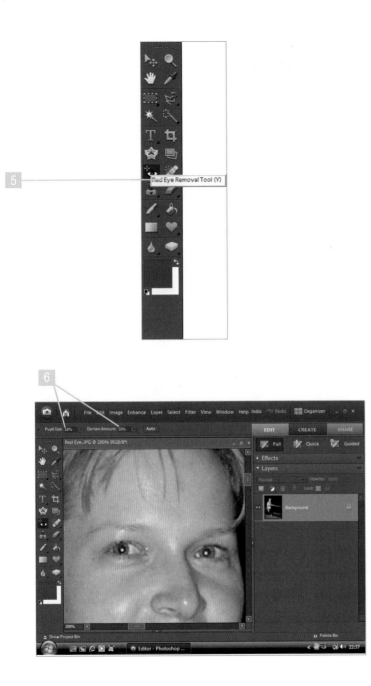

4 If you zoom in too far then hold down the Alt key on your keyboard and press the left mouse button again, so that you zoom out a step.

5 The red eye correction tool should be on the left hand side of the vertical toolbar, represented by a single red eye with a cross next to it. Select the Red Eye Tool, and the cursor will switch to a simple cross-hair when moved over the photo.

6 Along the top of the window the toolbar will change to reveal the Pupil Size and Darken Amount options, both of which will be set to their default values of 50%. These settings will be fine with the majority of photographs, but close-up shots such as portraits may require some adjustment.

4

Remove red eye (cont.)

7 Move the cross-hair over the eye and, with the left mouse button, click once in the pupil of the eye. Photoshop Elements will automatically detect the area that needs adjusting and correct the colour according to the settings you have selected.

8 If the correction fails to eliminate the red eye, or the selected area was incorrect, reverse the process by using CTRL + Z or open the History tab found under Window, Undo History. This allows you to select the action prior to the red eye correction and use the red eye reduction tool again. Try varying the selected region, darkness and pupil size to produce a natural-looking effect.

9 Repeat the process with each eye that requires correction. Remember to restore the settings for darkness and pupil size between subjects in the image.

Realizing the image in your mind's eye doesn't always go smoothly, and as you begin to practise with some more advanced techniques, you're likely to get one or two photos that fall just short of the perfect exposure. Don't let these setbacks dissuade you though. As with so much of life there's no short cut to experience. One of the key advantages of digital over film is the immediacy, the instant feedback of the display, which allows you the freedom to experiment. If you get home and still find your image is too bright or too dark, both can be tweaked to bring the photo closer to your original aims. In this task you will learn how to use Adobe Photoshop Elements to adjust the exposure of your images and save an otherwise good photo from the recycle bin.

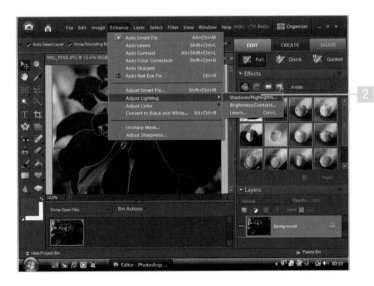

1 Open the photo by selecting the File menu and clicking on Open. Navigate to the folder where your photograph is stored and finally select the file and press Open. Photoshop Elements will now open your file, fitting the window to your screen.

2 Photoshop Elements has many tools which can adjust exposure, including Brightness/Contrast and a dedicated Levels setting, favoured by those who come from a photography background. However a simpler but more effective option exists in the Shadows/Highlights menu. Select the Enhance menu option from the top bar and hover the mouse over the Adjust Lighting option. Select Shadows/Highlights.

3 Shadows/Highlights can be very effective at illuminating dark backgrounds or correcting for a small amount of over-exposure.

4

Adjust exposure (cont.)

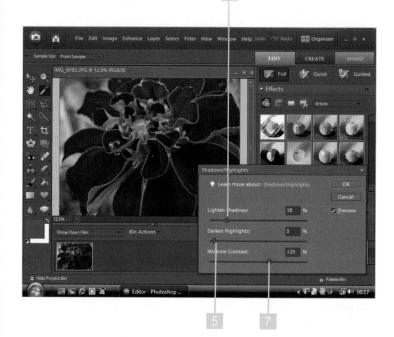

4 To brighten darker elements of the photograph, use the top slider, labelled Lighten Shadows, moving it to the right. You will notice how this only affects the darkest regions of the image.

5 Conversely, the highlights – which are the brightest aspects of the image – can be adjusted using the Darken Highlights slider.

6 Try to use these options sparingly as over-use will drain out all the contrast and flatten the dynamic range of your image.

7 If the corrected regions of your photograph lack punch, become flat or, conversely, the contrast is too harsh, the final slider Midtone Contrast can remedy the problems. By moving the slider to the right, relative contrast of the adjusted regions will increase. Moving the slider to the left will decrease contrast.

8 Try experimenting with these options to produce a properly exposed and balanced composition.

Did you know?

A good example of where this tool can be very effective is returning details to an over-exposed wedding dress.

Adjust exposure (cont.)

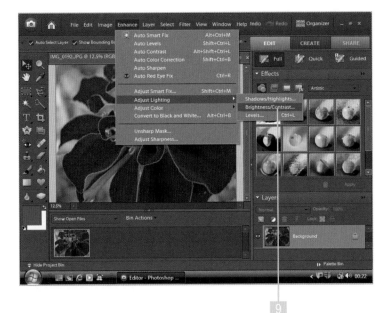

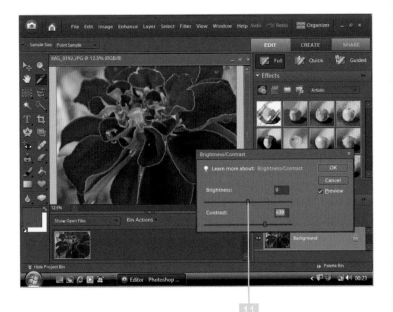

9 If you capture a really special moment, but later find the camera had been switched to the wrong mode, or you simply didn't judge the lighting correctly you'll likely need more latitude for adjustment. Instead of Shadows/Highlights, this time select Brightness/Contrast from the Enhance menu.

10 You will be presented with a similar set of sliders labelled, intuitively, Brightness and Contrast. However, this time each control works across the whole image rather than specifically targeting highlights or shadows.

11 Try increasing the brightness of your image by moving the slider to the right. You can compare the effect quickly by checking and un-checking the Preview box. When you're happy the image is as you intended it, you can press OK.

12 What this menu lacks in refinement it makes up for in brute force; even with an exceptionally dark exposure the image can be brought into the light. Be aware though that under-exposed images pushed back in this way will start to exhibit lots of digital noise.

See also

We'll look at reducing the effect of noise in the Control digital noise task later in this chapter on page 177.

Convert colour photos to black and white

Becoming passionate about photography has the effect of changing the way you look at the world. Before long, you'll find yourself admiring the shape and form of objects and the way light plays off reflective surfaces. Sometimes the contrast between shadow and light can be more engaging than the palette of colours in the scene. If you find it difficult to visualize the use of black and white, you can force many digital cameras to record the image in monochrome at the time of capture. But why limit your options when it's easier to stick with colour and convert your pictures in a photo editing package when you get back home. In this task you get hands on with several simple techniques that effortlessly convert colour images into striking black and white stills. The only prerequisite for this task is Adobe Photoshop Elements and a colour photo to experiment with.

1 In this task we will look at three different approaches to converting your sample image to black and white. At the end of each method you can either close the image and reopen it or simply click on the first step in the History panel as this will completely restore the image to its original state.

2 First we will look at the most basic approach. To use this method, first click on the Image option on the menu bar.

3 Next select Mode from the drop-down menu – this will offer numerous options including Grayscale. You need to select this, which will then open a small dialogue box that asks if you want to discard the colour information.

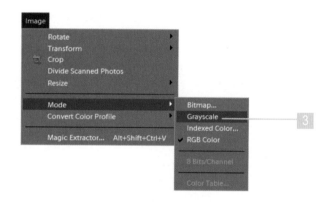

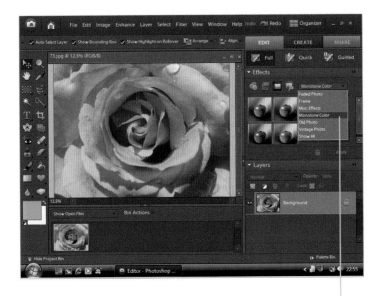

4 Press OK to proceed and you will be returned to your image, now converted to black and white. However it's important to note that switching the image to Grayscale means you can't add any colour back into it – so if you were going to add accent colours on a bouquet, for example, all of your paints will come out a shade of grey.

5 This brings us to our first preferred alternative. This time we open Photoshop Elements Palette Bin, which contains four sections: Effects, Layers, Content and Favourites. In this task we will look at Effects. When you first open the Effects section in the Palette Bin it will default to the Artistic selection, giving you a grid of thumbnail images depicting each effect.

6 To locate the black and white effect, click on the third icon, labelled Photo Effects. When the range of effects has changed, click on the arrow next to Faded Photo and select Monotone Colour from the drop-down menu.

Convert colour photos to black and white (cont.)

7 You w
a num
mono
Cyand
(brow
conve
settin
proce
way is
have
image
More
Eleme
the m
the to
a laye
alway
colou
Grays

8 The f
great
over
origii
infor
more
textu
white
you
back
is go
editii

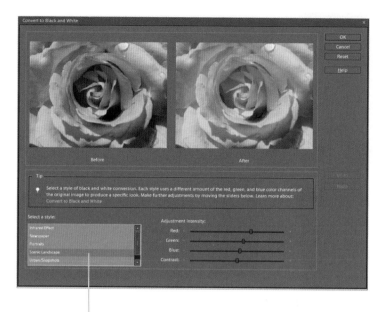

12 This will open a comprehensive menu providing a preview of your black and white image as 'before' and 'after'. This tool offers you a variety of preset styles, such as Newspaper, Infrared effect or Landscape, each with their own characteristics. Try selecting a number of them to see if the 'after' image represents the effect you're looking for.

13 To the right of the preset styles are four sliders that allow you to individually adjust the strength of the primary colours in the image, as well as altering the amount of contrast in your photo. This level of control gives you the freedom to experiment and ensures you can make your black and white photos eye-catching.

14 By clicking OK, the monochrome image is returned to Photoshop Elements. However, it should be noted that the photo is being handled as a full colour image and can still have colour added to it, should you want to include any finishing touches.

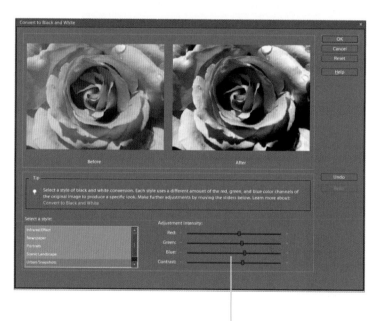

While traditional black and white images have a timeless quality about them, the advent of digital photography lets you really unleash your imagination and in this task you'll learn a more creative approach. By selectively retaining the colour on key parts of an image, it's possible to emphasize the picture's meaning or draw the viewer's eye to your intended subject. This technique is popularly employed in wedding photography and it's often used to great effect for moments such as throwing the confetti or bouquet. However, there is no reason why it can't be used inventively for group shots or portraits. Adobe's Photoshop Elements makes creating colour accents straightforward, employing layers to create the effect so you can quickly decide if the results are what you want and literally switch them on or off, leaving you to experiment safe in the knowledge your original photos aren't being altered.

1. Begin by opening the image you have decided to alter by adding a colour accent. Click File from the top menu bar, then, from the drop-down menu, select Open. This will open a new window that allows you to navigate to the file.

2. The image will open in the main window. For this task we will need the Palette Bin open; if it's not already available, open the Palette Bin by clicking in the bottom right of the window and toggle the panel open. When you have the Palette Bin visible you will see four sections. Ensure the Layers section is open. Effects, Content and Favourites can all be closed to make the workspace less cluttered.

3. In the Layers section, you should start with just one layer containing your chosen photo. This will be bookended by the symbol of an eye, to indicate that it is visible, and a padlock, as it's a background and by default a locked element. To achieve the colour accent effect a duplicate layer is required. Right click on the Background layer to open the submenu and click on Duplicate Layer.

Touching up images 161

Create colour accents (cont.)

4 Requesting a new duplicate layer will open a new window that asks you to name the copy. By default the layer will be named Background copy. For this task we will leave it with the standard name, however it can be very useful when working with complex projects to give more descriptive names to your layers.

5 Once you press OK you will be dropped back into the main screen. You can now use the zoom tool to magnify the specific areas of the image you want to retain their colours. If you get too close to any areas, simply press and hold the ALT key as you use the Zoom tool. This will have the effect of pulling away from the image.

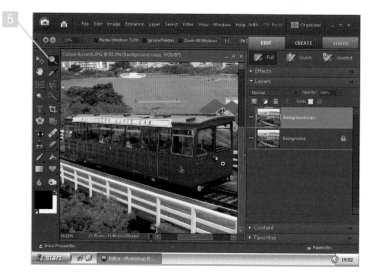

6 Next we need to use the Quick selection tool, found on the left hand toolbar and represented by a wand with a dotted circle behind it. The Quick selection tool works by automatically finding the edges of colours or areas of high contrast, making it easier to select the areas of an image that need any given

▶

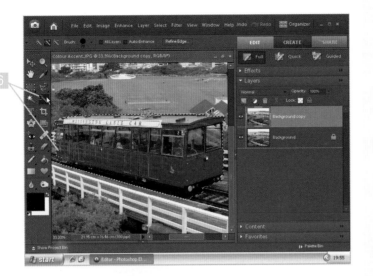

effect or filter applied to them. For this task you need to use the selection tool to mark the areas you wish to keep coloured.

7 You don't need to get too concerned with fine details at this stage. However, if large areas you don't want get accidentally included in the selection, don't give up and start again. If you press and hold the ALT button, the Quick selection tool switches from adding to removing, giving you the opportunity to refine your selected area quickly and easily.

8 Once you've got the area you want to keep coloured marked out, go to the top menu bar and click on Select, opening a drop-down menu. Click on one of the first options at the top of this menu, Inverse. This command swaps your selected area with the rest of the image, making it easy to drain out the colour from everything apart from the elements you wanted to retain.

Create colour
accents (cont.)

9　Now we need to employ an
adjustment layer. Click Layer on
the top menu bar and from the
drop-down menu navigate
down to New Adjustment
Layer. Hovering over New
Adjustment Layer will open
another submenu with eight
options. This same menu can
be used for any number of
effects. For this task we need
Hue/Saturation.

10　When you click Hue/Saturation
you will be presented with a
new window requesting a
name for the adjustment layer.
For the purpose of this task we
will leave this at the default and
press OK.

11　When you press OK another
window will open. This new
menu offers three sliders that
control Hue, Saturation and
Lightness. Just above these
three controls you will notice a
drop-down menu set to Master.
This option provides you with
the ability to single out a
particular colour to affect.
Ensure this drop-down is set to
the default setting of Master
and turn the saturation slider
down to zero, then press OK.

12 You will notice in the Layers tab there is now a third layer at the top of the stack, with an adjustment icon chained to a silhouette of the area you selected. By clicking on the adjustment icon you can go back at any time and make adjustments to the saturation. More importantly, if you notice any areas needing adjustment you can select the silhouette attached to the adjustment layer and use the Brush tool to make fine changes.

13 When the silhouette, known as a mask, is being edited the Brush tool only has two colours available, black and white. This is because you can only add or subtract from the mask. As a good tip you can switch between the two states by simply pressing X on the keyboard. Combine this with the keyboard shortcuts [and] that control the brush size and you can quickly work around the fine details of the image, creating a striking colour accent photograph.

4

Correct colour cast

1. To start with we need to find a photo with inaccurate colours. You are most likely to find this when taking photos indoors as a digital camera may struggle with incandescent or tungsten bulb lighting.

2. When examining your photos for a colour cast, always trust your first reaction to the photo as your brain will quickly compensate for any shift in colour and you will find yourself thinking even the most jaundiced of photos looks fine.

3. Once you have your test image, open it into Photoshop Elements. As with just about everything else in Elements there are several ways to approach correcting colour issues and we will look at three of the most popular ones. You can, of course, use the Auto Level or Auto Colour correction commands but these automated choices often fall short of the ideal results so, for this task, we'll try some more hands-on methods.

Switching away from the fully automatic mode of a digital camera gives you far more creative control, and allows you to really get the best from your camera. However, it does have its own pitfalls and if, for example, you forget to reset the settings before your next outing, you can find you've taken a whole day's photography on the wrong settings. Some mistakes are worse than others but manually selecting the wrong white balance needn't ruin great photos. In this task we will look at correcting colour casts using Adobe Photoshop Elements. Professional photographers ensure their prints have accurate colour rendition by calibrating the colours reproduced by their computer display and their printer, and anyone can buy a calibration scanner tool for under £100. If you would prefer not to outlay on specialists tools, you should set your display to use a preset colour temperature. Ideally opt for 6500K, where K stands for Kelvin, the scale used to describe colour temperature. In simple terms, higher numbers, such as 9200K, give a cooler appearance to a photograph and lower values give a warmer look. In this task you'll be introduced to several tools within Adobe Photoshop Elements, each of which takes a different approach to removing unwanted colour casts from your digital images. It's up to you which technique you prefer, but give them all a try.

4 The first method uses a series of thumbnails, each previewing slight changes to the image – this tool is called Variations.

5 To bring the Variation menu up you must first click on Enhance on the menu bar, this will open up a drop-down submenu.

6 On this drop-down menu, move the cursor over the Adjust Colour option, which will bring up yet another submenu on which you will find the Colour Variations command.

7 Variation typically displays six images which have each been adjusted slightly – each of them giving you a preview of a different colour tint. Also on the Variations menu is a separate control that shows both a lighter and darker version of the image should you need to adjust the exposure as well.

Correct colour cast (cont.)

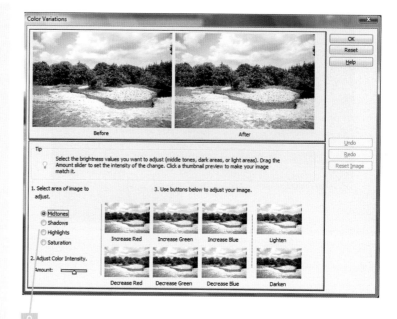

8 You will notice that any changes you make only seem to affect the mid-tone colours – as with many of the tools in Photoshop Elements, shadows, mid-tones and highlights are separated, allowing them to be adjusted individually.

9 To switch between the tonal ranges you want to adjust, move to the left of the menu where you will find controls to toggle between shadow, mid-tones, highlights and saturation. The Variation tool is a good starting point but despite the visual representation of your photo, it can often be very difficult to determine which, if any, changes are appropriate.

10 When you have made your adjustments to the test image you can either press first step on the History tab to restore the photo to its original colours or simply close the image without saving and then reopen it.

11 The Variations tool approaches colour correction by altering the image as a whole, but there is a much

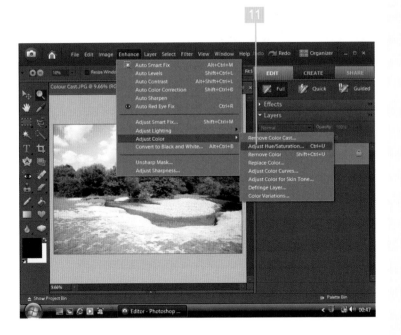

Correct colour cast (cont.)

more targeted solution. Adjust Hue/Saturation allows for specific colours to be adjusted without impacting the rest of the photo. Aside from allowing you to change familiar objects or people into weird alien colours, this tool can be used to remove unwanted tints from a photo.

12 To open the tool, click on the Enhance option on the menu bar. As before, move the cursor down to Adjust Colour, but this time select Adjust Hue/Saturation. This new menu offers three sliders that control Hue, Saturation and Lightness.

13 Underneath these sliders are two colourful bars that allow you to control the range of colour that is affected. When you first open this window, Photoshop Elements defaults to the Master setting. In this mode, Adjust Hue/Saturation alters all the colours as one; to remove a colour cast you need to select the colour you wish to eliminate from the drop-down menu. In this example we will select Green.

Touching up images 169

Correct colour cast (cont.)

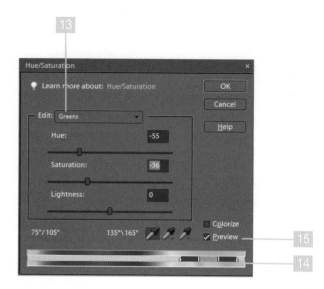

14 Sandwiched between the two bars you will now see a pair of bookends that mark the start and end of the colours you are about to adjust. To increase or reduce the range of colours you want to adjust you simply drag the bookends back and forth.

15 You can now adjust the Hue bar to remove any colour cast. It's also worth adjusting the Saturation slider, as this will often be a very effective way to remove any tints. Remember to work quickly when correcting colour, and try switching the Preview on and off, otherwise your brain will trick you into accepting the skewed colour as natural.

16 Once again, when you have achieved the desired colour balance, reset the image as in Step 10.

17 The last option for adjusting colour cast comes in the shape of the Levels control, easily one of the most powerful aspects of Photoshop Elements' arsenal but also, initially, one of the hardest to use. To access the Levels control, first click on Enhance, then, as before, move to Adjust Lighting before selecting Levels from the submenu.

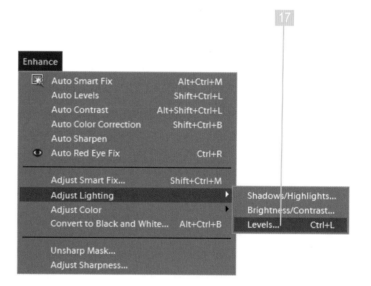

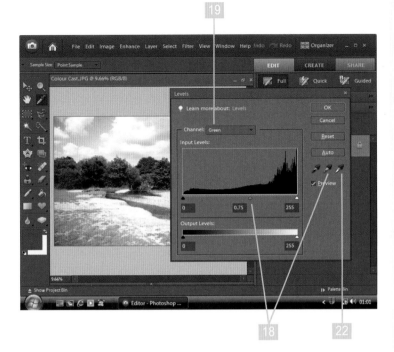

Correct colour cast (cont.)

18 The Levels menu defaults to showing the RGB combined values with a detailed histogram underneath. Directly beneath that are three arrows in black, grey and white. Also in black, grey and white are the droppers on the right of this small menu. These arrows and droppers are linked with the black, 18% grey and white points.

19 Levels adjustments can be made on colour channels individually, or all together. To select an individual colour channel, press the arrow to the right of the channel menu. This will provide four choices, each primary colour along with the combined RGB. For this task select Green.

20 You will notice that with just green selected, the histogram changes shape. This is because it now shows a breakdown of just the green in the photo. To reduce that, move the grey mid-point marker to the right, to increase it, slide the arrow to the left. This can be done on any of the colours to correct for unwanted tints.

4

Correct colour cast (cont.)

21 By combining the three channels you can also alter the image's brightness or contrast.

22 Lastly the droppers we mentioned before can be used not only to remove any colour cast instantly but also to change the brightness of the photo. It takes some practice, but if you select the grey dropper and click on what you believe to be grey on the photo, Photoshop Elements will use this new mid-point information to redraw the whole photo. This often produces excellent results, but you need to be careful what you select as grey – get it wrong and your image is likely to go some very funny colours.

22

Part of what engages so many people with photography is the ability to lock in so much detail. You might just intend to capture an event or record a celebration, but the details frozen in the periphery can be just as fascinating and charming. When digital cameras first hit the high street their early sensors were a poor cousin to film and they could only see around one megapixel. They were typically equipped with only basic plastic lenses, limiting the detail they were able to commit to a photo. The latest generation of digital cameras possess impressive specifications, such as ten or more megapixel sensors and computer optimized lens designs. This combination of cutting edge sensors and highly crafted optics should allow you to observe the very finest of details in the rolling hills of a landscape shot. However, digital SLRs and high end compacts are often set up to deliver a softer, more neutral image, leaving the photographer to tease out the details. This may seem a backwards step, but 'camera sharpening' can over sharpen the image, leaving artefacts such as unsightly halos around highly contrasting elements. In this task you will learn how to sharpen your photos using Adobe Photoshop Elements.

Jargon buster

Artefact – this term is most commonly used to describe problems attributed to the JPEG compression used by digital cameras. JPEG compression allows many more images to be stored on a memory card than would otherwise be possible, but poor implementation can introduce a stepped appearance to normally smooth lines, or unwanted patches in solid colours.

Sharpen your shots

1 When your camera, regardless of brand or price, takes a picture that isn't set in RAW mode, it will record the information provided by the sensor, then apply adjustments to the colour, sharpness and noise in order to try and present you with the most appealing photo. By default, compact cameras typically employ slightly more sharpening than a DSLR.

2 To adjust the level of sharpness offered by default from your camera you first need to open the camera's Setup menu. Depending on the camera, this can be done in a number of ways: with Nikon compacts it's normally contained within the setup option on the dial; on Canons, you can find the variables under the Menu option.

4

Sharpen your shots (cont.)

3 When you find the image settings the camera will normally be set to +1 or slightly sharper. If you find your photos aren't sharp enough and you don't want the hassle of sharpening your images later, experiment with higher settings. Boosting the contrast slightly will also make them appear sharper.

4 However, by using the camera to sharpen the photos you won't be getting the best results. This is because the brains of your digital camera, while undoubtedly very clever especially considering their diminutive dimensions, aren't as advanced as the algorithms employed by Photoshop Elements on your home computer. By using Photoshop Elements to sharpen the photos later, you can get much more detail from your images.

5 To sharpen your images in Photoshop Elements, first open your photo by clicking File then Open and browse to your photo's location.

For your information

Unsharp Mask

The term Unsharp Mask refers to a tool within modern photo editing packages that is used rather confusingly to actually sharpen the photo. The contradictory name originates from a printing technique that used a slightly blurred positive image combined with the original negative to create the effect that the final print was sharper.

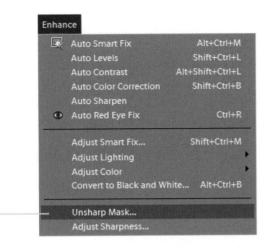

Sharpen your shots (cont.)

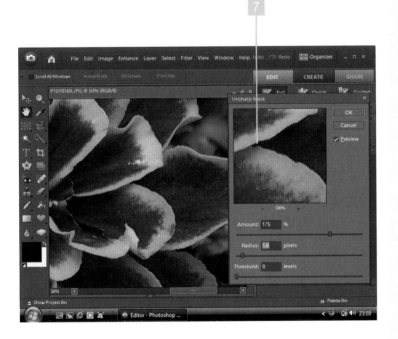

6 Once your photo is open, choose the Enhance option along the top menu bar – this will open a drop-down menu offering a range of choices, Select Unsharp Mask. While it sounds contradictory Unsharp Mask is one of the best tools for applying a subtle sharpening effect.

7 This will open a small menu with a preview window and three sliders to adjust the amount and style of sharpening you're after. The first line is self-explanatory and indicates the amount of sharpening in terms of percentage you wish to apply. This slider normally defaults to 50%.

Sharpen your shots (cont.)

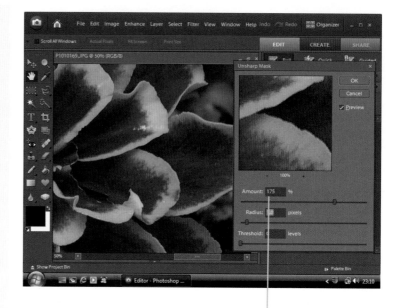

8 The next line is entitled Radius and refers to the area over which the program compares the colour or the pixels. The higher the value the more obvious edges become but at the expense of surface detail.

9 Finally there is the Threshold value which allows you to specify a minimum size of dot in the image to sharpen or ignore and can be useful if, for example, you don't want to accentuate dust on negatives.

10 From here you will have to learn the characteristics of your own camera and adjust the Unsharp Mask until you find a balance that provides plenty of detail without creating telltale halos around markedly contrasting subjects.

11 As recommended starting points, try raising the amount value to 150% and reducing the Radius to 0.3 pixels. The effect should be very subtle but just enough to bring out people's eyes in portraits and hidden details in landscapes.

In the last task you learnt about sharpening your photos, revealing hidden details and the ever-increasing number of megapixels in digital compact cameras. One thing you may not be quite so aware of, however, is the constant trade off between more megapixels and increased noise. When you hear the term 'noise' referred to in the context of photography, it isn't a criticism of the neighbour's poor choice in music or frustration at a camera that beeps like an excited Geiger counter. It actually refers to unwanted speckles or coloured dots appearing in an image, particularly in the darker areas. This noise or fizz in the image is partly a result of electrical interference, and is more common in cameras with higher megapixels. As camera manufacturers add more megapixels they need to control the increase in noise. The most successful brands have invested millions in redesigning sensors from the ground up. However, the more common approach is simply to employ heavy-handed image processing to filter out the noise. Filters of this nature, however, have the effect of softening the image, and can mean the extra megapixels often don't actually deliver any more detail. In this task you will look at controlling digital noise without losing image quality.

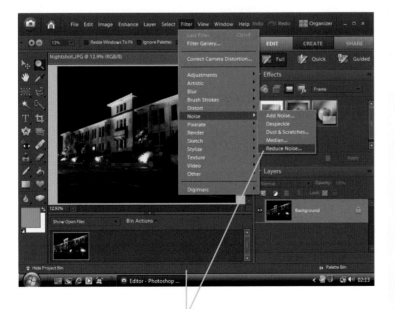

3

Control digital noise

First of all open your test image, preferably choosing an image taken later in the evening. The failing light always presents digital cameras with more of a challenge and the picture is much more likely to show signs of noise.

Photoshop Elements has several different tools for removing noise or in some cases adding it, should the photographer require that, but we are going to use the Reduce Noise, Median and Despeckle filters.

As its name suggests you can find the Reduce Noise tool by clicking Filter on the top menu bar, then moving down to Noise. This will pop open the submenu and allow us to select Reduce Noise.

4

Control digital noise (cont.)

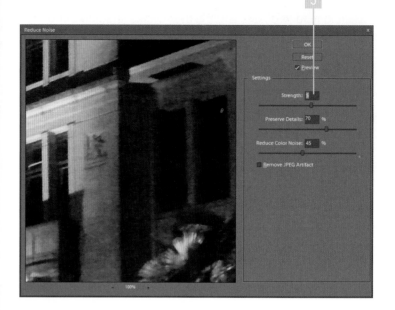

4 Upon opening the Reduce Noise tool you will be presented with a large preview window on the left of the menu, and on the right, three sliders controlling how the tool works.

5 From the top down, the individual sliders control first the strength of the noise reduction, which can be set anywhere from 0 to 10. At 0 there is no noise reduction employed, at 10 the image is subjected to very heavy-handed noise reduction which removes all the unwanted fizz but also smoothes over much of the photo's detail. To get the best results try moving the slider back and forth to see where you are happy to compromise.

6 The next slider works in conjunction with the first, helping to cling on to as much as detail as possible. This control is labelled as Preserve Details and moves from 0 to 100%.

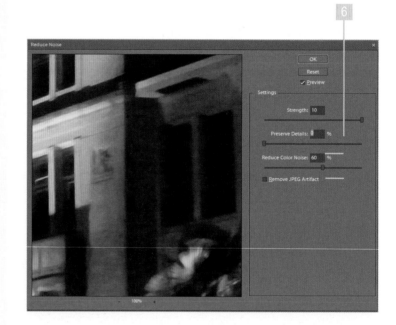

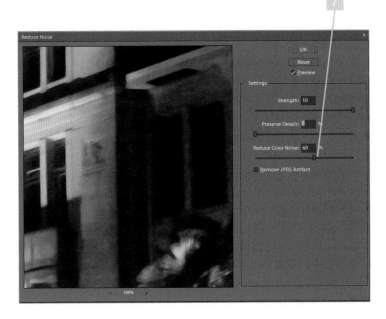

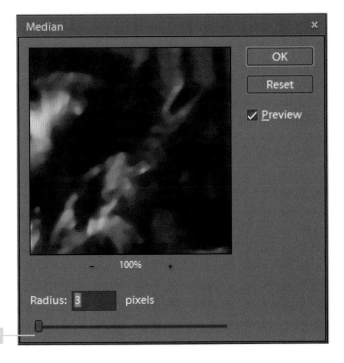

7 The next slider targets colour noise which is perhaps the most obvious issue created by digital noise. This slider works much like the previous control and can be set anywhere from 0 to 100%. Employing higher settings easily removes any coloured speckles, however it does have the side effect of making brighter colours a little flat. Again use it in moderation.

8 If you find the process of balancing these three sliders to tweak the image an onerous experience you can try using the simpler Median noise reduction tool. You can find this by clicking Filter on the top menu bar, then moving down to Noise. The same submenu will pop open, this time select Median.

9 As with the Reduce Noise tool, a new window will appear, but this time the interface is reduced down to one slider, targeting radius size. The larger the radius the softer the image will appear. As you move the slider the image will preview the results allowing you to get the appearance you want.

Control digital noise (cont.)

10 The last option we will look at is the Despeckle tool, a filter primarily aimed at removing any grain present in the image you have taken. As you can imagine this tool is well suited to improving film images, but when tackling digital images the results can be a bit hit and miss. Unlike the prior two filters this tool has no settings to adjust and clicking the option will immediately alter your photo. To undo the effect press CTRL and Z or, for Mac users, Command and Z.

Jargon buster

Noise – to photograph in low light or to use faster shutter speeds with film you might choose a higher ISO rated film. Its chemicals react faster to light, allowing additional creative options. The trade-off however, is that this film has a more obvious grain to it. Digital cameras emulate faster ISO speeds by amplifying the signal, which can introduce unwanted coloured pixels into the photo.

See also

To achieve the best results when removing noise you may find that you need to use these filters in conjunction with one of Photoshop Elements' sharpen tools. To find out more about how to restore as much detail as possible look back to the Sharpen your shots task in this chapter.

Landscape photography can be a rewarding pastime and a great way to remember the places you've visited over the years. As with so many other facets of photography, it's easy to learn but difficult to master. One of the most common mistakes made when photographing a landscape is getting an uneven horizon. This is understandable, as most of us don't carry a tripod equipped with a spirit level, and the compact size of many digital cameras makes it by no means easy to gauge on the screen. Thankfully, Adobe Photoshop Elements has a trick up its sleeves for just such a problem and in this task you will learn how to move heaven and earth to get a better landscape photo.

◀ **Level uneven horizons**

1. After transferring your photos to the computer find the lopsided landscape and open it in Photoshop Elements.

2. Next press the Maximize Window icon so that the image fits neatly in the screen. If the image is still larger than the screen, select the magnifying glass and then switch the tool to zoom out by keeping the ALT key pressed down. Whilst doing this, click anywhere on the photo to zoom out, repeating this until the photo fits in the screen.

3. Once the image is full screen, select View from the Photoshop Elements toolbar, and turn on Rulers. This will add measurements to the horizontal and vertical bars, making it easier to see where you've gone wrong.

4. From the toolbar on the left hand side select the Straighten tool, which resembles two photos placed over the top of one another. When you move the cursor over the photo you'll notice the pointer has changed to a small cross hair.

▶

Level uneven horizons (cont.)

5 With the cross hair sat just to the left of the photo, find where the horizon begins and press the left mouse button down.

6 With the mouse button still held down, begin to slowly drag the cross hair along the horizon – if you have correctly activated the Straighten tool you should see an expanding line stretching across the photo. It is possible to use the Straighten tool away from the horizon by simply ensuring the line runs parallel, but it's much easier to trace over the image you have.

7 Don't worry if you move the line away from the horizon – until you release the left mouse button the stretching line can be moved and repositioned until you are happy that it closely follows what you believe to represent the correct level of the horizon.

8 When you release the mouse button the photo will immediately rotate to straighten the landscape up. However, by rotating the image the canvas has had to expand and this means you're left with blank wedges on all four sides. These extra triangles will need to be trimmed off to make the final print look presentable.

Timesaver tip

For straightening other aspects of a photo you can overlay a grid by selecting it from the View menu. Grids can be adjusted to display in any size or colour, making them visible regardless of the image.

Timesaver tip

The Straighten tool in Photoshop Elements can be configured to automatically crop the image for you. By selecting Crop to Remove Background from the Canvas, Elements retains as much of the image as possible.

9 To crop away the unwanted white wedges we need to use the Crop tool, found on the toolbar on the left hand side, which looks like two L's overlapping each other. Click on the Crop tool and again your cursor will change to reflect the new function.

10 Before you use the Crop tool, click on the Aspect Ratio drop-down menu and select Use Photo Ratio. This will ensure that your final image remains the same shape as when you started.

11 Next click the Crop tool in the top left hand corner of the image and drag the box area it creates over the rest of the photo. You may have to restart this process several times in order to maximize the amount of the image you can hang on to. To discard the crop at any time simply press ESC, however if you progress too far and apply the unwanted crop press CTRL and Z to undo.

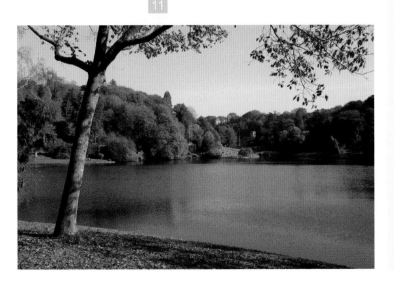

Add soft focus

The unparalleled success of Adobe Photoshop means the package has become synonymous with photo editing – in the same way that the brand name Hoover became the standard term for vacuum cleaners – and everyone knows their imperfections can be 'photoshopped' away. Any wedding photographer worth their salt will tell you they've lost count of how many times guests have asked for their wrinkles to be smoothed out, or a few inches taken away from their waist. Obviously, you should take these quips in the good humoured way they're intended. However, as you become more familiar with Photoshop Elements you'll learn about a range of tools that make it possible to fulfil any or all of these requests. In this task you'll begin by looking at adding soft focus, a technique which can be used to great effect in portraiture to soften a person's appearance, or to simulate a narrower depth of field and draw the viewer's eye to your subject.

1 With portrait photos it's preferable to have the background slightly softer as this draws your eyes to the person rather than the periphery. First off we need to open the image we wish to edit in Photoshop Elements. As before, we do this by clicking File on the top menu, then Open on the drop-down menu. You can then navigate to your image and select Open.

2 This will pop the image up on the display and we can begin our selective blurring. As with so much in Photoshop Elements there are numerous ways of achieving this: you could simply select the eleventh icon down on the toolbar – called the Blur tool – and brush over the sharper areas until you achieve what you were after, but this is a rather haphazard method and usually doesn't look that effective. So instead we will opt for a more involved but consistent approach.

File	
New	▶
Open...	Ctrl+O
Open As...	Alt+Ctrl+O
Open Recently Edited File	▶
Duplicate...	
Close	Ctrl+W
Close All	Alt+Ctrl+W
Save	Ctrl+S
Save As...	Shift+Ctrl+S
Save for Web...	Alt+Shift+Ctrl+S
File Info...	
Place...	
Organize Open Files...	
Process Multiple Files...	
Import	▶
Export	
Automation Tools	
Page Setup...	Shift+Ctrl+P
Print...	Ctrl+P
Print Multiple Photos...	Alt+Ctrl+P
Order Prints...	
Exit	Ctrl+Q

Add soft focus (cont.)

3 First open the Palette Bin on the right hand side and select the Layers tab. Next move your cursor over the background layer and press the right mouse button. This will open a submenu, from here select the option Duplicate Layer.

4 You should now be presented with a dialogue box asking you to name the new layer. You can do this if you wish but otherwise just press OK.

5 This will return you to the Layer menu, with the new Background Copy or whatever you called it, selected. This should create a perfect copy of the first photo layered over the original.

6 Now, from the toolbar on the left of the screen, select Magnetic Lasso, the third icon down on the right side of the bar, illustrated by a cartoon-style magnet over a brown lasso. As three lasso types share this slot, if you have used any other types of lasso prior to this, the icon could be hidden. To reveal the Magnetic Lasso simply click on whichever lasso icon you have and hold down the left mouse button to reveal the alternatives in a submenu.

Add soft focus
(cont.)

7 Once you have the Magnetic Lasso, left click next to the subject you wish to blur. This will start Photoshop Elements creating a lasso and, as you trace the outline of the area, it will draw a line that snaps to the outer edge.

8 You will notice small squares appearing on the line. At these points the line can bend more acutely so if you find the line won't turn enough, press the left mouse button again to drop an additional square.

9 Likewise if you want to backtrack a little, simply press Backspace. This will remove the last square and allow you to try navigating that nook or cranny again. For dead straight lines, such as the edge of the image, you can hold down the ALT key as you press the left mouse button once. This will toggle you to Polygon Lasso for one line, making it better suited to follow the edge.

10 It may take a couple of attempts to get the lasso perfect but once you join it in a loop the line will switch to the familiar marching ants.

11 It's likely that even after you have successfully lassoed your subject there will still be some fine-tuning to do. To include or exclude elements of the image select the Quick selection tool. By default, this will add to your existing selection, but by holding down the ALT key you can also remove areas.

12 If you still have difficulty tweaking the selected area to your requirements, try reducing the size of the Quick selection brush, this option can be found on the top bar.

Add soft focus
(cont.)

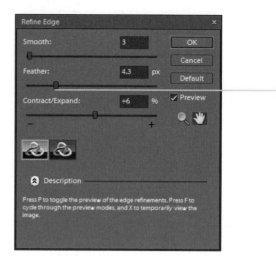

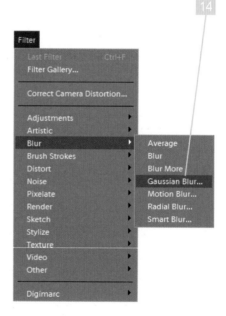

13 When you're happy the selected area is as close as you can get it, right click inside the selected area and choose Refine Edge. This will open a new menu, which allows you to Smooth, Feather, Contract or Expand the edges of the selected area. Smoothing can be useful to iron out any unwanted jagged parts of the selection. Feathering helps to add graduation between the area you have chosen and the rest of the image, a very effective way of preventing filters from looking unnatural or jarring. Contract and Expand can be used to ensure the selection is as tight to the subject as possible. When you're done, click OK.

14 Next, click on the Filter option on the menu. This will open a submenu where we select Blur. Here we are offered the complete range of blur effects. Depending on the subject, different effects are better suited to getting the look we are after. For example, with a still life our subject is stationary so we should opt for Gaussian Blur. However, if you are photographing motor sports the motion blur might be preferable. We will look at both, but let's start with the Gaussian Blur.

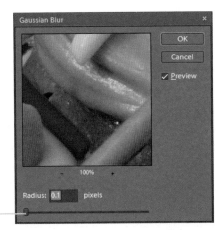

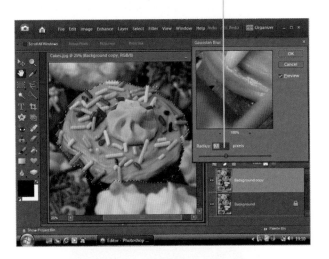

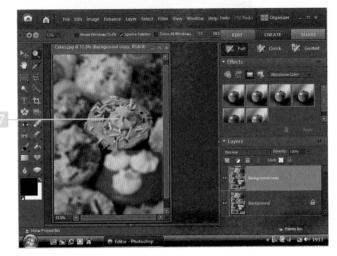

Add soft focus (cont.)

15 Once we have selected Gaussian Blur this will open up a new menu, with a simple slider. Try moving this back and forth until you get the effect you are after. Always try to use slightly less than you initially thought, this ensures you get the effect you want without making the effect too glaringly obvious.

16 If you were tackling a sports photo the Motion Blur can be used in a similar way to the Gaussian Blur menu. However apart from just the level of blur, you also need to consider the direction of the movement. To achieve this you are provided with a text box to type in the exact angle, if you know it, or more likely a simple rotating dial which you can adjust until the effect looks appropriate.

17 Finally press OK and then save the image by clicking File and choosing Save As. It's good practice to alter the original filename to reflect the addition of blur.

4

Create a perfect panorama

Regardless of whether the early bird truly gets the worm, if they bring their digital camera with them they'll have the best lighting conditions to capture some great landscape photographs. Morning light tends to be less harsh and can cast some intriguing shadows, but to really create some striking photographs you need to take a wider perspective. Digital cameras, like the film compacts before them, typically offer a 3x zoom, usually starting at an equivalent of 35mm. This makes the focal range well suited for photographing people and celebrations, but not powerful enough for distant objects such as wildlife, or wide enough to do justice to a beautiful landscape. To overcome these shortcomings digital cameras allow you to stitch together a series of images artificially creating a wide-angle photo far more expansive than anything but the most specialist film camera could ever imagine. In this task you'll learn the best way to handle your camera to capture the raw images, and get hands on with the software that allows you to seamlessly link them together.

1. Getting a good panoramic photo begins with how you take the images that make it up, the more care you take with the capture the easier the image will come together and the better the results will look.

2. Ideally when taking photos for a panoramic image, you should always use a tripod. This ensures your images are all taken at the same height, and with better tripods you can use the degree markers on the tripod to reduce the amount of overlap required. You can still create a panoramic image without a tripod, you just need to try and keep the camera as level as possible.

3. If your camera offers a panoramic mode, turn the Mode dial or access the menu to activate this feature. The camera will either overlay a translucent version of the previous frame on the side of the image, allowing you to line up the same landmark easily or simply add markers on the screen to assist composition.

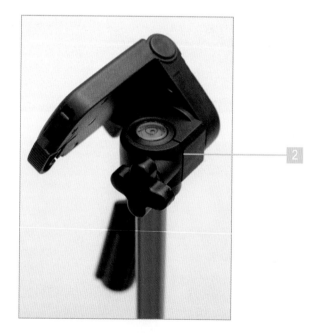

File **Edit** **View** **Tools** **Help**

Organize ▾ ▤ Views ▾ ▤ Slide Show ⊙ Burn

Favorite Links

Documents
Pictures
Music
Recently Changed
Searches
Public

Name | Date taken | Tags | Size | Rating

IMG_001.JPG IMG_002.JPG IMG_003.JPG IMG_004.JPG IMG_005.JPG IMG_006.JPG

IMG_007.JPG IMG_008.JPG IMG_009.JPG IMG_010.JPG IMG_011.JPG

Folders

11 items

Jargon buster

Barrel distortion – compact digital cameras balance flexibility against picture quality. Nowhere is this compromise more evident than in lens construction. When buying a digital camera shoppers often look for the longest zoom they can find. However, this can mean that the lens has trouble ensuring the lines in the image are straight at its widest point. Take, for example, a door frame where the lines gently bow outwards – this effect is known as barrel distortion.

4 Keeping in mind that you need to be able to identify where your last photo ended, line up your first photo with an eye on the landmarks towards the edge of frame. When you're happy with the image, take the shot.

5 Now, keeping the camera level, and without moving backwards or forwards turn the camera to frame up the next section of the horizon. Here is where you need to line up the edge of the previous shot with the beginning of the new one, allowing for approximately a fifth of the frame to overlap.

6 Keep repeating this process until you have the shot you want or have come 360 degrees and joined up with the original photo. It's important to be careful when building up a panoramic shot but don't worry too much if your images show some distortion such as barrelling, this can be corrected with the software later.

Create a perfect panorama (cont.)

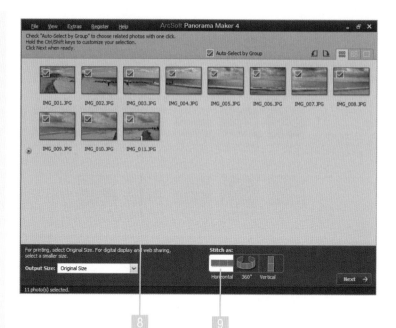

7 Back on the computer we now have the task of stitching the individual images together to create one long strip. It is possible to achieve this in Photoshop Elements but there are purpose-built applications much better suited to the task. Most digital cameras come bundled with a free package – we will be looking at ArcSoft's Panorama Maker 4.

8 Upon opening Panorama Maker, you will be dropped straight into the Pictures section of your PC, from here you can navigate to the images you wish to stitch together.

9 Along the bottom of the window you will see there are several options for the format of the panorama, you can either go horizontally, vertically or, if your image spanned a full 360 degrees, you can create a wrap-around image. Select the appropriate type.

Create a perfect panorama (cont.)

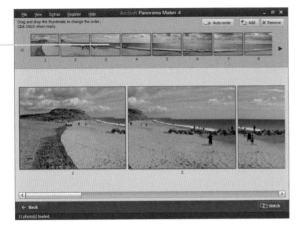

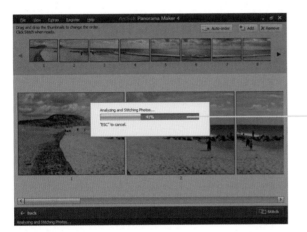

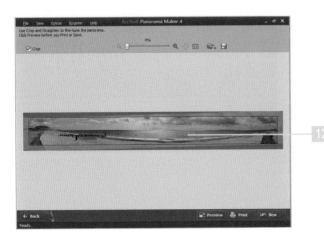

10 To begin the process of stitching them together, click the next button on the bottom right. This will move you on to the next stage where you can alter the sequence of the images if required. Simply press and hold the left mouse button and drag each image into the correct position.

11 Next, click on the stitch button in the bottom right. This will then look for similarities in the images and decide how the images should link correctly. When the process has finished you will be provided with the fine-tuning screen that allows you to manually override some of the decisions made by the computer.

12 In this menu you can also adjust the crop of the image to include more or less of the final print. If the result falls too far short of what you want, or the sequence was incorrect, you can choose to start over again. Once you are satisfied with the results remember to click Save because none of the image is saved up until this point.

Create high dynamic range images

1. Begin by opening the Photoshop Elements package. If the Project Bin isn't already available then click on the toggle switch in the bottom left corner to expand it. The Project Bin makes it much easier to deal with multiple images in Photoshop Elements.

2. To open your images, navigate to the top menu bar and left click on File, selecting Open from the drop-down menu. This will open a new window allowing you to select the photos you would like to combine. You can either repeat this process for each of the images you need, or a quicker way is to left click on each file whilst holding down the CTRL key, or Command for Mac users. This appends each additional image you click. When you have all of the images you would like to work with, press OK.

When buying a new digital camera it's easy to get swept up in a confusing torrent of technical terms and copyrighted acronyms, each as meaningless as the pseudoscience we're bombarded with in age-reversing cold creams and nourishing shampoos. For many the easiest yardstick to grip on to is that of megapixels, and manufacturers would certainly like you to believe that more is always better. However, this isn't always the case. The fact remains that despite the breakneck development of digital camera technology, the human eye is still capable of resolving more detail and a wider range of colours and light than any camera on the market. In this task we will look at using the best bits from a series of images to increase the dynamic range your camera can capture. To really get the best from this task, take a series of images using exposure bracketing. This gives you a broad range of exposures to work from. For this task, we will use Photoshop Elements, however there are many budget applications for both Windows PC or Mac, tailored solely to simplify the creation of High Dynamic Range images, or HDR photos.

Create high dynamic range images (cont.)

3 The images that will form your HDR image will now all appear in the Project Bin. To view each of them, either double-click on an image or open the Palette Bin on the right hand side and drag the image into the Layers section.

4 Next ensure all the images you wish to use are selected in the Project Bin, by keeping the CTRL or Command key held down as you left click on each of the photos.

5 Now in the Palette Bin click on Guided in the top three selections. This will open a series of wizards that allow you to easily remedy problems or make enhancements to photos. Photoshop Elements doesn't offer a specific tool aimed squarely at HDR photos, however the Group Shot tool under the Photomerge heading can be readily repurposed for this task. Click on Group Shot.

Create high dynamic range images (cont.)

6 This will switch the display into a new tool, showing you the selected photos along the bottom of the screen, with two larger images in the centre, one labelled as the Source, the other marked as Final. Initially the Final window won't have one of your images in it. Instead there will be a message asking you to decide on the base image. Think of this as the background, your canvas to work from.

7 Drag whichever of the images has the most elements you wish to retain into the final window. If your photos weren't taken using a tripod it's likely the images won't overlap perfectly. Photoshop Elements takes account of this and looks for points of similarity in the photos, automatically marrying these markers up. However, this process can't reinvent content that wasn't originally captured and in the final window you can end up with white space showing around the photo. Don't worry, we can crop this later.

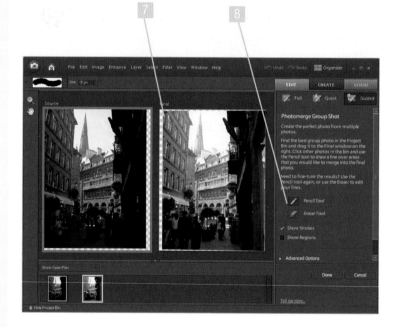

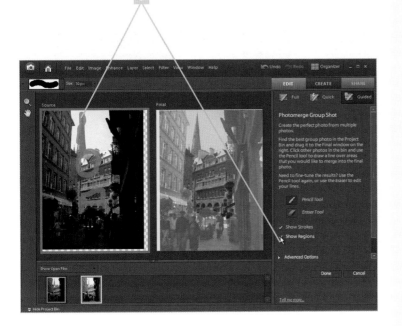

8 In the Palette Bin on the right of the screen there are now two tools, Pencil and Eraser. Using the Pencil tool allows you to mark out areas from the sources you wish to include in the final image.

9 Before you dive straight into marking out the areas to keep and bits to discard, switch on the Show Regions checkbox. This handy option applies a striking colour coding to the image, highlighting which part of the base or background image is being used and how much of the additional source photo the composite has picked up so far. You don't need to be particularly meticulous here as the tool is extremely clever at picking out the edges of buildings or scenery.

10 From experience, it's best to work on small areas at a time. Then if the tool spills out on to neighbouring territory you can always undo any mistakes by pressing CTRL+ Z. Where there are more than two photos in the Project Bin, the images and pencil are colour coded to make it easier to keep track of the bits you've added, and what's still to be done.

Create high dynamic range images (cont.)

11 Once you have successfully added the parts of each image you want to integrate, click the Done button. This will drop you back into the standard Photoshop Elements window, but remember you're not really done yet. Before you can save your new image you need to crop the rough edges away.

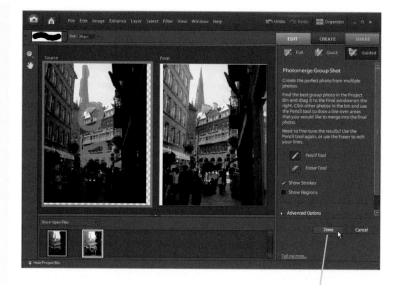

12 The crop tool can be found on the right hand tool bar and resembles two interlocking L's. Once you have selected the Crop icon, the menu bar along the top of the display will switch and the mouse cursor itself will switch from a pointer to the same overlapping L's.

Create high dynamic range images (cont.)

13 First from the drop-down menu marked Aspect Ratio select the size of print you would like, next click in one of the corners of the image and drag to the opposite corner. This will mark out the area you wish to keep. When you're happy you have the photo framed the way you would like, click the Tick icon and the image will be cropped.

14 Finally save the finished product by selecting File, Save As. Ideally give the new photo a name which indicates it is an HDR photo, for example let's call this image St.Malo HDR.jpg.

4

Selectively dodge and burn an image

As we saw in the Understand when to use spot, centre and matrix metering task in chapter two, the dynamic range captured by digital cameras can sometimes fall short of what your eyes are able to distinguish. As a result, no matter how well you balance your exposure, on scenes with a striking range of contrast, parts of the final image can be either too bright or too dark. Fortunately, just as it was possible to skilfully hand lighten or darken selective parts of a print in a darkroom, we can now use a range of digital editing tools. This task will introduce Adobe Photoshop Element's Dodge and Burn tools. Taking their names directly from the technique used in film processing, the effect is identical, and it is a great deal easier for the layperson to try their hand at. It takes a little practice to achieve completely realistic results, and the tools won't fix extremely poorly exposed photos, but they can salvage a lot of near misses.

1 We have already examined ways to adjust the exposure of an image to restore otherwise hidden details. Now we are going to make more subtle changes to sections of the image. These tools are known as the Dodge and Burn tools.

2 We will start with Dodge. It looks like a black lollipop on the toolbar. As this tool shares its location with both Sponge and Burn, it can be hidden when you go to use it. However, if you remember that it's always the bottom icon on the right of the toolbar, it's easy to track down.

3 Pressing and holding the left mouse button reveals a submenu, allowing you to select Dodge from the hidden options in Photoshop Elements.

4 When you click with the left mouse button you will activate the Dodge mode. This changes the top menu to show the brush size, range being targeted, whether it's shadows, mid-tones or highlights, and finally the exposure, which controls how fast any changes are made.

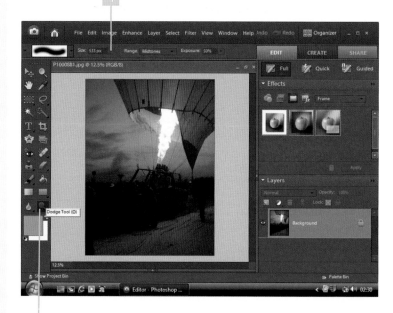

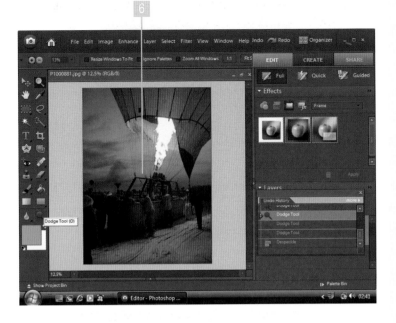

Selectively dodge and burn an image (cont.)

5 As you move the cursor over the image, the icon should switch to a small circle – this indicates the area that will be changed if you press the left mouse button.

6 As an experiment, switch the Range drop-down menu to highlights and increase the exposure to 50%. Once you have done this, choose a lighter element of the picture and hold the left mouse button while moving the cursor in small circles over the bright area. What effect has this had? You should see an even brighter circle quickly appear in the centre of this area but you will also notice that, at least initially, the underlying detail was retained.

7 What you have just done is an exaggerated version of normal practice. Typically if an element of a picture, such as a face, needs slightly brightening up, simply choose a large brush with a low exposure value and gently lighten these features up. As always try to use moderation to keep the effect realistic.

8 Return to the original image by clicking the first step on the History panel.

Timesaver tip

To quickly alter the size of the brush you are using in pretty much every part of Photoshop Elements you can press [to reduce the size, and] to increase it. You can also change the hardness or softness of the brush by pressing Shift at the same time.

4

Selectively dodge and burn an image (cont.)

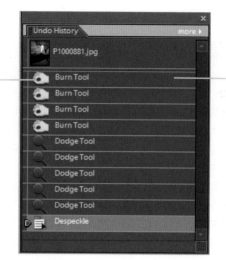

9 Of course as many times as we might need to brighten up an image, there are occasions when we need to darken washed-out elements. This is where the Burn tool comes in to play. The Burn tool is hidden under the same icon as the Dodge option and requires you to press and hold the left mouse button to access the hidden submenu.

10 The Burn tool looks like a hand pinching, but once selected the cursor switches back to the same familiar circle. As with the Dodge tool the menu bar along the top switches to the same options.

11 Thanks to the separated ranges it is possible to darken lighter aspects without unduly changing the neighbouring detail. Just make sure you choose the highlights rather than mid-tones or shadows.

12 When this tool is used sparingly, and in conjunction with the Shadows/Highlights tool detailed in the 'Adjusting exposure' task, it's possible to correct all but the worst photos. These tools are definitely worth practising with, but nothing beats getting the exposure right.

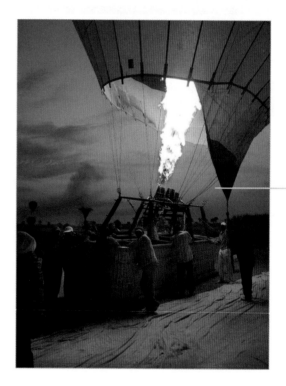

When you start to look at your photos with a more critical eye, you will nearly always find some aspect or detail that detracts from the overall image. This is where digital photography really comes into its own. By editing your images with applications such as Adobe Photoshop Elements you can make anything from fairly minor alterations, such as correcting the exposure or boosting the colour, right through to adding missing people into a group shot. For this task you will need an image with an obvious problem, for example, a photo where your thumb wandered into the frame. This task will show you step-by-step how to remove unwanted elements, along with offering some tips to help you think about adding others in. Everything you need is at your fingertips. You just need time and a little imagination.

1 For the purpose of this exercise find a digital image with something wrong with it, whether it's a scratch or blemish, or indeed something that was present at the time of capture you would prefer tidied up or removed such as that unwanted wheelie bin or someone using their fingers to add bunny ears to your portrait.

2 This task will look first of all at the different tools at your disposal and how you can make the best use of them. We will start with the Clone tool, the icon for which resembles an old-fashioned rubber stamp and is located eight buttons down from the top. Put simply, the Clone tool works by copying from one area of an image to another. This allows you to select a good area such as blue sky and copy over a bird, for example.

4

Add and remove elements (even people) (cont.)

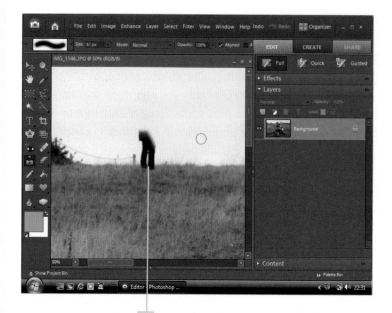

3 In order to correctly use the Clone tool you must first indicate where the tool will copy or sample from, this is known as anchoring. Holding down the ALT button changes the mouse pointer to a target, next select the area to sample from.

4 Move your cursor to the area you wish to copy over and press the left mouse button. Notice that as you move the cursor, a target moves over the anchored area being copied in exactly the same way. The Clone tool can be used for repairing damage to old photos or, with a steady hand, removing objects or people.

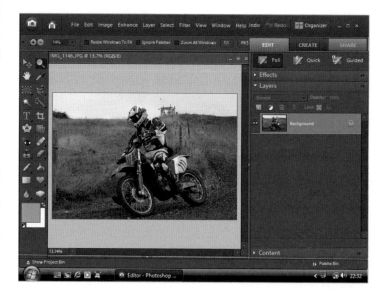

5 As the task's name suggests, it's also possible to add people or elements in that weren't previously there and the Clone tool can be used for this too. Simply open a second photo containing the aspect you want to blend in and anchor the Clone tool on the second photo. Then switch back to your original photo and brush the new item in.

▷

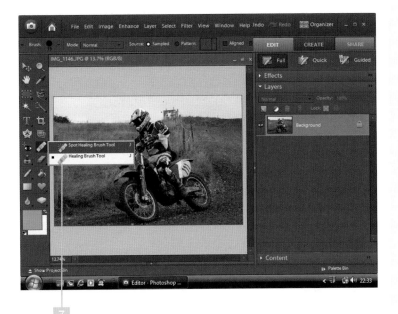

Add and remove elements (even people) (cont.)

6 The next tool available is the Healing Brush tool. This works in a similar fashion to the Clone tool, copying good parts of the image over bad. However, the Healing Brush is better suited to repairing damage in photos or cleaning up small defects. This is due to the intelligent way it blends the surrounding photo seamlessly.

7 First we select the Healing Brush tool by pressing and holding the left mouse button on the seventh icon down on the toolbar, this will look like a plaster with a dotted circle behind it. When you hold down the mouse button it will reveal an additional option featuring the same plaster minus the dotted circle, this is what we're after.

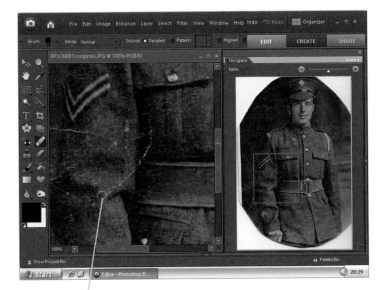

8 Once you have the Healing Brush tool selected, the cursor will change to a thin white circle. As with the clone tool, before you can start using this option, you first need to anchor the image.

Add and remove elements (even people) (cont.)

9 To ensure you get the best results you need to select a good area of the image without damage, and with similar characteristics to the area you want to replace. Once you're happy you've found a suitable anchoring point press ALT and left click the area.

10 It's worth checking that the brush size, located in the top left corner, is sufficient to cover the damage. If necessary this can be increased where the blemish or tear is wider than the standard 19 pixel brush head.

11 To start repairing the problem left click on the damaged area and slowly draw the cursor over the target area, drawing a blurred line along the path you chose.

12 When you let the mouse button go the computer will try and calculate how to incorporate the new area and should eliminate the problem. The Healing Brush tool is perfect for getting rid of rips in old photos but be careful because it samples from all around it and if there are big changes in contrast these can leak into the repaired area.

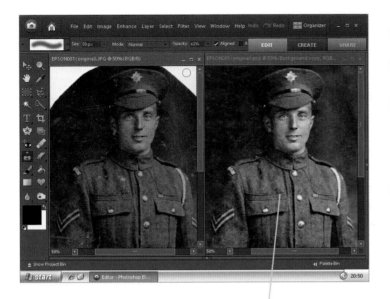

Add and remove elements (even people) (cont.)

13 We've all heard tales of super models having their skin cleaned up with Photoshop. Now here's you chance to use one of the tools designed specifically for removing every kind of spot. Return to the plaster icon and once again, press and hold it until the menu appears. Select the plaster with the small circle behind it – it should be labelled Spot Healing Brush tool.

14 The Spot Healing Brush tool works much more directly than the two previous tools. When the icon is chosen, the cursor changes to a small circle that you move over small blemishes and then press the left mouse button. One click and they're removed and it's on to the next one.

15 By using a combination of these tools you can either remove small problems, patch up damaged photos or copy trees over unwanted aspects of an otherwise perfect horizon. It's worth practising with all three tools as no single one of them can be used for everything.

Restore
damaged prints

1. Don't rush to remove your print from the frame or sleeve it's spent the last couple of years in. If the photograph was printed with a gloss finish and placed directly under glass there's a strong chance that trying to remove it will damage the surface of the print.

2. Before you try and remove it, make sure you clean as much of the glass surface as you can and either scan the print through the glass, or try taking a digital photo of the image as it is. That way if your attempts to remove the photograph end up damaging it further you still have the image, if not the original.

3. Be delicate when you try and remove the print. To make it easier you could invest in a micro spatula that will give you more control. As a last resort you can also try soaking the print in water with Photo-Flo. This may take several hours but will separate the print and glass without having to pry them apart.

Looking back over our own lives it's easy to empathize with people who place a higher value on their photographs than many other possessions, and to understand the upset when their photos begin to show the signs of age or suffer accidental damage. In the past you might have tried using archival tape to patch a photo up from the back, or even have committed the cardinal sin of Sellotaping the photo on its front. The adhesive in clear tapes is not specifically designed for archival use and often damages the photos even faster, never mind the yellowing of the tape over time or trying to remove it after the glue hardens. The best option is to scan the damaged print in and do the repair work in Photoshop Elements. There is no messing around with glue and if you make a serious mistake you can just press Undo. In this task we will explore ways to scan in, repair and ultimately generate new photographs from badly damaged prints.

See also

If the image has faded or discoloured over time refer back to the Correct colour cast task to learn how to restore the original colours. For older monochrome prints flick back to Convert colour photos to black and white for the best results.

Restore damaged prints (cont.)

4 Once you have your image intact and dry, you're ready to scan it. Make sure the glass of your scanner is dust free and clean, then place the print face down on the scanner, lined up with the edge but not touching it. Some scanners don't capture right up to the edge, so move the print ¼ of an inch away from both edges.

5 Open Photoshop Elements and click on File from the top menu bar, opening a drop-down menu. From this menu move your cursor over Import to reveal a submenu. You may have a number of options relating to your own model of scanner, all of which should work fine. However, if you have one, select the WIA option.

6 A new window will open with the question What do you want to scan? Beneath this question are four radial buttons with the choices Colour picture, Grayscale, Black and white and Custom Settings. By default, Colour picture should be selected.

Scan using EPSON Stylus Photo RX620

What do you want to scan?

Select an option below for the type of picture you want to scan.

○ Color picture

○ Grayscale picture

○ Black and white picture or text

○ Custom Settings

You can also:

Adjust the quality of the scanned picture

Preview Scan Cancel

Restore damaged prints (cont.)

7 Towards the bottom of the window, click on the link offering you the option to Adjust the quality of the scan to open the Advanced Properties menu. This allows you to alter the scan's Brightness, Contrast, and Resolution. By default the resolution is set at 100 DPI, increase this to 300 DPI and click OK. Back in the scanner options the selection in the radial buttons will have switched to Custom Settings.

8 To ensure the scanner doesn't lop off parts of the image or swell the scan with the blank background, click Preview. This makes a single pass of the image and provides you with a rough copy of the print to manually adjust the four corner points around.

9 Once you have successfully marked the area for the full scan, click Scan. This switches the window to a progress bar. When this completes, the image will be dropped into Photoshop Elements ready for you to begin restoration.

Restore damaged prints (cont.)

10 Start by duplicating the background layer to ensure the original remains unedited. Right click on the background layer and select Duplicate Layer from the pop-up menu. After naming the new layer, ensure it is highlighted as the active layer.

11 The clone, healing brush and spot healing brush tools which we used in the last task can also be used for repairing images. Depending on the scale of the damage, each tool has its strengths and weaknesses. When an image has been cut to fit a frame and you need to recreate the missing corners the Clone tool is best suited to the task. Select the icon resembling an old fashioned rubber stamp located eight buttons down from the top. Now look for an area on the image that could be copied without looking out of place. When you find your anchor point press and hold the ALT key as you select it.

4

Restore
damaged prints
(cont.)

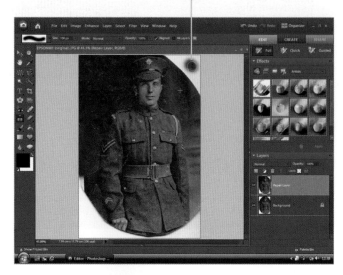

12 Now move your cursor to the missing or damaged area and press the left mouse button. As you move the cursor a target moves over the anchored area being copied in exactly the same way, so be careful not to clone in any unwanted neighbouring details.

13 For smaller areas of damage such as cracks or folds try opting for the healing brush tool. This uses the same method of cloning good parts over bad. However it cleverly uses the surrounding elements of the image to generate the repair.

14 Select the Healing Brush tool; it looks like a plaster with a dotted circle behind it. When you hold down the mouse button you'll see an additional option featuring the same plaster without the dotted circle.

15 When you select the healing brush tool your cursor will switch to a thin white circle. To get a good finish select an area of the image without damage and with similar characteristics to the area you want to replace, then anchor the healing brush by pressing ALT and left clicking the area.

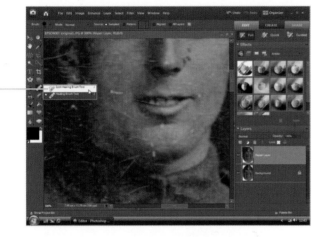

Restore damaged prints (cont.)

16 It's worth checking that the Brush size, located in the top left corner, is sufficient to cover the damage. If necessary you can increase or decrease the brush size by pressing [or] on the keyboard.

17 To start repairing the problem, left click on the damaged area and slowly draw the cursor over the target area. This draws a blurred line along the path you choose. When you release the mouse button the computer will attempt to repair the damage. If you don't get the result you want first time click Undo and try again, altering the size of the brush or the anchoring area you use.

18 For removing small marks or chips you can use the Spot Healing Brush tool. To locate this tool return to the plaster icon and once again press and hold until the menu appears and then select the plaster with the small circle behind it. No need for an anchor point this time, just click on the damaged areas one at a time.

19 When you've finished restoring your image, remember to save one copy as a JPG ready to be reprinted and a second in Adobe's own PSD file format should you want to come back to the file and make alterations.

Touching up images 213

Perfect your group photos

Despite our best intentions, getting all the extended family together often proves to be a rare occasion, one that unsurprisingly goes hand in hand with getting a good group photo. If you thought coordinating everyone to meet up for the occasion was hard, wait until you try convincing three or four generations of family to sit still for a once in a decade portrait. It's not always the children that create the problems, even those happy to follow your instructions seem to break out in a fit of blinking the minute someone mentions a family photo, making it almost impossible to get one good photo with everyone's eyes open. All of these problems mean it's a brave person who takes on the role of the photographer. In this task we will show you how technology can make the whole process a lot easier and less stressful. Using Adobe Photoshop Elements we are going to combine the good bits from a series of otherwise flawed group photos.

1. For this task to work you must always take several images when photographing groups, this is good practice regardless of the size of your group. Start by opening the series of group photos you wish to work on, to do this click File and select Open.

2. You can open the files one at a time, however it's worth noting that by pressing and holding CTRL, or Command for Mac users, as you click on each image, all the photos can be opened at once.

3. Next if it's not already open press the arrow in the bottom left corner to show the Project Bin. This should contain thumbnails of the images you want to work with. At this stage we need to look though the snaps to decide which ones we can use elements from and which we can discard.

4 Double-click on each thumbnail and the main window will switch to that photo, whilst highlighting the thumbnail in blue. If there's nothing you can use, right click the thumbnail and select Close from the submenu.

5 After whittling down the selection, press and hold CTRL, or Command, and left click on each of the remaining photos. This will highlight everything in the Project Bin.

6 On the right hand side ensure the Palette Bin is switched into the Guided view, this will simplify the four standard tabs down into specific actions. Under the heading of Photomerge click on Group Shot.

Perfect your group photos (cont.)

7 After a momentary pause the display will switch to show two windows, headed Source and Final. The images in the Project Bin will each be highlighted in different colours and the Palette Bin will offer you two tools to begin piecing together your group photo.

8 The first step is to decide which photo you would like to set as the base or template for any editing. When you've decided, drag the photo into the Final window. Don't worry if you change your mind at any stage, simply drag the new image into the Final window and it will switch painlessly.

9 Next click on one of the other images and select the Pencil tool from the Palette Bin. Using this tool, circle or draw over the elements of the photo you want to keep. If the detail is quite intricate you can always use the Zoom tool on the left toolbar to get a better view of your image.

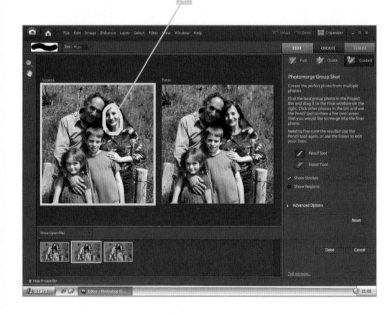

216

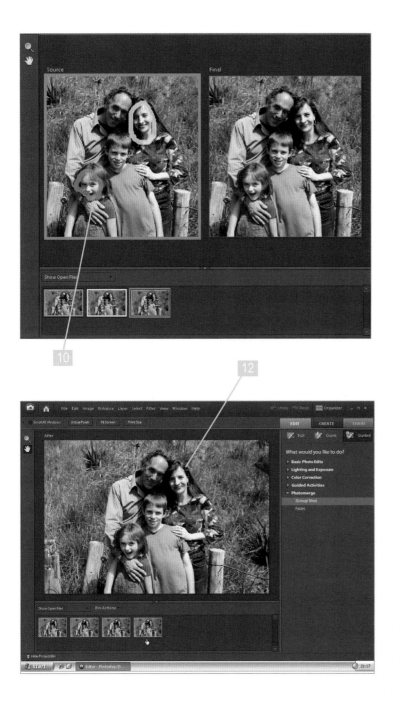

10 If you have more than two photos, once you've successfully marked the area you want to use click on the next photo. This will switch the source image and you'll notice the pencil drawing will remain from all the previous images, making it easy to see what still needs tweaking.

11 Each time you switch photos the pencil colour will match the highlighting. It's worth noting that the final image will preview the results of the selections you make as you build the composite group photo up. If at any stage you want to undo any additions, you can click on the corresponding coloured thumbnail and use the Eraser tool to wipe away and try again.

12 When the Final window looks perfect click Done and the composite image will be dropped into your Project Bin. Before patting yourself on the back remember to click File and Save the image away safely.

Crop your photos ready for print

Matching what your camera sees with the image in your mind's eye can be a frustrating experience, made worse by passing strangers aimlessly wandering in and out of frame as you try to squeeze in the whole view. The frustration doesn't end there though. If you have your photos printed in a 6x4 format, all your painstaking time getting the perfect composition will be thrown out the window when your prints come back seriously cropped. The reason for the crops isn't a difference of artistic opinion. If you roll back around a decade, photographers used 35mm film to take their holiday snaps. Examine an individual negative and you'll notice it has a 3:2 ratio, perfect for 6x4 prints. The captured image fits, with nothing overlapping and nothing cropped. The same can't be said of digital cameras, which use a variety of different sized sensors, none of which match 6x4. This task will teach you how to crop your own image at home. That way you retain control over how you compose the final photo and take the guesswork out of your prints.

1. When you have some photos that you would like to print, open one of them in Photoshop Elements. You can either click on the File option from the Photoshop Elements menu bar, select Open and navigate to your images or alternatively, with Photoshop Elements already open, you can drag the images either one at a time or in multiples directly onto the open workspace.

2. If you have chosen to open multiple images they will appear in the Project Bin along the bottom of the display.

3. Decide what size you would like the prints to be. The most common selections are 6x4 or 7x5 but remember that if you want to you can crop the same image several different ways. You just need to save the variations under different names. Using the dimensions in the file name helps to identify them.

Crop your photos ready for print (cont.)

4 Now we need to select the Cropping tool. This option can be found a third of the way down from the left on the Photoshop Elements toolbar. Once you have selected the tool, when you move the cursor over the photo it will change to the same overlapping L's.

5 Before you use the tool on the image, look at the new menu bar along the top of Photoshop Elements, this will have changed to show a width, height and resolution field. The first two may be empty with the resolution field showing 72 pixels per inch.

6 You can type directly into all three fields; for Width type 4 inch and in Height type 6 inch. As you press Return you will notice the word 'inch' is abbreviated to 'in'. Under the Resolution field type in 300 – this will ensure your prints retain a high level of quality.

Timesaver tip

If you don't have the time to go through your images cropping them the way you would prefer, you can always simply print them 7x5, this format still crops a little from the top but the effect is much less noticeable.

Touching up images 219

Crop your photos ready for print (cont.)

7 Try pressing the left mouse button at the top left of your photo and with the button still depressed drag it as far as it will go towards the bottom right. These settings will restrict the way the Crop tool works ensuring the ratio is correctly preserved and you can get what you expect.

8 If your photo is vertical (i.e. portrait) rather than horizontal (landscape), the Crop tool won't allow you to get very much in, however you can easily switch from portrait to landscape by pressing the opposing arrows on the menu bar between the width and height fields.

9 After you drag the Crop tool over the area you wish to keep, everything outside this area will become greyed out, however at this stage you can still tweak the area to be cropped. By pressing the left mouse button anywhere in the centre you can move the area around. Also by pressing on the four corners you can adjust the cropped area's size.

Crop your photos ready for print (cont.)

10 Finally if you want to rotate the area being cropped slightly for a better match to your subject this is possible too. You need to hover the cursor just outside one of the cropped area's corners – this will switch the cursor to a small arch with arrowheads on it. At this point, if you press and hold the left mouse button you can manually spin the area being cropped – ideal for lop-sided landscapes.

11 Remember that cropping your photos can produce a similar effect to using the camera's built-in digital zoom. With this in mind, don't crop too aggressively as the quality of the final print is likely to suffer.

12 Once you have the images adjusted for printing, don't save them over the originals. After all, if you change your mind about how you trimmed the image and you had done that, there'd be no going back.

Experiment with vignettes

In earlier chapters you discovered how wide apertures could affect your available depth of field. For example, opening the aperture to F2.8 can soften the foreground and background detail, ensuring your viewer's gaze is drawn to your intended subject. Sometimes when you get home and check your images on a larger display, the photo can be too busy, and soft focus can effectively simulate a wider aperture better suited to portraiture. However, there are other ways to direct attention and in this task you'll learn how to create a simple vignette to darken the photo surround. This is an attractive way to frame portraits and it's also a great way to mock up effects such as light fall off. While light fall off is normally an unwanted symptom of poor quality optics it can add impact to landscapes.

1 Start by opening Adobe Photoshop Elements and use the File drop-down on the top menu to locate and open the image you wish to add a vignette to. Ideally you should look for a landscape image to experiment with.

2 Next, to ensure your original image remains intact without adding alterations you might regret later, right click on the background layer and select Duplicate Layer from the pop-up menu. This opens a new window, giving you a chance to name the effect you wish to apply. Type in Vignette and click OK.

3 On the left of the Photoshop Elements toolbar, click on the Gradient tool, represented by a small rectangle transitioning from yellow to blue. This icon is located second from the bottom on the left.

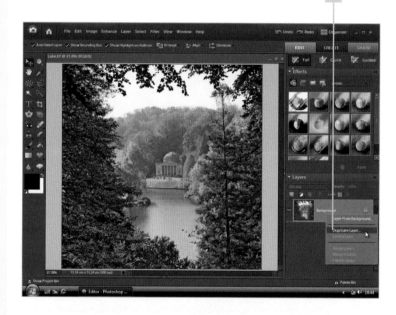

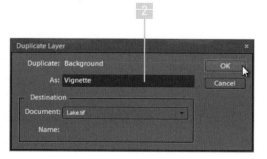

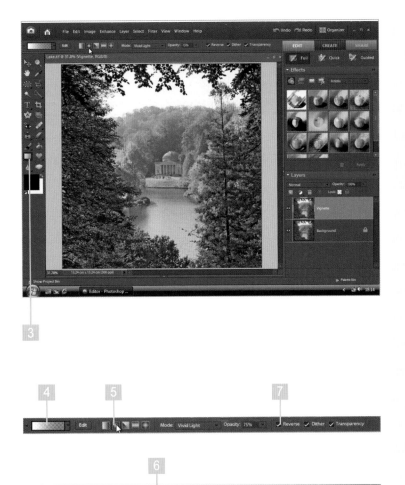

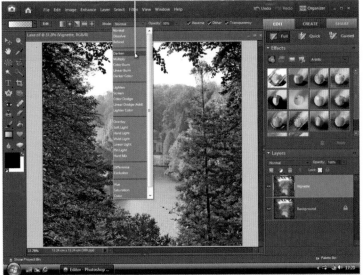

4 The top menu bar will now show the controls for the graduated fill. On the far left there is a small checked preview of the current effect, with an Edit button that allows you to fine tune the results.

5 Also on the bar are five methods of applying the effect: Linear, Radial, Angle, Reflected and Diamond. Select Radial, which gives a circular fade around the centre of the image.

6 Further along the menu bar is the mode selection box, this is currently set to normal. Click on the drop-down arrow and select Darken. Now you need to adjust the opacity to create the individual look you're after, try setting this to 75% and experiment to see what works best.

7 There are now three check boxes labelled Reverse, Dither and Transparency. Make sure all three of these boxes are ticked. Otherwise, rather than a darker vignette being created, you'll end up with a dark spot in the centre of your image.

5

Updating your albums and sharing your images

5

Introduction

Having trouble tracking down that photo of your caravanning holiday on the Camargue? Even the most fastidiously organized person can find searching for specific prints from the past time consuming. Especially if you struggle to remember when images were taken and your albums are organized by year, it's time to upgrade your filing system. In this chapter you'll not only learn how to electronically organize your old photos, but also how to scan them in and share them with your family and friends worldwide. You'll also work through a vital step-by-step exercise to ensure both your new and old digital images are properly archived should your computer decide to prematurely expire.

What you'll do

Archive your old photos

Use a digital album

Master metadata

Burn to CD or DVD

Create a CD cover

Make an attractive slideshow

Add images to family trees

Recover lost images

Understand portable image storage

Use online albums

Share your photos

Watermark your images

Archive your old photos

Now that all your new photos are digital, and can be viewed on the computer or family TV accompanied by your favourite music, you may find yourself not getting the old albums out so much. Rather than leaving so much of your family history and so many memories gathering dust in the attic, why not convert some of the old family photographs to digital by scanning in the prints, or better yet the negatives themselves. In an age of social websites such as Facebook and MySpace, families and friends share their old photos more than ever before. In this task you'll look at the best way of converting your photos to digital and the right format to save them in.

1 Before you begin the process of converting your old family photos, remember that this task is about archiving copies of your images, not discarding the originals. With this in mind, treat your original negatives or precious prints gingerly. If your photographs have lived in a frame for the past two decades, be very careful when removing them. This is especially true of glossy prints, which have a tendency to adhere to surfaces over time.

2 As with so many things in life if you want the best quality you need to go back to the source. In this case, try to find your negatives, as scanning these will produce the best digital images. Processed negatives are normally cut into strips of four or six exposures. Don't cut them into individual frames as this makes scanning them an arduous task. Slides are fine as individual exposures as they typically come mounted.

3 It's entirely up to you if you want to scan the negatives yourself or get a developer to do the conversion for you. Be ▶

5

advised, however, getting a high street developer to scan several hundred negatives can be an extremely costly affair. If you have the time, it can work out much cheaper to buy your own negative scanner and work your way through your back catalogue in your spare time. When you're finished with the scanner you can always recoup your outlay by selling it on EBay.

4 If you elect to purchase your own negative scanner look for one with an automatic strip feeder. Manual variants are much cheaper but do little to prevent dust creeping into the images, and the process is time consuming enough without having to manually move the strip for each and every image.

5 Before you begin scanning a strip of negatives check for dust on the surface, and use a simple puffer blower to remove any. For any particles unwilling to release their grip you can use a static free brush and sweep them from the surface. Try to avoid handling your negatives more than you need to, as your own static charge will draw dust on to them.

5

Archive your old photos (cont.)

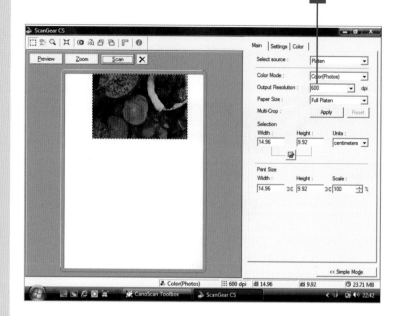

6 When scanning negatives or slides the detail in the images is much smaller than a conventional print. As a result you need to increase the resolution to 2700 ppi or above. Increasing the 'pixels per inch' acts like increasing the magnification on a microscope, at a higher ppi the scanner can make out much finer detail and allows the final image to be enlarged or cropped and still look sharp.

7 If you've lost the negatives or simply don't want to invest in a negative scanner, don't worry you can still use a flatbed scanner to convert your prints or negatives to digital images. Using a flatbed scanner doesn't provide the automation of a film scanner, but it's still worth approaching the process in the same systematic way. Start by cleaning the glass between each image, you only need to blow dust free from the surface, or polish off any residue transferred from the prints themselves.

8 If you scan in prints, the scanning area is significantly larger than for negatives and ▶

slides so the resolution only needs to be set at around 300 ppi. If you find a print image you'd ideally like to enlarge, set the ppi to around 600 for better results. Try not to go much higher though as the file sizes will become unmanageable.

9 Once you've scanned in your images the temptation is to jump ahead and start editing them. Try not to give in to the urges before you save the unedited image, as this is now your modern equivalent of a negative. For the very best results, which can still be opened on most computers, you can opt to save as lossless TIFF. However, this format uses very little compression and as a result creates very large files. It's more practical to save as a JPEG as there is minimal loss in quality and the file sizes are much more manageable.

5

Burn to CD or DVD ▶

1 First of all you need to determine whether or not your home computer actually has a CD or DVD writer built into it. Typically if you use a desktop PC this will be on the front of the computer, if you have a notebook it's more likely to be located on the side.

2 If your drive has a tray in which to load the CD or DVD have a good look at what is written on the front – it needs to say something along the lines of Compact Disc Rewritable or DVDR. However, if the drive only mentions CDROM or DVD with nothing coming after that, you may have to shell out on an upgrade.

3 If you're still unsure as to whether you have a CD or DVD writer, putting a blank disk in will prove it either way. The issue is which disks you need. Brandwise, the choice is entirely yours, however we can give you direction as to the right type for differing tasks.

Isn't it frustrating how every MOT something fails on your car? Whether it's a wiper, a brake pad or headlight there's always at least one part over a year that wears out. Your PC might not have as many moving parts, but the mechanical hard drive holding your priceless photos is just as prone to failure. To be safe you need to keep backups, copies of all your images and vital files stored separately. By far the most practical and cost effective solution is to burn your photos to CD or DVD. The term burn or burning refers to the laser used to burn the data on to an optical disk. In this task you'll learn about the difference between CDs and DVDs, including everything from +Rs to –RWs, what formats best suit your needs and how to setup your disks for archiving or printing.

2

For your information ⓘ

You don't have to print your pictures

Many households already have a perfect way of enjoying images right there in their living room in the shape of the DVD player. Your DVD player doesn't have to cost a fortune, indeed the least expensive are often amongst the most versatile. So long as your player is capable of playing back JPEG files you can sit back and enjoy a slideshow of your digital photos.

▶

4 If you want to take images to a photo developer you need the disk to be as widely compatible as possible, for this we would suggest a CDR. You will see different disks such as 74mins and 80mins – either will do. CDR disks can be written to in stages but it's *not* possible to erase at all.

5 You will also notice that there are disks known as CDRW, these offer the same amount of storage as CDR but offer the additional benefit of being completely rewritable. This could be useful if you were editing photos in different locations, but there are better, more portable solutions such as USB keys.

6 In most good digital camera shops you should find a selection of blank DVD disks nestling in amongst the CDs. Just like CDs you have disks that can only be written to, namely DVDR, and rewritable disks namely DVDRW. There are also two competing formats known as plus or minus and you need to be sure which your drive supports. Most drives will accept both.

5

Create a CD cover ▶

When you first start burning CDs or DVDs it might not seem that important to label your disks thoroughly with plenty of information about their contents. However, when you get on to your fiftieth disc and need to find a single image, the arduous task of loading and checking through stacks of identical CDs will leave you in no doubt as to the value of these little details. If you can get into the habit of creating eye catching covers, it's easier to find archive images, and they create a better impression when you give friends one of your collections. In this task you'll learn how to label and date your disks, how to create your own unique CD or DVD covers or how to put your images on the sleeve for an instant visual guide. There are numerous applications you can use to create CD covers but here we will look at Adobe Photoshop Elements once again.

1 Open your favourite or most memorable image from the collection you've saved to that CD. Once Photoshop Elements has finished loading the image, ensure the Palette Bin is open.

2 Next, above the Palette Bin switch the mode from Edit to Create. In the Create mode you'll be presented with four buttons offering you step-by-step solutions to the most commonly experienced tasks, however what we are after is relegated to the More Options tab just beneath.

3 Click on More Options and select CD/DVD Label from the submenu. It's worth noting that this menu also contains tools for CD and DVD jackets, so you can really smarten up your collection.

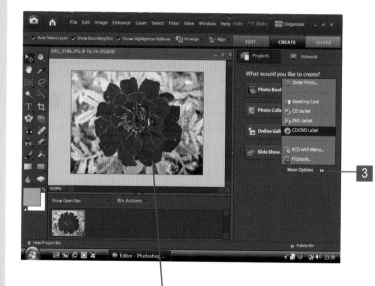

▶

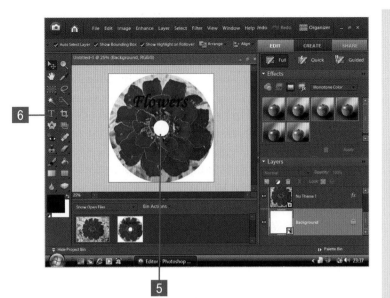

4 The first stage of the CD/DVD Label tool is to select whether to use one of Photoshop Elements' extensive range of themes. For this task we will opt not to, but by all means try revisiting this task and using one of the colourful options on offer.

5 After you press OK you are dropped back to your image, now with a neatly cut circle in the centre, however the image may not cover the whole disk. Using the eight squares surrounding your image, you can move and enlarge your image to fill the CD.

6 Confirm the adjustments by pressing the green tick. Your label is now ready for printing. Remember you can also create the CD jacket itself in the same way, just open an image and press the corresponding tool under More Options. If you wish to add text to the CD or your covers simply press the T icon and type in your text.

Make an attractive slideshow

1 Opening the Magix application brings you to the Record tab, with an empty timeline across the bottom half of the display. On the top half are four video creation wizards, and above those you'll see three clickable tabs labelled Record, Edit and Burn.

2 To import the images for the slideshow, select the Edit tab. This switches to a new interface with a video screen to preview your slideshow and a series of tabs offering effects, and directories full of your images or even videos.

3 On the bottom left of the screen is a button marked Timeline which toggles the display back and forth between the simple and complex views. To ensure you are in the simple mode the middle button should be in illuminated in blue.

4 To select the images you wish to include on your DVD, first click the Import tab then click on My media. This shows you the contents of this directory and allows you to select any images you want. You can add images from other directories but you will need to browse to them by clicking on the folder tree view button.

If you've ever been subjected to an excessively long slideshow, detailing some mind-numbingly dull subject like caravan sites in Belgium, you'll know that there are points when you find your will to live ebbing away. Indeed, even the term slideshow can be enough to send some of us into an almost catatonic sleep, but slideshows don't have to be boring and this task is here to help you put some energy back in to your photos. In the previous task, you learnt how to burn a CD that would play a basic slideshow in a DVD player. In this task you'll look at bringing your slideshows bang up to date, by adding music, eye-catching transitions, animated titling and even a DVD-style menu. Don't worry if this all sounds complicated and time consuming, to ease your introduction to cutting edge slideshows you'll be using the Magix Movie Edit Pro 14 PLUS application.

Make an attractive slideshow (cont.)

5 Next, simply drag the images one at a time into the lower portion of the screen, or alternatively press and hold the left mouse button to drag a box around multiple images and drag them all at once to the timeline.

6 Once in the timeline, the images can be easily rearranged by clicking and holding on an image then dragging it to its new position in the sequence.

7 You will also notice that the duration each image is on the screen can be controlled by adjusting the value under it. Don't worry about this too much, however, as we will rely on the software to adjust it for us.

8 Before moving on to add music and effects we need to ensure the red vertical marker in the timeline is right back at the beginning, otherwise any music we add will come in half way through.

5

Make an attractive slideshow (cont.)

9 We can tailor the video to look more professional by pressing File on the menu bar, then selecting MovieShow Maker. This menu is designed to simplify the process and comes in three steps.

10 First you select the style of video you would like from a wide array including 70s party, Photo Album and Cutting and Soft Blending. For this task, click on Cutting and Soft Blending.

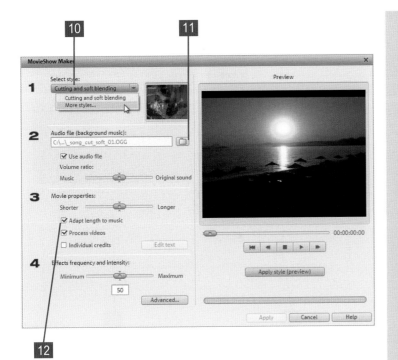

11 In the second section you can opt for a series of built-in accompanying music tracks. If however, you have your own music you would like to include, press on the yellow folder to bring up a familiar browse box. Once you have selected a file, click OK. Remember that if you change your mind about the music you can simply repeat this stage and pick again.

12 The third portion of the menu allows you to control the speed of the sequence. We would suggest if it isn't already checked, then click on the Adapt length to music box. By activating this option, the music will synchronize better with the photos.

13 If you wish to add credits you can do so by checking the Individual Credits option then clicking on Edit Text.

Make an attractive slideshow (cont.)

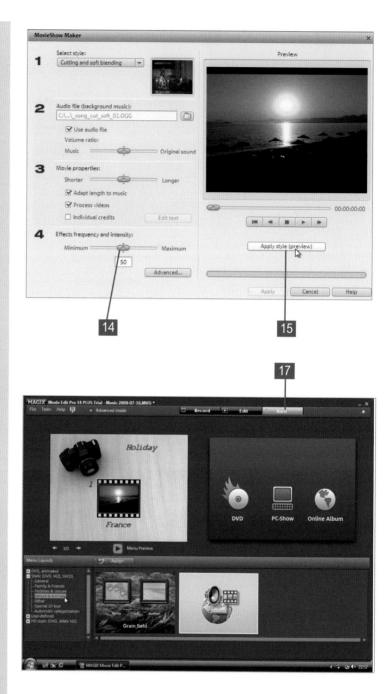

14 You can also alter the frequency and intensity of the selected effects. To customize your chosen theme simply move the Effects frequency and intensity slider left or right.

15 Beneath the preview window you will see the Apply style (preview) button. Clicking this sets the computer off creating the movie. When it's finished you will be able to see a preview video to confirm it's what you're after.

16 When you are happy with the results press Apply. This will drop you back to the simplified timeline. If you want to double-check your work so far you can do so by pressing Play on the preview pane.

17 Once you've finished altering the slideshow and want to commit it to DVD, select the third and final tab on the top of the window, Burn. This switches the whole display into a preview of how your DVD will look. Along the bottom of the display are numerous templates for different example styles. Feel free to explore and find a suitable design. ▶

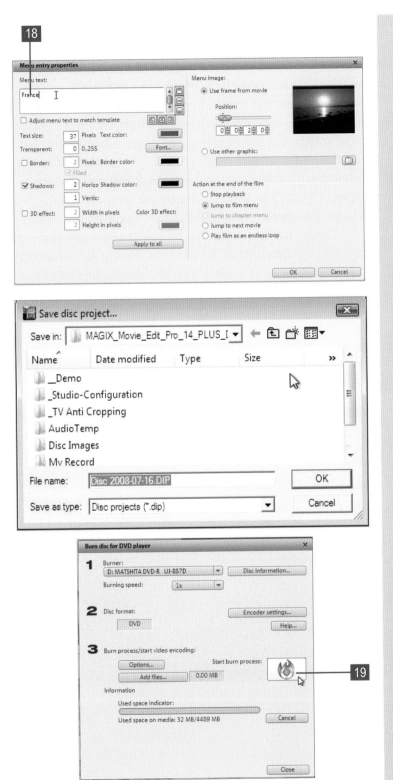

18 As well as being able to alter the appearance you can also change any chapter titles by double-clicking on them with the left mouse button.

19 When you are happy with the overall DVD, you can burn a copy by clicking on the DVD icon. This will first of all, save your project to ensure you can quickly make more copies, then it will present you with several DVD writing options – the default values should be fine. When you have put a blank DVD in the drive you can start the disk off by pressing the flaming DVD button.

20 The process will go through several stages and on a longer slideshow can take over 30 minutes. At the end, a notice will pop up saying that the disk is finished – clicking this will eject the completed DVD. Congratulations! You have made your first photo DVD.

5

Add images to family trees

1. Vista users should ideally begin by collecting your family photographs together in one place, preferably the Pictures folder. This will make it easier to browse to each image later and associate it with a relative.

2. Next open a web browser and access the website at www.genesreunited.co.uk. If you're not already a member click on the Register Free button at the top of the page, otherwise skip to step 5.

3. The registration page records your personal details, including forenames, surnames, date and place of birth and country of residence. This information isn't used in your family tree. It's purely for security.

4. When you have completed the first section you will be asked to enter your email address and most importantly a password. Make sure your password is memorable but don't make it too simple. Remember this site will contain lots of personal data that could be used for identity theft. A good password should contain both ▶

As fascinating as family trees are, discovering hitherto unknown relations, uncovering the debauched life story of a black sheep and ensuring the heroism of a past generation stays as vital and powerful to the children of this one, wouldn't be the same without photos to really transport you into those bygone times. Admiring the details of yesteryear can be the most entertaining and engaging part of genealogy for children. However, some of your oldest photos could be at risk if they're handled without due care. In this task you will use what you learnt in the Archive your old photos task and, with your images now captured digitally, discover how to embed photos into a digital family tree that can be shared safely with relatives far and wide. Genes Reunited is a great introduction for anyone interested in building a family tree. This simple, free service allows you to search for relatives, look on the census and communicate with an active community of other people interested in genealogy. If you get stuck tracing a family member this can be an invaluable resource.

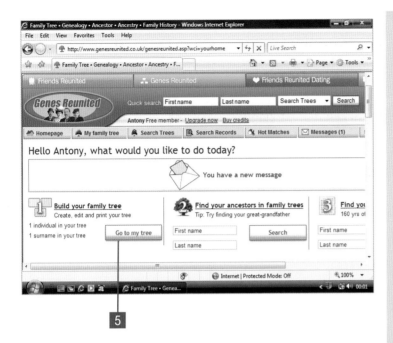

uppercase and lowercase letters mixed with numbers.

5 Once you have submitted your information, you will be returned to your Genes Reunited home page. The home page is split into three easy to follow sections, Build your family tree, Find your ancestors in family trees and Find your family in official records. To begin, click on the Go to my tree button in the first section.

6 If you are new to the site your family tree will be empty, however you can quickly build up your immediate family by clicking one of the Add Partner, Add Child, Add Sibling, Add Father or Add Mother buttons. When you have exhausted everything you know about your close family, you can start adding the photos.

5

Add images to family trees (cont.)

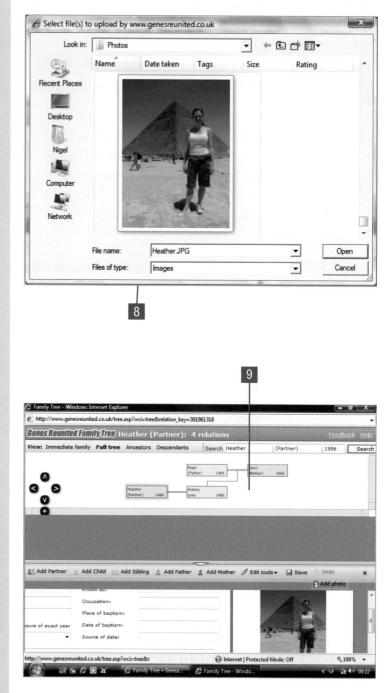

7 On the top half of the display click on the first record you have a photo for, this will switch the details on the bottom half of the screen to their personal details. To the right of the display you should see a box with the text Photo not yet added in bold. Click just above this, on the Add photo option.

8 You now have the chance to browse to your photos. If you saved them in the Pictures section they should be easy to find. Select the right photo for the family member and click on Open. You can choose more than one as all the images will be available to flick through. Before the images are saved you can review the list. When you're happy they're correct click on Upload.

9 As the images are being uploaded a bar will appear to show you the progress. When it's complete you'll be returned to the record of the family member, now with his or her new photos.

If you've ever mistakenly opened the back of a film camera only to be confronted with your last, as yet unfinished, unwound and now unusable roll of film, the sinking feeling you get when you accidentally delete a photo, or worse still format the whole card will be all too familiar. However if you can contain yourself long enough to count to ten, that might give you long enough to point your web browser towards any one of a number of excellent software packages purpose-built to recover your deleted photos. For this task we will take you through an application by Image Recall called Don't Panic 3. You'll learn how to restore deleted images and even repair a corrupted memory card. One word of caution though, this application is very thorough and will reveal images you intentionally deleted alongside the accidental causalities: you've been warned.

2

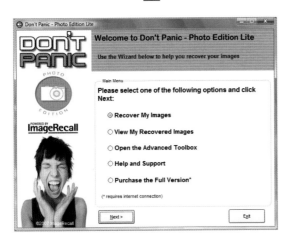

Recover lost images

1 First follow the install instructions for your software. Once it is completely installed, open the program. In the case of Don't Panic this will bring you to a Drive Selection screen.

2 If you use your digital camera with a flash card reader, remove the memory card and insert it into the correct slot on the reader.

3 Alternatively if you simply connect the camera directly to the computer, ensure that your batteries have sufficient charge, then connect up your camera as usual.

5

Recover lost images (cont.)

4 Once you've waited for your computer to acknowledge the card or camera, use the drop-down menu to select the drive letter for the memory card that contains the deleted images or corrupt files.

5 With the appropriate drive selected, start the software scanning for files. On the Don't Panic software this is represented by a magnifying glass. Remember this package is very thorough and will also find images that you intentionally deleted, so maybe don't start this program with an audience?

6 After starting the scan running, you will see a bar steadily moving across the screen to indicate the progress of the recovery. Above this all of the retrieved images such as JPEG and TIFF files will systematically pop up on the display.

Jargon buster

JPEG – refers to a form of compression designed to significantly reduce the storage requirements of photographic images. The name JPEG comes from the Joint Photographic Experts Group, a committee of specialists who defined the ISO 10918-1 standard in 1992. JPEG is what's known as a lossy compression, which means that in compressing the image, some of the original information and as a result, some of the quality, is lost.

▶

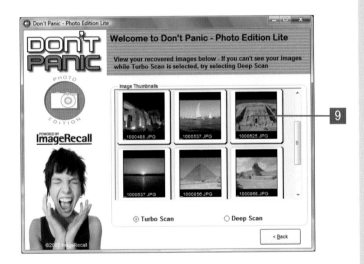

7 While the scan is running you will also notice in the corner a record of how many read errors the card contains. This number is important especially if the loss of the images was due to memory card failure. One or two could mean the card was removed whilst still writing and a simple format of the card will solve it, several hundred and you should probably consider replacing the card.

8 At the end of the scan process, Don't Panic will ask you if you wish to view the files it found, press Yes.

9 Thumbnails will then appear to give you a quick reference to the photos Don't Panic was able to claw back from your memory card. Above the photos there is the option to see the recovered files. Pressing this will take you to their location on the computer and allow you to copy them wherever you want.

5

Recover lost images (cont.)

10 The package has a number of useful additional features but perhaps one of the more sensible is the ability to write to CD or burn a recovered file to CD as it is labelled.

11 By selecting this option you can ensure your images are safe and secure on a separate disk, giving you peace of mind if your computer were to fall victim to a virus.

Jargon buster

TIFF – stands for Tagged Image File Format and works in a similar way to JPEG. TIFF, however, can compress photos without any loss of quality, also TIFF files have the advantage of being able to support layers. As a result, while some digital cameras do support TIFF files it's far more likely you will encounter TIFF files while using a photo editing package.

Anyone who grew up using a film camera will enjoy the freedom digital photography allows, primarily the ability to view your images immediately and discard any you are not happy with, but also the sheer number of images you can capture. Gone are the days when you took 24 or 36 exposures while you were on holiday. Now you can take literally hundreds of images. Some people, however, find even this can be restrictive and this is where portable storage devices come in. If you're embarking on a world cruise, backpacking across Asia or enjoying some other prolonged period of travel where carrying lots of memory cards might be an expensive solution, these devices adopt a similar approach to photos as iPods do to music. They allow you to store literally thousands of images in virtual albums which can, in some cases, be reviewed on the built-in screen or hooked up to a television.

When selecting what portable storage device suits you best, remember they can vary pretty widely with the simplest being little more than a hard drive with a memory card reader bolted on. The most powerful may be only marginally less powerful than a full-blown laptop. Obviously your budget will dictate where on the scale you buy in.

The entry-level devices typically feature a simple monochrome LCD screen designed to show only the essential information such as the amount of used and free storage, and the progress of any memory card transfers.

In most cases, to begin the process of backing up your photos, you only need to press a transfer button. Do remember though, never to remove the memory card or turn off the storage device until the data backup is complete.

The drawback to these entry-level devices is that without a proper colour display you can't see your photos until they are transferred off the device. Obviously by then you may have reused the card and it would be too late to recover the images.

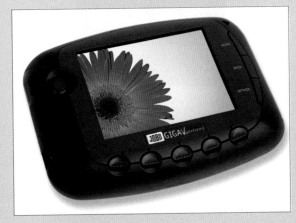

5

Understand portable image storage (cont.)

If your budget extends to one, you could try one of the latest generation of purpose-built photo viewers. These higher-priced models not only allow you to scan quickly through any of your images stored on the device, but they can also be connected to external displays or printers, without requiring a computer.

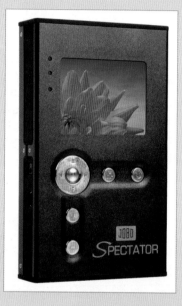

When considering what type of storage device to purchase, the most obvious consideration is the capacity. The current crop of portable storage devices come in a multitude of storage capacities ranging from 40 to well over 100 gigabytes. Aside from the sheer size of the storage you should also look into the formats the device supports, such as JPEG, TIFF and RAW files.

Before committing to any of the more expensive devices, request an opportunity to see how clear the display is and how long the device takes to move between each image. You'll find you don't bother to use it regardless of how clear the screen is if it takes over a minute to load each photo.

Lastly, remember that these units are used away from home so check how long the batteries last. This could make the difference between a backup device and a brick.

Years ago sharing your photos meant meeting in the local church or Conservative Club to get together with like-minded enthusiasts and discuss the relative merits of each other's images. In the digital age, photography clubs are still thriving but why limit your audience to a handful of people when you can post your photos on the web and potentially have thousands of eyes critiquing your work? Just be prepared: the perceived anonymity of the web seems to bring out the worst in some fellow photographers. Don't let a few bad apples spoil it for you though, websites such as Flickr offer completely free web storage for images, along with the ability to comment on your own and others' images. Flickr can be an excellent site to browse, with some very imaginative takes on conventional portraiture and landscape photography. In this task you'll learn how you can upload and share your own work with the world.

◀ **Use online albums**

1 Begin by opening your web browser, for Windows users this will be Internet Explorer 7, on an Apple Mac the default browser will be Safari. Flickr doesn't require any specific downloads and will work with any standard browser.

2 In the address bar type in flickr.com, as you can see this website does not require www preceding the address. Press the Return key or click the Go button and this will open the Flickr home page.

3 In the top right corner of the home page you can sign in or, if you don't already have a Flickr or Yahoo account, there is a button to Create Your Account. In this task we will first look at creating a new Yahoo account.

4 Pressing the Create Your Account button will open up a new page giving you the option to login or create a new account. On this page click Sign Up.

5

▶

Use online albums (cont.)

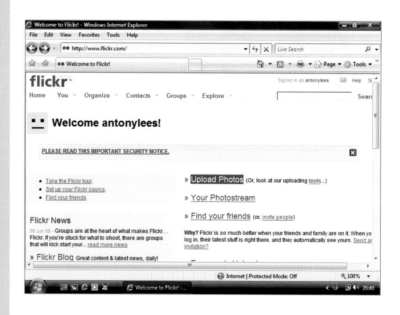

5 You will be presented with a new page asking for your personal details to create a Yahoo account. While this account can be used in a variety of applications, such as instant messaging, for the purpose of this task we are only interested in its application to Flickr.

6 Complete the form and enter the characters from the graphic at the bottom, this graphic is used to increase security. If you can't read the first one don't worry you can ask for an alternative version.

7 You will now have your username and password with which to enter the Flickr site. Return to the Flickr homepage and click Sign In to login with your new details.

8 The next page you come to will ask you to name your Flickr account, this can be whatever you would like and can differ from your login name. Once you have decided on an account name press the Create a New Account button on the bottom of the display.

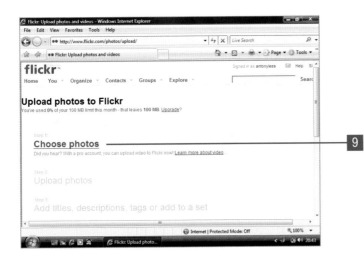

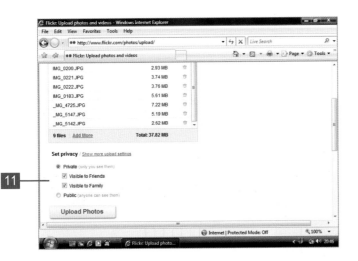

9 The next page you will see is broken into three stages, first Choose photos, next Upload photos and finally Add titles, descriptions, tags or add to a set. Click on the Choose photos line and this will open a standard file open window asking you which images you wish to include. You can select multiple images by simply holding down CTRL, or Command on a Mac. When you have the images you want press OK.

10 You will now see the images you've selected to be uploaded listed on the Flickr page. If you have more images held in different directories you can access these by clicking on Add More on this upload page. Repeat this until you have selected all the photos you want to transfer.

11 You will notice there are several options that allow you to control access to your uploaded images. By default the access is set to Public, allowing anyone to see or comment on your photos. There are, however, alternatives such as Visible to Friends or Visible to Family.

5

Use online albums (cont.)

12 Once you've selected the appropriate checkbox, press Upload Photos. This will start the list of images uploading and, depending on your Internet connection and the number of images you're uploading, this can take quite a long time. When the transfer has completed the screen will announce it's finished and ask you to describe your photos.

13 On this new page you are given an opportunity to Title and Tag your photos. You can also provide a brief Description of each photo, useful for recording where or how an image was taken.

14 After describing your photos you can invite your friends to enjoy your photos from anywhere in the world by simply clicking on the View as slideshow option.

In the last task we looked at a simple way to enjoy your photographs on the web, easily making your photos visible to other like-minded photographers or just your friends and family. However many of us already use websites set up specifically for keeping in contact with our network of friends. While social networking sites like those pioneered by MySpace and Facebook are not tailormade for viewing photos, they do offer an increasingly popular and easy way to share photos. These sites allow you to quickly record parties or events and distribute the resulting photos between the people you really want to see them.

In this task we will look at the process of getting your snaps on to Facebook, delve into what tagging is and find out how to tag the people in your images. This task assumes you already have a Facebook account but if you're new to the world of social networking you can find a simple tutorial on creating an account at www.facebook.com/sitetour/.

◀ **Share your photos**

1 Begin by opening your web browser. For Windows users this will be Internet Explorer 7, on an Apple Mac the default browser will be Safari. Facebook in its default configuration will work with any standard browser, so you won't need to download any third party applications.

2 In the address bar type in www.facebook.com, then press the Return key or click the Go button to open up the Facebook login page. In the centre of the screen you are offered an opportunity to sign up, however we are interested in the two fields in the left hand column.

3 In these two fields type in your username and password. Underneath you can make logging in quicker by ticking the Remember me box, however this is not advised on shared computers. When you have entered these details click the Login button.

5

Share your photos (cont.)

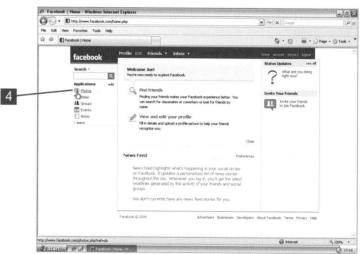

4 You will now be in your Profile page which allows you to provide as much information about yourself as you like. On the left hand side you will see the range of standard applications that Facebook provides when you create a profile. Click on Photos.

5 Facebook will switch to the photos page, which will list all your friends' viewable albums. To upload your own images click on the Create a Photo Album button in the top right corner. If your friends haven't yet uploaded any albums this page will invite you to start your first album.

6 You need to provide a name for the collection and you can add more details such as a brief description of the content, or where and when they were taken. Finally you have the option to restrict the people you want to be able to see this album. There is a great deal of control over this with standard options such as Only friends or Friends of friends, and more customizable choices that even go so far as to name individuals to allow or exclude.

▶

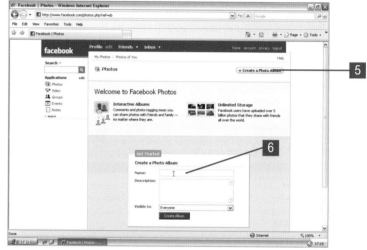

Jargon buster

Compression – there are numerous different ways of compressing images. However, they fall into two camps, lossless and lossy. When using lossless compression the image is squeezed into a smaller file but when the image is reopened the original file is identical, no information is lost in the process. TIFF files can be compressed in a lossless way. With lossy compression the file can be squashed much smaller making it more suitable for transfer or web usage but when the image is opened again the result is a representation of the original but some of the quality is lost. JPEG files carefully balance image quality against file size but the process still involves some loss of quality.

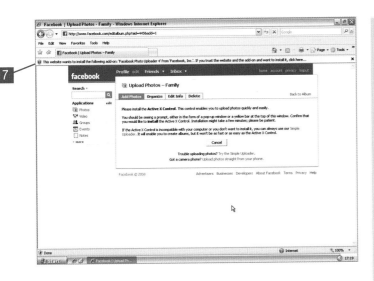

Share your photos (cont.)

7 If it's the first time you've used the Photos tool within Facebook you will most likely be prompted to install an Active X or Java control. In spite of the numerous warning banners there's nothing to be concerned about, simply click on the banner or dialogue box and allow the software package to install. If you use a third party security application you may need to temporarily disable this to proceed.

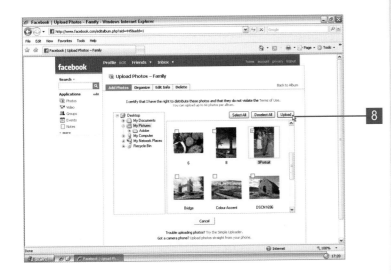

8 Once this software has successfully installed you will see a slick uploader, which previews your images in thumbnails and allows you to easily navigate around your computer, ticking the checkbox next to images you want to include in your new album. (Uploading will be quicker if you compress your images first). When you have checked all the images you want press the Upload button.

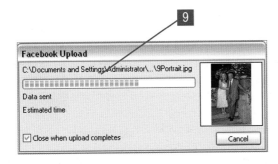

9 As the images are uploaded to your Facebook profile you should see a progress bar. When this window has closed you will be given the opportunity to edit your album, or delete images you may have included in error.

Share your photos (cont.)

10 One of the excellent features offered by Facebook is the ability to tag photos. Tagging allows you to identify the people in your photographs. If these people have their own Facebook accounts they are then informed about the photo immediately, otherwise you can supply an email address for communication. This interlinking of photos makes sharing your snapshots a much more enjoyable experience.

11 To tag the people in your images move the cursor over the photo and a small cross hair will appear. Position this target over the face of the person you want to tag and click the left mouse button.

12 This will draw a square around that person's head, bringing up a list of your friends on Facebook. If the person is on that list simply tick the box next to their name, otherwise type their name in the top text field. When you have entered their email details finish by clicking the Tag button. ▶

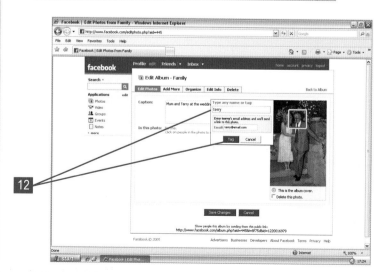

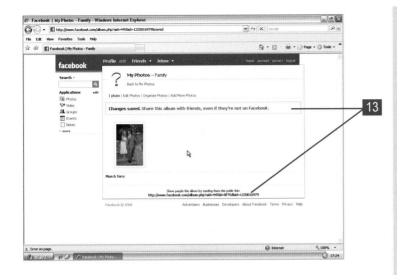

13 When you have tagged all the people in your collection of photos, click the Save Changes button at the bottom of the page. The page will change to show your new album. You can distribute your photos by sending people the public link at the bottom of the page or by clicking the highlighted text to open a new page that simplifies the process.

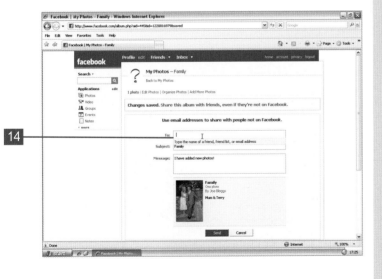

14 By clicking the option to Share the album you are presented with a series of options. Much like composing an email, you can write a message, give the message a subject and most importantly select friends from Facebook to send the message to.

15 If you want to send the images to people outside your Facebook contacts, just type the recipients' full email addresses and they will receive an email which links to the new shared album.

5

Watermark your images

▶

If you put your images on the web at any kind of good quality, you need to be aware that others will download them and use them for their own purposes! You may wish to consider watermarking your best images to protect them.

1 In both examples we first need to open the photo for editing. Select the File option from the top menu bar and then from the drop-down menu left click Open to find your image.

2 Once the file has opened left click once on the T on the toolbar. This allows you to add text to the image. Move the cursor to where you would like the text. Remember this isn't to compliment the photo it's to stop someone using it without your permission, so be ruthless.

3 On the top of the menu you will see several options including the size and font to be used. Also controlled here is the colour of the text. Typically you should set the colour of the font to 50% grey, however, for this example we have chosen to highlight the text in red.

4 Choose whichever font you prefer, if these images are destined to go on your own website, try and keep the theme of the site and use the same font. It is generally advisable to choose thick fonts for maximum effect. ▶

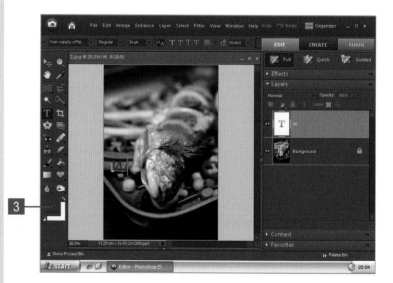

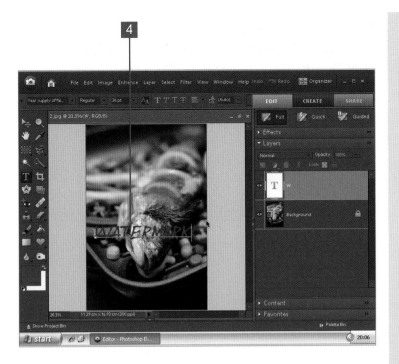

5 Now that you have configured the text to your preferred style and colour, type in your name followed by a copyright logo. When done click the tick on the top bar to confirm the addition.

6 If you're not comfortable with the size or position of the text you can then use the boxes at the corners of the text to resize or rotate it. Clicking in the centre of the text box allows you to drag the words around the photo.

7 Next click the left mouse button on the Blending drop-down in the Layers panel at the right of the screen, by default this will be set to Normal. You should be greeted by an extensive list of effects, try a couple of options and see what best suits your requirements.

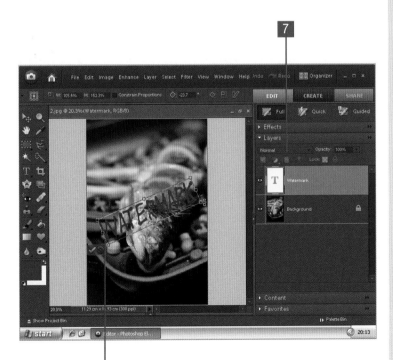

Watermark your images (cont.)

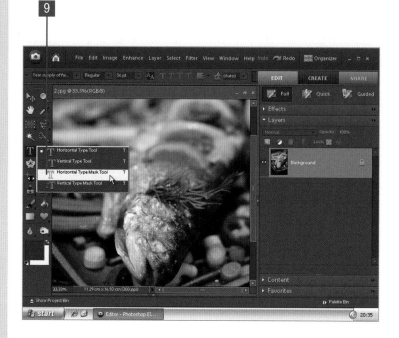

8 If this approach seems too distracting don't despair, the second method allows for more subtle markings. Using the Undo History return your image to the original photo.

9 This time click and hold the T icon to reveal four alternative tools, from these settings choose Horizontal Type Mask Tool. You can now type out your watermark text, you'll notice this tool obscures the whole image save for the text itself. Try and place the text where you want it at this stage, as moving it later is much more awkward.

▶

10 Once the text is placed and confirmed, the red transparent mask disappears leaving the text as an active selection. From here you can choose any filter, garish or minimalist to sign your photos. This example shows Clouds.

11 Finally, save this image as a JPEG under the original name but with wm or watermark added to it. If you put these images on a website or send them to people via email, you can be guaranteed they won't simply steal them.

5

6

Getting real prints from your digital images

6

Introduction

So far you've covered all things digital, creating your own DVD and tracing long lost family members in your old prints. In previous chapters you've even learnt how to convert your old prints into digital images for repair, archiving and cataloguing. However there are always occasions when a good quality print is what you're after and in this chapter you'll find out more about the available methods of printing and their strengths and weaknesses. There's also a step-by-step guide to using one of the popular high street developers' self-service kiosks.

What you'll do

Print at home

Use desktop publishing to create calendars

Use online developers

Use a digital kiosk

Get poster prints or canvases

Print at home

Direct printing via cable

1. First we need to load the photo paper into the printer. It's generally suggested that you buy the same brand of paper as you buy inks as this means that the way the inks bond to the page is predictable and you should get the best results. For this task we will assume you have a printer designed for photo reproduction.

2. Next look for the word Pictbridge on your printer. This means your printer and camera can talk to each other directly without necessarily needing to be used in conjunction with a home computer. In fact many of the smaller 6x4 printers can not only be used directly from the camera but often have provision for battery power, making the whole solution very portable.

You've already learnt about ways you can adjust, restore, organize, archive and repair photos, ensuring your memories are kept in the best possible digital format, but there's nothing quite like handling the final prints themselves. In this task you'll take your digital images and create real life prints. It's often said the immediacy of digital photography is one of its most attractive benefits, take a picture and you can view the results instantly on the camera's sizable LCD display. Marry the camera's clear display with a capable colour printer and you never have to wait for your prints again. When looking for a colour printer, try and find one with individual colour cartridges. That way, if your images are biased to one colour, you won't waste ink. Another useful thing to consider is the longevity of the ink and paper. Many photo printers now boast a fade resistance of over ten years, meaning your photos won't discolour or fade altogether. Finally, beware bargain printers. Often the ink costs more to replace than the printer itself.

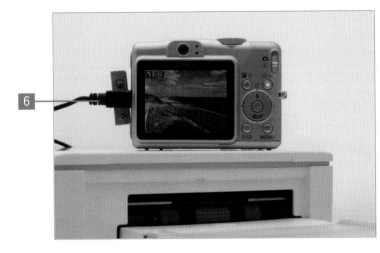

6

Timesaver tip

Refill inks are often much cheaper than the genuine article. However, their use can affect your printer's warranty and they also can produce inconsistent or unexpected results with branded paper.

3 Aside from just taking photos, many digital cameras can also be used as webcams or simple storage devices. In order to ensure the camera is in the correct mode, go into the setup menu by rotating the mode dial to Setup or simply pressing the menu button and scrolling to the Setup option.

4 You should find an option that refers to USB or interface. Toggle through the options until you find PTP, PICT or Direct Print. These options allow the camera to control a similarly equipped printer.

5 Next we need to switch the camera into Playback mode, ready to be connected to a printer. It's a good idea before connecting the camera to scan through the images and find the photo you wish to print.

6 Find the standard USB cable that came with your digital camera for connecting to the computer and instead, connect this directly to the USB socket on the photo printer.

Print at home (cont.)

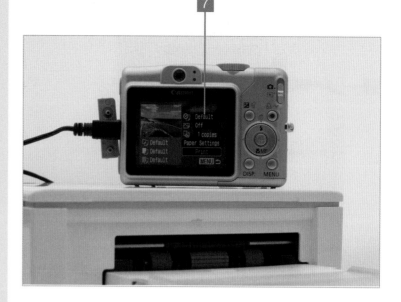

7 Once the two devices are connected, they should react to indicate communication between the two. In most cases the camera screen will change and display a simple array of print options, typically including how many prints you want, making an index print, adding a time stamp, or on more advanced printers, the ability to crop out a small portion of a photo to be printed.

8 Pick out one of your favourite images and select one print from the camera menu.

9 Once you have your final print, it's best to situate it away from direct sunlight and under glass in order to ensure that the colours remain strong and don't shift. By enclosing the print, the pollutants in the air are less likely to interact with the inks.

▶

For your information

Getting the best results from your photo printer

As the technology behind digital photography continues apace, photo printers have matched many of the developments with increasingly complex selections of inks, media and features. For many this complexity makes printing at home a hit and miss affair, however there are some simple rules to help get consistent high quality prints from your Photo printer. Firstly, when it comes to photos don't skimp on the ink. Cheap refills might be fine for bar charts and homework, but they will throw off the colour balance of your prints. Buy high quality photo paper, preferably the same brand as your printer. This way you can select the paper on your computer's print menu and the results won't yield any unpleasant surprises. Use your printer's highest available DPI. Printing will take significantly longer but the results will speak for themselves. Maintain your printer. A blocked nozzle or misaligned print head will ruin any prints, so run the print head clean and alignment adjustment programs at least once every three months. Finally, when your print drops out of the photo printer, give it around 12 hours to dry completely before you put it behind glass or in an album.

Direct printing via memory

1 Being able to connect your camera directly to the printer greatly simplifies the process of printing but it isn't without its drawbacks. By connecting up your camera to make your print, your batteries are being run down the whole time.

2 If your printer comes equipped with memory card slots it's also possible to insert your camera's media directly into the printer. Turn off your camera and remove the memory from the slot. Note that many memory cards are spring-loaded and must first be pushed in before you can remove them.

3 Next find the corresponding memory slot on the printer. Ensure that the memory card is the right way round before pushing it into the printer. It's unlikely the card will be difficult to insert so if it's not going in, check you have it the right way round.

▶

Print at home (cont.)

4 Once the card is correctly installed, the printer should indicate the pictures are being read. Printers which are geared to print photos typically feature a small screen, much like the display on your digital camera. This enables you to select which images you wish to print. It may also show more detailed directions.

5 Next using the printer's controls, select the image you wish to have printed. Once you have found the desired image, you should be presented with numerous options including the size of print required and number of prints.

6 Use the printer's menu to select one standard 6x4 print. This should start the printing process.

7 As before, keep your print away from direct sunlight and under glass. Enclosing the print protects it from airborne pollutants which might discolour the inks.

2

Use the computer to print

1 Printing directly using a photo printer is extremely straightforward but doesn't give us much flexibility. For edited images we need to hook the printer up to a computer.

2 To do this we need an A to B USB cable. Unfortunately these don't come supplied as standard when buying your printer so make sure you ask for one.

3 Look at the USB cable: one end will be square the other rectangular. Take the square end and plug this into the printer, next take the rectangular end and find a spare socket on the computer. It doesn't matter which one you pick.

4 The printer should come with a driver disk. Simply follow the accompanying instructions to install this software – which tells the computer how to communicate with the new device.

▶

Print at home (cont.)

5 After the software is installed, load the printer with A4 photo paper.

6 Next open one of your photos and click on File from the top menu, this will open a drop-down menu and you should be able to select Print with Preview.

7 If you use an application such as Photoshop Elements you will be presented with a new screen with lots of information about how the photo could be handled. On the left is a picture of your photo and how it will appear on the page.

8 To alter the size of the photo first ensure the centre image box is checked, then type in the size you wish to print in the height and width boxes. For this task choose 6x9 inches. Should you wish to use the entire page simply check the Scale to Fit Media box.

▶

Jargon buster

TWAIN – before 1992 getting your scanner to talk to your PC or your application to actually acknowledge its presence could be a very hit and miss affair – that was before TWAIN became established. Despite not officially being an acronym TWAIN stands for Toolkit Without An Interesting Name, and is the industry standard for communication between scanners, printers and applications.

9 If your image uses a landscape ratio, simply press the Page Setup option and switch the page from portrait to landscape, before pressing OK.

10 Next, press Print. This will then open the printer's own settings menu. Every printer shows different options but typically you must press Properties to access the current print configuration. Ensure the paper size is correct and the quality is set for photo.

11 When you've confirmed the settings, press Print. This will start the computer sending the image to the printer and begin printing your photo.

Use desktop publishing to create calendars

▶

Desktop publishing (DTP) has been around for over two decades, and is used each and every day in high-pressure environments. Through years of constant development, DTP has gone from being the reserve of highly skilled professional printers to a truly accessible tool, making it simple for beginners to easily dip in and experiment with. You don't have to start your own newspaper, or volunteer to take over the community leaflet, to use DTP. It can also be a great way to create fun party invitations or posters for events. In this task you'll use Microsoft Publisher 2007 to construct your own calendar, complete with personalized photographs.

1 Begin by opening Publisher 2007 from the Start bar. Vista users can jump straight to the program by typing 'Publisher' in the Start search. Windows XP users need to navigate the Start menu to Microsoft Office Programs.

2 When Publisher opens you're dropped straight into the template selection menu. From here you can choose to either start fresh with a blank page or, thanks to the expansive collection of ready-made designs stored both locally and on the Internet, choose a stylish template.

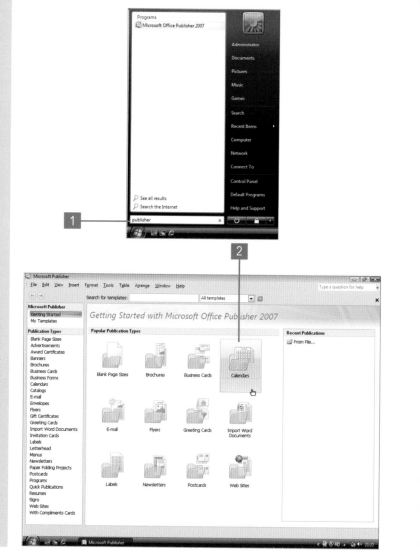

▶

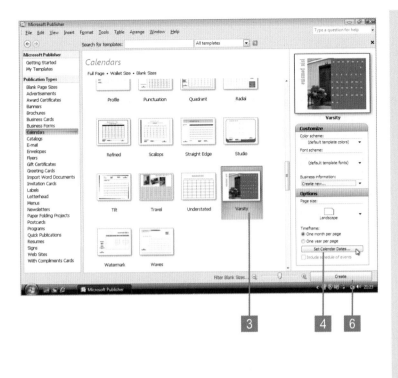

3 For this task you're going to create an attractive 2 page 2009 calendar so double click on the Calendars section and pick a suitable design. When you've found a design you'd like to use, click once on the icon so as to highlight but not open your selection.

4 On the right hand bar you'll notice the top image has switched to a preview of the template. Click on the Set Calendar Dates button at the bottom of this section before opening the template.

5 You can now override the default settings, which run twelve months from the current date. This new window gives you the opportunity to customize the start and end date of your calendar. Let's go for a traditional January to December layout.

Use desktop publishing to create calendars (cont.)

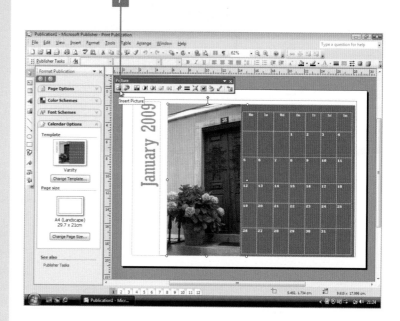

6 Now that you've got a useful date range and a design you like, you can build the design by clicking the Create button in the bottom right corner. This changes the view to your template calendar, with twelve months spread over 12 pages. To switch between pages simply click the small numbered icons that appear along the bottom of the screen

7 Beginning with January, click the main image for that month. On the new tool menu, use the first icon to browse for a replacement image of your own choosing.

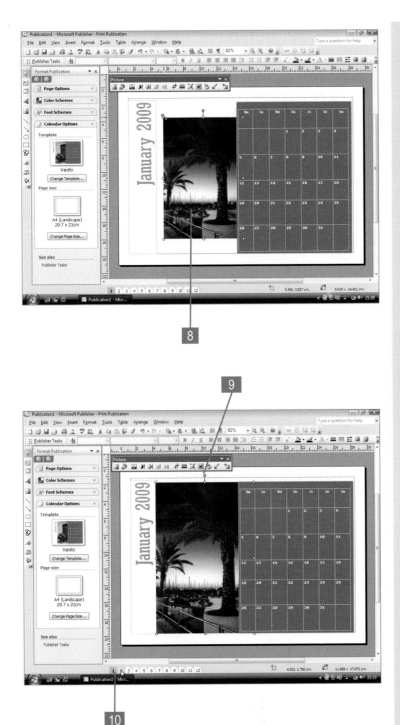

8 When the image is placed in the calendar template it might not match the size correctly, however you can resize your photo using the eight points around the edge of the image. By pressing and holding the shift key whilst you drag the corners in or out, it's possible to ensure the image doesn't get distorted while being resized.

9 You can also rotate your photograph. On the top centre adjustment point you will notice a green ball on a stalk. This allows you to freely rotate the image both clockwise and counter-clockwise.

10 When you're happy with the placement of the photo, you can progress one month at a time through the entire calendar by clicking on the page markers along the bottom of the window.

Use online developers

1. Open a web browser and type in the address of your chosen online developer.

2. Most web-based developers require that you become a member of their site before they will allow you to start adding your photos. You shouldn't have to provide many more details than your name, address and email address.

3. You will also be required to select a password. Try to make this memorable but not something that is likely to be guessed easily.

In an earlier task you learnt how to make the best of your home printer. However, even if you hunt around for economical refill inks and third party photo paper, printing all your holiday snaps can be really expensive. Indeed, while printing at home is well suited to digitally developing photos on an impulse, if you don't need your photos immediately opting for an online photo developer will get you better results for much less money. In this task you will get hands on with a developer's website and learn how to upload, select and adjust images to ensure you get your final prints exactly as you want them. For the best results you will require a broadband Internet connection, as uploading multiple images will be near impossible on conventional dial up.

4 Once you have signed up you should then have the ability to add or remove images from a web-based photo album. Using PhotoBox, the option to Upload Photos is located on the top of the page, by selecting this the computer downloads a tiny application. This may prompt your computer to issue a security warning. In order to proceed you will need to allow this software to install.

5 Once installed, the web page will change and present you with a three-step guide to transferring your photos. The first stage is deciding in what album you want your photos to be saved. This allows you to categorize your images making them easier to find later.

6 The next step is to pick out which photos you want to transfer. You can select individual images or the whole directory. Remember you can only select JPEG or TIFF files, RAW files won't be accepted.

Jargon buster

RAW – when digital cameras take a photo they process the image to convert it to JPEG or TIFF, making decisions as to how sharp you want the image, how much colour you want and what level of compression you would like to employ. Unusually for an electronic term, RAW isn't an acronym. It simply means raw or unprocessed. Choosing to use RAW files means you tell the camera to leave the images alone, allowing you to make these decisions later when you convert the images on your computer.

Use online developers (cont.)

7 The last step in uploading the images is to press the Upload button. This sends your collection of images over to the online developers. There will be a short delay as the images are transferred, the more images you select the longer this will be.

8 Once the upload completes, the website will display a confirmation screen showing you the images uploaded. You will have the option to purchase prints of each image in a variety of sizes.

9 If you want to make up an order with both new and old images, simply press the Move to another album option which will give you access to everything you have uploaded to date. You can then pick any images and view them in more detail, delete them or add them to an order.

10 Remember that besides the size of the prints, you can also select your preferred finish. Some online developers also make provision for borders to be added.

▶

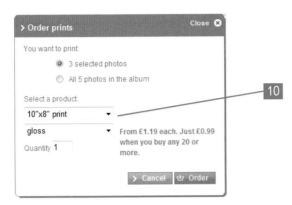

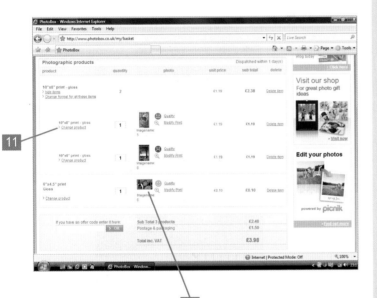

11 After you have chosen the images you want printed, quickly check your basket which will list your selection and show how each image is going to be printed, complete with any crops.

12 If you've selected a size which doesn't fit the image completely the thumbnail will have a red box surrounding the area that is going to be printed. This is your opportunity to either select a different size or move this box to ensure it prints the elements you want.

13 After making any changes you deem necessary, continue to the checkout and enter your payment details.

14 Keep an eye open for how your prints are packaged when they arrive, a good developer should provide a sturdy card envelope to ensure your prints arrive undamaged. If your prints arrive in an ordinary manila envelope you would be advised to spend your money elsewhere.

Use a digital kiosk

▶

Over the last decade it seems everything has been about more choice, whether it's the hundreds of variations on the humble cup of coffee or exotic deli choices for sandwiches. The problem is too much choice can be overwhelming. With film cameras, your most arduous choice when you dropped off your roll of film was whether you waited 24 hours or circled the block for the one hour service, but with digital cameras it's all got a lot more hands on. In the digital age you need to bring your memory card, or in some cases the whole camera along with USB cable, along with you to a developer. Digital developers often have a bank of computers not too dissimilar to cash points. However, instead of feeding them your debit card, you slot in your camera's memory. In this task you will learn how using a Snappy Snaps kiosk can be simple and straightforward, and you can get perfect prints directly from your digital memory.

1 For this task you will need to get your images to a photo developer. You can bring a CD of the images you want printed or if your camera has removable memory you can choose to take just this.

2 If your camera doesn't have removable memory and you choose to take the camera to the developers, remember to take your USB connecting cable otherwise you'll be making a return journey.

3 Once you're at the console most systems are touch-sensitive, so to start the process simply touch the screen.

4 Typically this screen will then offer you the range of services available, for example instant and poster printing. More recently some of the larger chains of photo developers have even been selling photo gifts ranging from calendars through to greeting cards and photo collages. On this example select the kiosk's Order Prints option.

▶

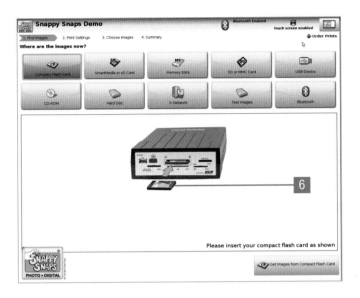

Please insert your compact flash card as shown

5 Don't worry about making mistakes you can always start again and experienced staff are always on hand to help you. If you order too much simply ask at the counter for cancellation of the order. Finally, don't fret about the potential to delete your images – typically kiosks don't offer a deletion option.

6 After selecting Order Prints, you will then be asked to insert your media. At this point slide in your memory or CD. If you have any concerns about handling the memory ask for some assistance. Most memory, however, is very resilient.

7 If your camera doesn't have any removable memory you should, at this point, connect the camera in exactly the same way you would at home – the kiosk is after all just a customized home computer. You may even hear the characteristic acknowledgement sound as your camera is recognized and the images are retrieved.

Jargon buster

Memory stick – different camera manufacturers often use different memory formats to store their images. Memory Stick is Sony's answer to the problem. Memory Stick itself has numerous different physical formats with Micro, DUO, PRO and PRO-HG. Predictably each new format is smaller than the last with increasing storage capacities and higher transfer speeds to enable smoother video or faster burst speeds.

Use a digital kiosk (cont.)

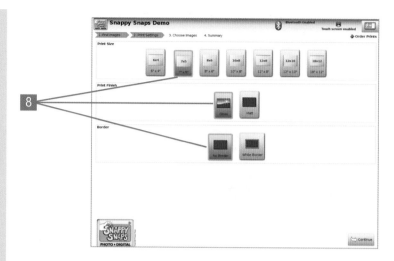

8 When you have inserted or connected the media or device holding your photos, touch the corresponding option on the display. After the images are downloaded from your media or camera the kiosk will offer you a variety of options for your prints covering the Size, Finish and details such as whether the prints have a Border or not.

9 The next menu will show miniature versions of your photos or thumbnails. Pick out the images you want to have printed, to do this touch the Plus symbol under the images you want. You'll notice each of the images has a red rectangle on it, this gives you a preview of how the final print will turn out. If you mistakenly order too many copies simply use the Minus to remove the unwanted additions.

10 Many kiosks are very advanced and allow for editing even at this late stage. To access the edit options via a Snappy Snaps kiosk simply press the View Larger button. Among many other features this will give you the chance to give the final image a Custom Crop or switch the image to Sepia or Black and White.

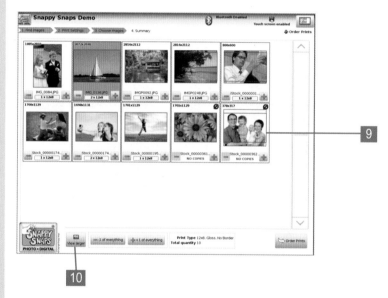

Jargon buster

CompactFlash – as one of the oldest memory formats, CompactFlash is also one of the largest. This physical size means manufacturers no longer provide support for it in compact digital cameras. In the professional arena CompactFlash remains a firm favourite and is used in nearly all DSLR cameras.

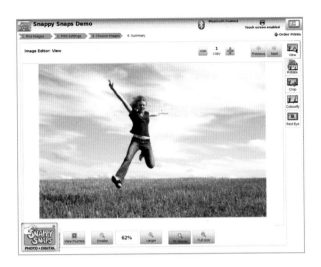

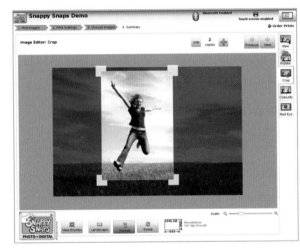

11 When you have selected all the photos you want printed, touch the Order Prints button in the bottom right of the screen. This will open a new window which requests you type in your personal details, normally consisting of your name and contact number. Don't worry, this information isn't going anywhere, the kiosks just add your name to a printed slip at the end which is used to match up with the photos. When you've typed in your details press Confirm Order.

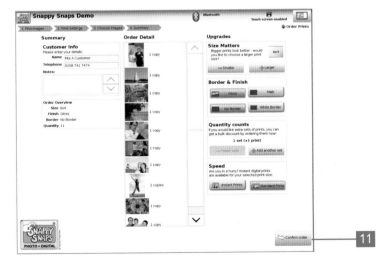

Use a digital kiosk (cont.)

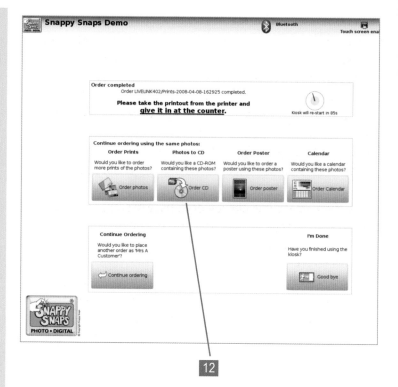

12 Different kiosks will present you with different choices, but generally you should be offered the option of having your images written to a CD. This is a worthwhile addition as it serves as your equivalent to negatives and if your computer was to break, or worse get stolen, you would still have your memories.

13 If you choose to write a CD, be prepared for a five-minute wait as the disk writes. After this, the kiosk will print you a ticket. In some instances you are required to pay via a card on the kiosk itself, while others leave that to the shop staff. Either way your work here is done, now you just have to kill some time.

It's worth remembering, photos don't have to be limited to standard sizes or shoehorned into a frame. If the image was captured at a high enough resolution, for example five megapixels or over, then there's no reason why your images couldn't hang over the fireplace rather than just sit on top of the mantelpiece. For this task we will go back to the online developer account we set up previously and advance on to creating much larger images. Remember, for poster prints or canvas images to look effective the original photograph needs to be captured at the highest resolution your digital camera offers, if the image has already been heavily cropped or taken at a low quality any compression or other imperfections will be shown only too clearly. Also, if the photo is saved as a RAW file you'll still need to process it, as very few online developers currently accept RAW formats. Finally, when you're creating a canvas you also need to consider how much of the image will be wrapped around the edge of the frame. With a little planning this can look extremely effective but get it wrong and the canvas could be ruined.

Get poster prints or canvases

6

1. Open a web browser and type in the address of your online developer.

2. When the page has finished loading, if you haven't previously registered, you will need to enter your personal details before you can upload any images. Otherwise, click on the Sign In button and type in your email address and your password.

3. Once you have successfully logged in you will be presented with your digital album. Obviously if this is the first time you have signed in there will only be an empty album.

4. If you intend to create the canvas from an existing image simply open the appropriate album. Otherwise, to add a new image, press the Upload photos option at the top of the page.

Get poster prints or canvases (cont.)

5 To upload your new image, choose the destination album then select the photo to be uploaded. When you click Upload File there will be a delay before the website acknowledges receipt of the file. It will then drop you back to the list of albums.

6 Next, open the album containing your new image and select the size you would like the canvas to be. You need to consider the ratio of the image, as choosing the wrong ratio will mean the image, needs to be cropped in order to fit.

7 Before proceeding to the checkout, press the View Basket option. This allows you to check your order and if cropping is required, you can manually select the area you wish to be used.

8 Once you have the canvas the way you want it, press Checkout and provide your payment details. Unfortunately canvases aren't next-day delivery and you'll have to wait for your masterpiece to arrive for around two weeks.

A

Appendix: Upgrading your digital camera

A

Introduction

We understand that you have probably just bought your digital camera and are looking to develop your skills and hundreds of images before you ever entertain the idea of buying your next camera, but this section aims to offer some assistance when you do, with simple pointers to help you avoid any potential pitfalls. By breaking down the technical jargon we aim to fill in the gaps that sales people so effortlessly glide over, giving you the ammunition to ask the right questions and better still, understand their responses. We will start this chapter by looking in more detail at the elements of a digital camera.

What we'll cover

Understand the anatomy of a digital camera

Understand megapixels

What to look for in a lens

Understand memory cards

Understand the anatomy of a digital camera

Sensor

This is the heart of the digital camera, the part which records the image. There are two principal technologies that can be employed for the sensor, the first known as CCD, which is an abbreviation of Charge-Coupled Device, the second, CMOS or Complementary Metal Oxide Semiconductor.

Viewfinder

Until very recently, most compact digital cameras featured a small optical viewfinder. This simple lens allows you to bring the camera up to your eye rather than using the screen at arm's length. Viewfinders are a rare animal these days as many cameras use the space for increasingly large displays.

Display

As digital cameras share more and more features with video cameras, their displays have got larger and larger. Thankfully they have also been created with better contrast ratios and antiglare treatments so they can finally rival a basic viewfinder in bright conditions. The latest generation of compacts even incorporates touch-sensitive screens to replace many of the buttons.

Zoom lens

Most compact digital cameras offer a three times optical zoom lens. Don't be fooled by claims of 12? or 15? lenses – these figures always include the less attractive digital zoom. If you want a bigger zoom you have to buy a bigger camera.

Mode dial

By employing a dial most compact digital cameras can make accessing a number of scene modes intuitive, without having to navigate your way through a complex menu.

Power switch

If you're looking for an easy-to-use compact camera, always try the power switch a couple of times. There's nothing worse than missing a shot because your camera is slow to start or you can't press the button easily.

Built-in flash

Don't expect miracles from the standard built-in flash bulbs. They are designed to help with portraits in a darkened room, not light up a concert hall. If you really need to add light, try the flash combined with a longer exposure.

Focus assist lamp

Confronted with a dark environment your camera may struggle to find focus. This powerful LED will add just enough illumination to help the camera pick out its subject.

Zoom buttons/rocker

Depending on your camera, the zoom may be controlled with two buttons or perhaps a simple rocker. By moving the rocker or buttons to T you zoom in, and towards W, will zoom out.

Understand the anatomy of a digital camera (cont.)

USB socket

The USB plug or socket is the standard way of transferring your photos to a computer whether it's a PC or a Mac. Check if your camera uses USB 1.1 or the newer 2.0 standard, as this will dramatically cut the time to move your photos off the camera.

A

A/V socket

The A/V or audio video socket connects your camera directly to your TV, making it possible to watch a slideshow or playback any captured videos.

Power socket

Transferring images to your computer can be a drain on the batteries. You can purchase an optional power supply which allows you to power the camera without running down its batteries.

Microphone

Many cameras have a microphone mounted on the front to record sound in video. However, sometimes the microphone is located on the top, making it more suitable for dubbing existing stills. As with the flash, don't expect too much of these simple microphones – they don't rival those found in camcorders, yet.

Playback

To review any images taken on the camera, either move the slider to Playback or press the green playback triangle button. Pressing this button again will switch you back to record mode.

For your information

Avoid shutter lag

Digital cameras were for a long time tarred with the reputation that they were slow and often missed great photo opportunities as they whirred and clicked, considering your requests before finally actually taking a photo. These delays were known as shutter lag and were symptomatic of the slower processors used in the first generations of digital cameras. Modern cameras have for the most part eliminated these problems but it's still good practice to review the specifications and see what claims the manufacturers make. As a rule of thumb, if the shutter lag is documented it's unlikely to create any issues, if you can't find any reference to shutter lag, alarm bells should be ringing.

Don't be afraid to ask to test drive any potential purchases, this way you can get a feel for the responsiveness of a camera. Remember always half press the shutter release to lock the focus before completely pressing the button – this will show you the shutter lag. Other aspects of the camera to consider are the time to focus, this is often mistaken as the shutter lag and can be equally as frustrating when trying to capture spontaneous snaps of your children. Try focusing on near and distant objects in turn to see just how quick your camera can react.

Understand the anatomy of a digital camera (cont.)

Speaker

While in playback, the speaker allows you to enjoy the movies with full sound.

Delete button

Careful with this one, pressing it gives you the option of deleting individual images or the whole lot in one go.

Battery compartment

Typically situated on the bottom of the camera. Digital cameras use either AA batteries or lithium ion power cells.

Memory compartment

Often shares the same compartment as the batteries. Your memory card must be installed correctly before you can start shooting. If you are in any doubt, review the memory card task in Chapter 1.

Indicator lights

Many cameras have two indicator lights, the first tells you when the flash is ready, the second informs you when the focus is locked in.

Wrist strap mount

This simple loop allows you to wear the camera safely around your neck or on your wrist.

Direct printing button

With compatible printers, this button allows you to direct print without a computer.

Four-way navigation pad

Some digital cameras feature a four-way navigation pad. This helps you move your way around the camera's menu system.

The technology behind a digital camera's ability to record light and ultimately capture a photograph lies in its sensor. This component is made up of millions of microscopic wells, each of which can be filled with light. The amount of light received by each is measured and converted into data. These wells are known as photosites and each one refers to a point of light making up the final image. These individual points are known as pixels and this is where the term megapixels derives from, a short hand name for 'millions of pixels'.

When digital cameras were first introduced, they offered a very low resolution, barely capable of recording enough information to produce a photo-quality 6x4 print. When successive generations boasted higher and higher resolution sensors this yardstick was simple to understand and made selecting a camera easier. However, with cameras now exceeding ten and twelve

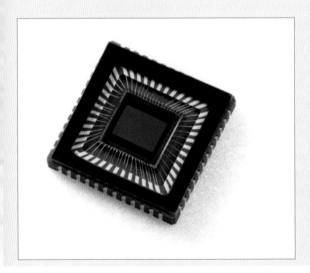

megapixels, the picture, at least when it comes to choosing a camera, is not quite so clear. The quality between one camera and another is much harder to quantify, especially as the faithful yardstick of higher megapixels could potentially be a reason to expect lower quality images. To understand why, you have to look at the dimensions of the sensor itself.

With film cameras, the light sensitive area would be a standard, always remaining constant. The same can't be said of digital cameras. Between brands, and indeed models, each camera can have its own proprietary sensor size, often measured in obscure imperial measurements. So, for example, two cameras both with eight megapixel sensors could have radically different sensor sizes. In order to avoid a grainy image or a loss of detail, each individual photosite in the array of millions needs to have a clean source power, and mustn't be affected by interference from the surrounding elements. On a larger sensor it's far easier to reduce electrical interference and ensure the image is processed cleanly.

So if it's not about megapixels, what should you look for? Though it's currently not a widely stated figure, comparing pixel density alongside total megapixels provides a better indication of the complexity of a camera's sensor. At present, digital compact cameras have no standard sensor size, but digital SLR cameras typically offer an APS-C sensor and high-end cameras have a full frame sensor. This size of sensor mimics the dimensions of a 35mm negative.

What to look for in a lens ▶

If you look at the numbers emblazoned on the front of a camera's lens and feel they are as alien as the calibre of a gun, then this section is aimed at you. On every camera one of the most important components is the lens. The quality of this part, however, is much harder for most people to identify. The problem is that camera manufacturers continually harp on about megapixels and zoom, areas where simple marketing can drum home a message that bigger is better however unqualified the claims are. They very rarely expend any energy telling you about the lens used. To help you understand what the specifications of a lens mean we have included a short guide.

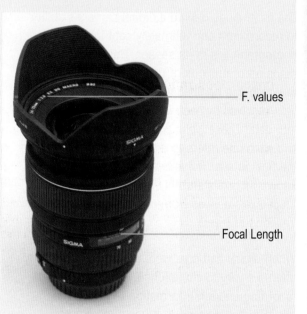

F. values

Focal Length

F values

When you look at a zoom lens the front will typically have an F number, this figure represents the largest aperture available on the lens. The lower the number the better suited the camera will be to work in low light. As an example, a lens with F2.8 on it, might be well suited to use in low light. However, if the camera had instead, a figure of F4 it might struggle where the F2.8 could still cope. Most modern digital cameras incorporate an optical zoom lens, which will typically have two F values – these two figures detail the largest aperture at both ends of the zoom.

Focal length

The focal length will also be present on the front of the lens. This, however, directly relates to the size of

the sensors and as digital cameras use a variety of different sized sensors this information can be difficult to interpret. To make the specifications more intelligible, manufacturers provide the figures as they relate to a 35mm camera. You may need to look in the manual for this information but it gives you an idea as to the perspective offered by the camera. If the camera offers 28–105mm it will be ideal for indoor photography or group shots. If instead it starts at 38–380mm you may find the camera better for sports.

Last, also keep an eye out for optical image stabilization, this helps keep the camera steady and improves your chances of getting a sharp photo.

▶

For your information

Image stabilization (electronic – optical)

One of the most common problems people experience when taking photographs is camera shake. Even tiny movements of your hands can result in images which at best lack clarity or at worst are unrecognizable. It becomes harder to hold your camera still when the elements are against you, the light is failing or you're using a powerful zoom as this magnifies the shake as well as the subject. To combat these issues manufacturers provide image stabilization. This has the effect of ironing out the movements of your hand to aid you in difficult circumstances. There are numerous types of it available, although most can be put into one of two categories: electronic and optical. Electronic stabilization uses less of the camera's sensor to capture a photo, preferring instead to use the rest to smooth the camera's movement. Optical stabilization employs the whole sensor and relies on either a correcting lens or moving sensor to counteract any movement.

Understand memory cards

For early adopters of digital cameras, memory cards were a significant outlay, often costing at least a third of the price of the camera and not really giving you a particularly large quantity of images to play with. Move forward to today and the situation has changed dramatically. Now you can purchase inexpensive cards offering you the ability to store literally hundreds of images or well in excess of an hour's worth TV quality video courtesy of the latest advances in video compression. Unfortunately it's not all good news. When digital cameras were relatively new there were only three formats of memory card to choose between, now there are several times that number with new variations being released all the time. In this section we are going to look at memory types so when you think about buying your next camera it might be one of the questions that drives your purchasing decision rather than simply a consequence of it. We'll look at the different types, which ones are compatible with one another and simple maintenance to ensure your photos are safe.

We'll start by looking at the most common formats available in the market today.

CompactFlash

As one of the oldest types of memory, CompactFlash is also one of the largest, in both physical dimensions and market presence. Most professional digital cameras use CompactFlash as the primary memory format. This is because CompactFlash still offers the largest capacity cards available and typically at

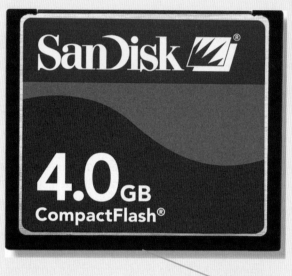

CompactFlash

the lowest per Mb price, making it most suited to professional use. In the enthusiast's market however the situation is very different. Thanks in part to its size, CompactFlash is no longer used in any consumer cameras and formats like the smaller Secure Digital have all but stolen this market.

Secure Digital

This memory format was originally created by Matsushita electronics, better known as Panasonic. The design was considerably smaller than CompactFlash and so initially at least, the cards were more expensive and offered smaller capacities. Nowadays the prices are comparable but CompactFlash cards still have the edge on capacity. Secure Digital or SD card as it has been abbreviated, has grown in popularity and with each generation of compact cameras getting

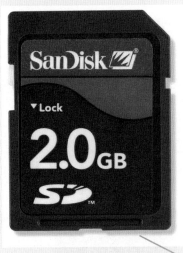

Secure Digital

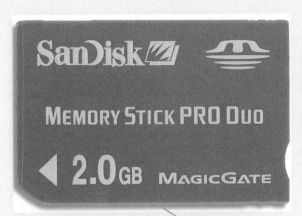

Memory Stick Duo

smaller they are now amongst the most popular type in any camera, and used in all Casio, Canon, Ricoh, HP and predictably Panasonic cameras.

Development never stands still and even smaller formats such as MiniSD and MicroSD have been introduced that can be used in mobile phones and also, thanks to supplied card adaptors, in digital cameras.

Memory Stick

If your camera needs a Memory Stick then it's a safe bet you have a Sony digital camera. Designed by Sony, the Memory Stick format has seen numerous revisions over the years, changing the level of security, the speed and the physical shape of the cards. If you scan through the adverts in any camera magazine you will find numerous different types of Memory Stick

mentioned varying from Memory Stick Pro, Micro, DUO and now PRO-HG. With the latest generation of Sony cameras, the company has moved to its smaller, faster, Duo format which can be used with an adaptor, to work in standard Memory Stick slots. However, if you are buying memory for an old Sony camera, stick to standard Memory Stick.

xD Picture Card

Predicting that digital cameras would need faster and faster memory cards to deal with the increasing number of megapixels in their sensors, Fujifilm, Olympus and Toshiba set about developing a new format that would be unique to their cameras and offer the speed they felt would be necessary. The fruit of this union was the xD Picture Card. This type of memory is used almost exclusively only by these three manufacturers so the price for the cards is marginally higher than more widely adopted

Understand memory cards (cont.)

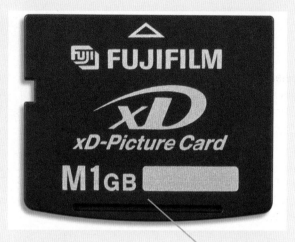

xD Picture Card

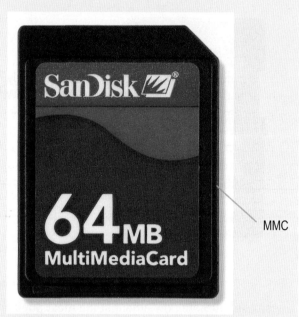

MMC

comparable cards such as SD or CompactFlash. So long as you're happy to pay for it, then xD Picture Card offers the same range of capacities as the more seasoned SD.

SmartMedia

Developed by Fujifilm and Olympus in partnership this type of memory is no longer considered a current format, although it is still possible to purchase 128Mb cards. When looking to purchase a new camera, avoid any that utilize this type of card, it gives their age away.

Multi Media Card

These cards look similar to Secure Digital. They are, however, fractionally slimmer and usually slower than their SD counterpart. Like Secure

Digital, MMC also has a new smaller version known as Reduced Size Multi Media Card or RS-MMC. If your camera accepts Secure Digital it will usually accept MMC.

Ultimately there is no single memory type that is better, faster or more suited to everyone's use. You always run the risk that whatever camera you purchase, it will use a type that in just two years' time will have shop assistants scratching their heads, struggling to remember a long-dead format. The best advice is to opt for a camera that has a more generic storage type used across numerous manufacturers. Currently, Secure Digital appears the most widely adopted.

?

A

Did you know?

When you delete your photos you're not actually deleting them, think of your memory card like a book and your images are pages in this book. When you choose to delete your unwanted photos your camera goes to the index and removes the reference to them, apparently freeing up the space and making it impossible to view them in playback. However, if you were to somehow flick through to the pages, all the information is still there and using image recovery software it's possible to get them back. The drawback to this is that over time your memory card can get corrupted and eventually even damage all the other images. To avoid problems, it's good practice to occasionally format your memory cards as this wipes the information completely – returning to our book analogy formatting removes the references and blanks the pages.

Jargon buster

35mm equivalence – the standard measurements adopted by manufacturers, given that digital cameras have differing sizes of sensors, to give an idea of the focal range of a camera lens, for example, a typical 3x optical zoom would be an equivalent of 35-105mm.

AF servo – refers to a camera's ability to continually focus on a moving subject, sometimes called AI Servo or Continuous. This focus mode is ideally suited to use with sports events or motor sports. To start the process of focusing, the shutter release typically needs to be half pressed – on higher-end cameras, the camera will even continue to adjust its focus as the image is recorded.

Aperture – the hole through which the light travels. In photography, the term is used to describe the diameter of the diaphragm, which controls the access of light. Using a larger opening, more light comes in, creating an image with a shallower depth of field, with a smaller opening the camera takes longer to get the same light, but the image has a larger depth of field.

Aperture priority – cameras equipped with this mode allow you to select your desired aperture value, whilst automatically adjusting the shutter speed to ensure the exposure is still correct for the image. Aperture priority mode can be useful for controlling depth of field.

Artefact – most commonly used to describe problems attributed to the JPEG compression used by digital cameras. JPEG compression allows many more images to be stored on a memory card than would otherwise be possible, but poor implementation can introduce a stepped appearance to normally smooth lines, or unwanted patches in solid colours.

Auto-bracketing – this is taking a series of shots, usually between three and five, with exposures slightly above and below the suggested metered exposure. It is used to deal with situations where there are both very bright and very dark elements.

Backlit – this is where a sitter is photographed with their back to a bright light source which can fool the camera into capturing them as a silhouette. This is caused by the camera trying to weigh up the darkness of the subject and the brilliance of the background. Using a fill-in flash can help to balance the image and ensure the subject is correctly captured.

Barrel distortion – this describes the effect where, for example, the lines of a door frame bow gently outwards. It is one of the results of the balance between flexibility and picture quality – the long zoom sought by camera buyers means that the lens has trouble ensuring the lines in the image are straight at its widest point.

Blooming – the millions of tiny receptors in a camera's sensor act like tiny wells. If a bright area saturates its well the excess sometimes spills into neighbouring ones. This overflow

artificially increases the brightness of the surrounding areas. To lessen or avoid this 'blooming' modern digital cameras use gating systems.

Burst mode – otherwise known as continuous shooting – it is when the camera takes a series of photos in rapid succession giving you more chance to get the crucial moment. Useful when photographing sports. Cameras are often quoted with a FPS or frames per second.

CCD – stands for Charge-Coupled Device, which forms the basis of most modern digital cameras. The alternative to the technology is known as CMOS or Complementary Metal Oxide Semiconductor – this was historically used for low-cost cameras as it was inferior to CCD but cost less to manufacture. However the two technologies now offer identical results at similar costs.

Chromatic aberration – simply means that the colours on the print are out of alignment. Different colours of light have different wavelengths which are bent by the elements of camera lenses at slightly different angles. Unless the lens has additional correcting elements the print will show slight red and blue edges on high-contrast subjects.

See also: Fringing.

Colour accent – this converts a colour photo into black and white leaving only one colour element such as a bridal bouquet, which provides a bold contrasting detail.

CompactFlash – one of the oldest memory formats and also one of the largest. This physical size means that manufacturers no longer provide support for it in compact digital cameras but in the professional field it remains a firm favourite and is used in nearly all DSLR cameras.

Compression – There are numerous ways of compressing images but they fall into two camps: lossless and lossy. Lossless compression is when the image is squeezed into a smaller file but when it is reopened the original file is identical, no information being lost in the process. TIFF files can be compressed in a lossless way. With lossy compression the file can be squashed much smaller making it more suitable for transfer or web usage but when the image is opened again the result is a representation of the original but some of the quality is lost. JPEG files carefully balance image quality against file size but the process still involves some loss of quality.

Cropping – term used to describe how photographers block out or trim off those parts of an image they don't want to use.

Depth of field – the distance between the nearest and furthest points that a camera has in focus. Adjusting the camera's aperture directly controls this area. Higher F numbers such as F22 can offer almost infinite depth of field, whereas lower F numbers such as F2.8 are more suitable for portraiture as they offer a very limited focus area.

Digital zoom – unlike an optical zoom lens, digital zoom doesn't use the lens to magnify the subject. Instead the camera discards some of the light hitting the sensor opting instead to use just the centre portion. This has the effect of making the image appear magnified. However, as less of the sensor is used it does have the drawback of reducing the picture quality.

Electronic viewfinder – used to simulate the experience of using a single lens reflex camera. It can relay the live image coming in through the lens without have to incorporate another bulky lens solely for the viewfinder. Another benefit of an EVF is the inclusion of the current shot settings. Often associated with cameras with powerful optical zooms.

EXIF – the Exchangeable Image File or EXIF header is information embedded in the image file itself. It records details of the exposure, type of camera and, if you have entered it, the time and date.

Exposure compensation – this allows you to override the camera's choice and force it to lighten or darken the exposure. Useful when conditions mean that the camera will struggle to produce the desired results on its own.

Focal length – this is the distance in mm from the centre of the lens to the focal point when the subject is at infinity and in sharp focus. In a digital camera the focus point is the sensor. Focal length is normally represented as mm on the front of the lens. However, for these figures to be useful you need to know the 35mm equivalent – everything lower than 35mm is considered wide angle, over 80mm is normally referred to as telephoto.

Focal length multiplier – conventional lenses can be used on some digital SLR cameras but these have a smaller sensor size than conventional 35mm film, meaning that the focal length offered by the lens produces a different field of view, with a narrower perspective. This effect is known as a Focal Length Multiplier. Typically, most entry-level digital SLRs have a 1.5x or 1.6x multiplier – this means that the bundled lenses which offer such alien focal lengths as 18-55mm actually produce similar results to a more conventional 29-88mm.

Focus and recompose – auto-focus cameras often try and focus on the centre of the scene, which may not be the part you want to be sharp. By pointing at the subject first then recomposing the image you get around this.

Format – removes all data from the storage being formatted, similar to simply deleting your images but the process is more thorough.

Fringing – similar to chromatic aberration, and also caused by the differing wavelengths of light not being sufficiently corrected for. Fringing however, occurs at the camera's microlenses. On some sensors, tiny lenses are added to help funnel the light into the small receptors.

Icon – graphical representation of a mode or setting. Typically used to indicate a preset exposure setting such as portrait or sports mode.

Interpolation – use of a complex mathematical calculation to produce a larger image than was originally recorded. It has the effect of producing images that offer a higher megapixel count than the sensor itself physically offers.

JPEG – stands for Joint Photographic Experts Group, a committee of specialists who defined the ISO 10918-1 standard in 1992 – the term refers to a form of compression designed to significantly reduce the storage requirements of photographic images. It is a lossy compression, meaning that some of the original information, and as a result, some of the quality, is lost.

See also: Compression.

LCD – an abbreviation for Liquid Crystal Display – describes the technology used in most modern digital cameras to provide a real-time view-and-review screen. Often used as a generic term although manufacturers have many new technologies such as OLED – these more advanced display technologies promise to provide better battery life whilst still being big enough and bright enough to use in direct sunlight.

Macro – the macro setting on a camera allows you to focus the lens very closely. By focusing only a short distance from the lens, cameras can capture very fine detail on smaller subjects. Typically used for insects and plants, the icon for macro is, in fact, a simplistic flower.

Megapixel – one million pixels. The light coming into a camera's lens is recorded on a sensor, or CCD, made up of thousands of individual receptors known as photosites or pixels. Modern cameras are typically measured in six to eight megapixels. While it is true that the more megapixels the bigger the image is, it doesn't directly relate to quality.

Memory card – the digital equivalent of film, and where images are stored. (It is not sensitive to light, but it is good practice to take care of it.)

Memory stick – the memory format used by Sony to store images. It has numerous different physical formats with PRO, DUO, Micro and PRO-HG. Each new format is smaller, faster and has increased storage capacity to enable smoother video or faster burst speeds.

Noise – to photograph in low light or to use faster shutter speeds with conventional film cameras a higher ISO rated film is often used. Its chemicals react faster to light but it has a more obvious grain. Digital cameras emulate this film by amplifying the signal which can introduce unwanted coloured pixels or 'noise' into the photo.

Pincushion distortion – a characteristic effect of bad lens design as manufacturers try to squeeze the most flexible zoom they can into a camera design. The resulting poor image quality can be seen when looking at the lines of a window, often the straight frame will curve gently inwards.

Pixel – short for picture element, it represents the smallest part of an image.

PPI – pixels per inch – a measurement of the resolution of images. If your images are going to be printed, it should be set to 300ppi, the standard resolution used by many commercial printers but for the Web, 72ppi is more suitable. Changing the ppi changes the image's output size but it does not change the total number of pixels

in the image so that there is no impact on image quality.

RAW – simply means raw or unprocessed, it is not an acronym. Choosing to use RAW files means that you tell the camera to leave the images alone, allowing you to make decisions on the sharpness, colour and compression of the image later when you convert it on your computer. This is instead of allowing the camera to process the image to convert it to JPEG or TIFF.

Reflector – a fold-out disk or panel with a reflective white, silver or gold surface. Reflectors are normally used in portrait or studio work to direct light in order to lighten any darker aspects of the image.

Scene modes – digital cameras include numerous scene modes to take the guesswork out of configuring the camera. For example, when taking portraits, a narrow depth of field is generally preferable as it draws attention to the model rather than the periphery. By selecting portrait mode the camera elects to use the largest available aperture.

Shutter priority – allows you to specify exactly what shutter speed you require to create your exposure. However, in order to achieve this the camera automatically adjusts the aperture value to ensure the exposure is still correct.

Shutter release – the button which releases the shutter and allows it to momentarily snap open and shut exposing the sensor to light.

Shutter speed – the speed at which the camera allows the shutter to open and close allowing light in to create an exposure. It is normally measured in fractions of a second, but longer exposures can be several seconds or more.

TIFF – stands for Tagged Image File Format. It works in a similar way to JPEG but can compress photos without any loss of quality.

TIFF files also have the advantage of being able to support layers. As a result, while some digital cameras do support TIFF files it is far more likely that you will encounter them while using a photo editing package.

TTL-metering – TTL stands for Through the Lens and is usually used in the context of how cameras interact with a flash. Using TTL, the required exposure is measured from the light travelling directly down the camera's lens. When firing a flash, the sensors in the camera can then adjust the flash's output, ensuring the exposure is as accurate as possible.

TWAIN – not officially an acronym, it stands for Toolkit Without An Interesting Name and is the industry standard for communication between scanners, printers and applications. Before it was established in 1992 getting, for example, your scanner to talk to your PC could be a very hit and miss affair.

Unsharp mask – a tool within modern photo editing packages used to, in fact, *sharpen* a photo. Its contradictory name originates from a printing technique that used a slightly blurred positive image combined with the original negative to create the effect that the final print was sharper.

USB – abbreviation for Universal Serial Bus – by far the most common way to connect a digital camera to a home computer. Identify the presence of a USB by looking for its trident icon. Unlike older methods, it allows for new accessories to be connected safely while the computer is still turned on. There are currently two types of USB, 1.1 and 2.0, the latter is over 40x faster than its predecessor.

White balance – digital cameras come equipped with numerous preset white balances, including tungsten, daylight, cloudy, etc. These settings are designed to compensate for the differing wavelengths of light coming from the different light sources their names represent. For example, photographing under a fluorescent strip light without selecting the correct white balance is likely to give the image a blue appearance.

Troubleshooting guide

Taking photos

Why do my photos come out blurred?

It's likely your exposure is set very long either because there isn't enough light, or you have simply selected a slow shutter speed. Try using flash by reading up on page 27 or adjusting the shutter speed – see our section on shutter priority on page 53.

Why are my photos too dark?

Have you have accidentally disabled your flash? Check out page 27 for more details. Or you might need some help using the manual mode, if so read up on page 56.

Why do my photos vary from too light to too dark?

Check your metering settings you might find the camera is set to use spot metering. To learn more about the various metering modes turn to page 62.

My photos all have white skies with no detail, what can I do?

Ultimately most digital cameras have to make a compromise between exposing the sky or the buildings, however you could try using auto bracketing. Read more on pages 64 & 103.

How do I stop my photos appearing grainy?

Grainy photos can be caused by too little light or too high an ISO setting on the camera, check out page 59's task focused on ISO to learn more.

Whenever I take photos indoors, they come out orange, what am I doing wrong?

Getting a strong colour cast of this nature is usually associated with the wrong white balance settings, see page 125 to get the low down.

Why can't I get my prints any bigger?

If you're struggling to get enlargements printed the most likely cause is that the image resolution is set too low. Otherwise it could be you have been using the digital zoom, learn more about digital zoom on page 24.

Why do the eyes of my subjects always appear red?

What you're seeing is the light bouncing back from your subject's eye. There are ways to reduce this in the camera, see page 29, but if they persist you can ensure they are removed in Photoshop Elements, see page 150.

Why do my flash photos look bleached out?

Your subject may be too close to the camera. Try lowering the flash power. Turn to page 72 to learn about flash compensation.

I keep taking photos but when I look at them there is nothing there, what am I doing wrong?

Many cameras allow you to continue taking photos even when the memory card has run out of space, or if it's missing altogether. Have a look over page 8 to check both possibilities.

When taking close-up pictures the composition of the final image doesn't reflect how I originally framed the shot. What is happening?

On compact digital cameras equipped with both an LCD screen and an optical viewfinder, there is a physical difference between the placement of the lens and the viewfinder. Normally the viewfinder gives a pretty accurate preview of your final image, however, as the subject gets closer you can begin to see the effects of the two viewpoints. This is known as Parallax. As you become more familiar with your camera you can try and compensate for the shift.

Manipulating photos

Can I convert a black and white print to colour?

If you take the photo using a digital filter as on page 119, the short answer is 'No'. However, if you have converted the image using Photoshop Elements you might be able to go back through the file's history and restore the colour. Check page 156.

Can I use the computer to adjust the exposure of my poorer quality shots?

Very often, although there are limits to the computer's power. See page 153.

How can I sharpen up a slightly blurred image?

Take a look at page 173 for suggestions.

Can I remove unwanted items from my pictures?

This is very straightforward if you follow the instructions on page 203.

Is there anything I can do to get a really perfect group shot?

Thanks to the power of Photoshop Elements, perfect group shots are possible. See page 214 for details.

The digital frames that I select for my images never seem to fit perfectly. What's going wrong?

You need to adjust the image size. Page 226 tells you how.

I have upgraded to a digital SLR. However my photos don't appear as crisp as those I took with my previous digital compact, what am I doing wrong?

This is quite a common complaint as many digital SLR cameras produce a very neutral photo, allowing you to adjust the image to your preference. Digital compact cameras produce an excessively sharpened and contrasting image and as a result the images appear crisper and more striking. You can use Adobe Photoshop Elements to reproduce the same image characteristics if you choose. See page 173.

I want to split up a group photo into several portrait photos. However, when I print the headshots, the photos come out grainy.

In cropping a large proportion of the image away you are left with much less information. For example, if the photo was taken with an 8 megapixel camera but you discarded over three quarters of the image, the remaining portion could be as little as 1 megapixel. When blown up to the same size as the original, the image will now appear to be much lower quality. Higher megapixel cameras can help but ultimately, composing your image for each individual is a far better option.

Saving and printing photos

I want to edit my photographs. What format should I be saving photos in so they don't lose quality?

Using the JPEG format ensures compatibility with any other computer. However, repeated editing and saving degrades the overall image quality. Using a lossless TIFF format retains compatibility with many systems, trading the smaller file size for better quality. The best format to use with Photoshop Elements is its native PSD, which ensures utmost quality and provides layer information. See pages 146, 262 and 264 for details.

Is it important to use the same brand for both photographic paper and printer ink?

Ensuring predictable results is often much easier when you use the recommended brands. However, some manufacturers give higher quality than others. The best advice is to experiment!

I don't have a printer at home. How can I get copies of my photos?

You can have your photos printed at many places on the high street (see page 298) or order prints online (see page 294).

How do I back up my photo albums to ensure I don't lose them?

This is an extremely important thing to do. Turn to page 244 for advice.

Can I set my holiday photos to music?

Oh yes! All the instructions are on page 252.

I'd like to show my photos to my friends in Australia. How do I do this without getting on a plane?

There are many sites on the Internet that allow you to set up online albums and share your photos with anyone you choose. See pages 267 & 271.

I've lost some really important pictures. Is it possible to recover them?

Not always, but there is hope. Turn to page 261 for suggestions.

When I frame my favourite prints, they develop a water-stained appearance shortly after putting them behind glass. Why is this?

This 'stain' is actually just the effect of the photograph sticking to the glass. You can avoid it by using a raised border to separate the image and the glass, or by printing the photo onto paper with a luster finish rather than gloss. This stops the surface sticking.